STANLEY KUNITZ---JONAS MEKAS---DUANE MICHALS---JOHN BERNARD MYERS---OCTAVIO PAZ---TERRY SCHUTTE

ALBUM

Dore Ashton

A Joseph Cornell Album

A JOSEPH CORNELL

WITH SPECIAL CONTRIBUTIONS BY JOHN ASHBERY---PETER BAZELEY---

ELIZABETH BISHOP---DENISE HARE---RICHARD HOWARD-

AND ASSORTED EPHEMERA---READINGS--DECORATIONS-

AND REPRODUCTIONS OF WORKS BY JOSEPH CORNELL

Contents

———————————— CORNELL'S HOMAGE TO CHILDREN

Foreword

Joseph Cornell paid me his first visit sometime during the mid-1950s. He came bearing a tin of French biscuits which he held on his lap during the entire two hours we attempted a conversation. Only as he left did he tender his offering. He sat tensely, gripping the knobs on the arms of his chair, and most often averting his eyes. It was a slow, painful beginning. His shyness was almost insurmountable. However, we managed to begin a conversation—mostly about our enthusiasms in literature—which lasted until his death in 1972. We visited back and forth desultorily, corresponded, and when my children were born, Joseph began corresponding with them. Although it was difficult to follow Cornell in his moods and occasional sudden antipathies, I found him an affectionate friend.

Like so many others, I regarded Cornell as an American eccentric, an authentic original. His work seemed to me, and still does, a genuine expression of what used to be called a poetic soul. When I undertook this book, it was to render homage to his working self with all its poetic vagaries and inconsistencies. My text is drawn from my experience with his work and thought, and this album is meant to be in his spirit.

Cornell's personality presented difficulties to many of his acquaintances. His moods ranged from uneasy dourness to quiet satisfaction; at times he was excessively suspicious. He was a difficult person to remain friends with. On the whole he got on better with the family of kindred souls he discovered for himself

in the distant past than with his contemporaries. Still, my own experience was consistently pleasant, and I have even seen him positively exuberant with cordiality.

One such occasion has a direct bearing on this book. On December 12, 1971, Barbara Burn, an editor at The Viking Press and an admirer of Cornell's work; Octavio Paz, the Mexican poet, and his wife Marie-José; and my youngest daughter and I embarked on a visit to Utopia Parkway. Knowing his love for desserts, Barbara had baked a pie, and this, I'm inclined to think, set the tone for the long afternoon. Joseph, who knew of my friendship with Paz, had asked me to bring him and when he caught sight of Octavio's vivacious French wife, he smiled broadly—something few of his acquaintances had ever witnessed. Usually Joseph's smile was small, hesitant. During the afternoon Cornell spoke with unaccustomed ease, bringing forth his knowledge of French poetry and engaging in an animated discussion of Mallarmé's sonnets with both Octavio and Marie-José. He took us to the cellar, showed us all his works in progress as well as some completed boxes, and thoroughly enjoyed himself. Before we left, he drew me aside, and whispered with a certain ingenuousness: "Was he really an ambassador?"

That visit, with its exceptional ambiance, was the real beginning of this album.

There is little in the text to indicate Cornell's complex relationship with the world at large. He was an assiduous correspondent, and far from being the recluse his legend suggested, reached out constantly for potential friendships. Sometimes his relationships were brief and foundered in misunderstanding. His erratic behavior simply defeated the patience of his acquaintances. Cecil Beaton, who had engaged Cornell to find illustrations for his book on New York, found him a difficult collaborator. He "never seemed content and he disappeared and could not be got hold of," Beaton says, adding that he was ugly to look at and untidy. Allen Porter, who knew him during the 1930s, thinks of him as "one of the great bores of the world . . . socially, that is." Remembering the old days when Cornell was constantly at

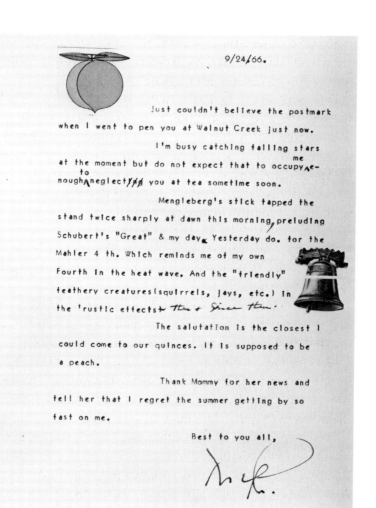

9/24/66.

Just couldn't believe the postmark
when I went to pen you at Walnut Creek just now.

I'm busy catching falling stars
at the moment but do not expect that to occupy me e-
nough neglect/ng you at tea sometime soon.

Mengleberg's stick tapped the
stand twice sharply at dawn this morning, preluding
Schubert's "Great" & my day. Yesterday do. for the
Mahler 4 th. Which reminds me of my own
Fourth in the heat wave. And the "friendly"
feathery creatures(squirrels, jays, etc.) in
the 'rustic effects+ then + Since then.

The salutation is the closest I
could come to our quinces. It is supposed to be
a peach.

Thank Mommy for her news and
tell her that I regret the summer getting by so
fast on me.

Best to you all,

the Julien Levy Gallery, Porter notes, "He was so embarrassingly shy, everything he said was monosyllable; he would ask questions mostly about what the artists he admired like Dali or Ernst were like, and once when I introduced him to Duchamp, I thought he'd faint and he made for the WC, where he stayed an hour." Porter adds: "Everyone presumes because so much of his work was lively and gay and amusing that it stemmed from a fascinating personality. . . . Alas, you'd never believe how

Letter from Cornell to Sasha Yunkers

downright dull he could be." But, another Museum of Modern Art official of the period, James Thrall Soby, remembers Cornell as "one of the most magical people I've ever known." Such contradictory views of Cornell as a personality indicate how inaccessible he really was, and how hard it was for him to deal with the world. Even those who tried to please him sometimes ran afoul. Most of the critics who wrote enthusiastic articles about him or his work were roundly condemned. He used to refer to them as "Trojan horses," particularly those who for a time had been regular visitors to Utopia Parkway.

Cornell was puzzling in other ways. For instance, his curious affection for the trivial, for even downright kitsch, surprised many of his admirers. If you came upon his letters or writings without knowing much about him—as did Ruth Gay—you were likely to be baffled. Mrs. Gay describes a letter in the Yale Archives: "It is written (by hand) on a perfectly ordinary piece of onion skin paper. This is then folded down into thirds and thirds again, and then attached to an absolutely banal 'Wedgwood' Hallmark greeting card. This was then further decorated by a color printed star and butterfly which had been cut out of somewhere and stuck onto the card." Such "banal" offerings were typical for Cornell. But so were his creative ideas, which so often, as he himself put it, were "bursts that crowd so fast and explode like novae." In this album, it is his creative life that is honored rather than his personality.

Acknowledgments

The exceptional good will and assistance this book brought forth on the part of many people makes it difficult to express the full measure of my gratitude.

I thank, first of all, its editor, Barbara Bullard Burn, whose contribution goes far beyond mere editing and whose collaboration has given me great pleasure.

To my friends Denise Hare, Duane Michals, and Terry Schutté, whose photographs are not mere documents but contributing commentaries, my admiring thanks. And to my friends the poets Richard Howard, Stanley Kunitz, Octavio Paz, and Elizabeth Bishop for their original contributions, and to John Ashbery for permission to use his homage to Cornell, I am exceedingly grateful.

I thank George Kott, Esta Greenfield, and Terry Schutté, all of whom worked as Cornell's assistants at one time or another, for their insights and help.

Many individuals met with me, or wrote letters in the kindest spirit: Robert Schoelkopf, David Mann, Nicki Thiras, Jeanne Reynal, Donald Windham, Ruth Gay, Allen Porter, Harry Torczyner, Cecil Beaton, Susan Sontag, Paul Magriel, James Thrall Soby, Grace Hartigan, Julien Levy, Eleanore Ward, Bartlett Hayes, Jr., Richard Feigen, Irving Blum, Russell Lynes, Rudi Burckhardt, Lincoln Kirstein, Brooke Alexander, Joella Bayer, and E. A. Bergman.

I am especially grateful to Messrs. Blum, Feigen, and Bergman

and to Miss Ward for permission to use reproductions of works in their collections. I thank Sasha and Marina Yunkers for permission to quote from letters they received from Joseph Cornell. And I thank my secretary, Gayle Ellis, for her time, patience, and effectiveness.

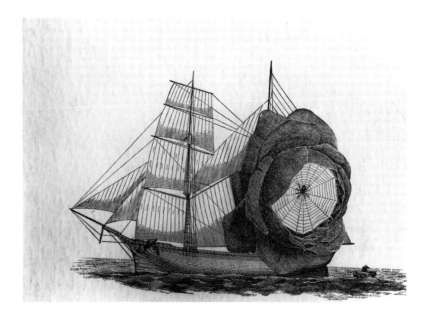

Untitled collage (Schooner), 1931

A Joseph Cornell Album

Joseph Cornell

Joseph Cornell's admirers relish the coincidence that this man who revered reverie lived on Utopia Parkway. Toward the end of his life there were several published accounts of the petit-bourgeois house with its white shingles and blue trim, planted amidst a row of similar houses in the crowded Flushing suburb. Visitors were surprised to find this thrall of the exquisite ensconced in a commonplace house, crowded with too much furniture and too many traces of former family life, and with piles of books and papers everywhere. They noted shocking objects—shocking only in their humble and sometimes bad taste—such as plaster figures of animals, or a tablecloth with the garishly painted legend "Welcome to Jamaica" and a turbaned calypso singer beckoning. An anomaly—this man who could fashion exquisitely arcane images and who lived amidst the most ordinary of ordinary bric-a-brac.

The house on Utopia Parkway can be understood as the carapace of Cornell's soul (for he, being the issue of nineteenth-century Romanticism *had* a soul, to which he was profoundly devoted). In this shelter each fragment, whether a china squirrel, a ship's model, wood, beads, or trifles from the sea, was significant to him. The poetic enactments which are his boxes and collages are the visible issue of this palace of dreams and associations. Like des Esseintes, Cornell did not have to travel (indeed, it is doubtful that he could ever bear to leave his trove of books,

notes, and dossiers, which were his sustenance and inspiration). His mind, like a shell, spiraled to infinity.

No one visiting Utopia Parkway could avoid becoming part, at least for a moment, of Cornell's quest for the infinite. He would often receive visitors in the kitchen, or in the tiny dining room crammed with dossiers, where he would promptly take out his legal pad. As the conversation haltingly opened, Cornell seemed to withdraw, his pencil poised, as though trying to remember something from long ago that perhaps only the living presence of his visitor could retrieve. At such times, only the word mattered. Cornell could not exist without the magic of the word. His lifelong habit of notation was both his despair and his solace. At times he would ask friends to help him put his mass of notes and files in order ("This place is bulging with dossiers, something has got to be done"). But usually he reconsidered. The words, dispersed everywhere, were after all part of his magic, as were the innumerable newspaper cuttings, magazine images, feathers, engravings, and pressed flowers that occupied the album of his imagination.

The one word that alone could not solace him, and which he had to transmute into visual images, was "mystery." All the same, the mysteries prepared in his basement or kitchen, emerging as singular boxed poetry, were incomplete for Cornell. He sought always to return them to the word. Other people were resources for Cornell—possible kindred spirits who might respond to what he made by endowing his creations with meaning. His numerous assistants over the years report how anxious he was to receive their impressions of his work, and how uncanny his instinct was for the "right" response. No "work" could ever be really finished, for much of its meaning continued to mill in his imagination.

The house on Utopia Parkway was full of phrases. The visual works were materials in a continuum. While it is not unreasonable to see the impact of twentieth-century art in Cornell's works, his poetic habits of mind were firmly rooted in the nineteenth century. Cornell himself eluded the category of "artist,"

Cornell at home on Utopia Parkway, early 1960s 3

at first perhaps from diffidence, but later unmistakably by his certitude that his creations were not "constructions" or "sculptures" or "collages" in the modern tradition, but poetic enactments, verbal bibelots, static theater—anything but mere works of visual art. As early as 1936 he responded unabashedly to the Museum of Modern Art's biographical inquiry:

EDUCATION: Went to Andover
No Art instruction
Natural talent

PARTICULARS: Shadow boxes
Montages
Two surrealist scenarios. . . .

Twenty-four years later he was saying, "I've never called myself an artist. On voter registration, I call myself a designer," and in 1967 he said, "I never went to college and I never had an art lesson. I can't draw, paint, sculpt, make lithographs. My work was a natural outcome of love for the city."[1] (Not the city as most of us experience it, but a city of mysteries and hidden treasures, one that he liked to refer to as Le Corbusier's *catastrophe féerique*.)

If he didn't exactly see himself as an artist, there is considerable reason to believe that he genuinely saw himself as a magician. On occasion he hinted that what he made could transform the right recipient. Once, to a young dancer, he confessed that he would have liked to make his haven in Utopia Parkway into a kind of magical commune, with young people who might carry on his "work." He believed, as did his literary forebears in other centuries, that the young and pure of heart could grasp his poetry. During the 1950s he wrote to the Whitney Museum that he didn't want to exhibit since he felt his works were "more suitable to a class room," and, in a letter to the author, said he wanted to "reach some of the wonderful young dreaming browsers—serious ones looking for a contact. . . ." This, too, was part of the quest for confirmation of his dreams, and it cul-

[1] Quoted by Jack Kroll, *Newsweek*, June 5, 1967.

minated, shortly before his death, with a special exhibition for children at the Cooper Union.

But the relationship to children that he tried to maintain was neither simple nor childlike. Actually he was only interested in the archetypal child. It is true that he collected toys for hospitalized children, and that his first exhibition at the Julien Levy Gallery was billed as "toys for adults," but Cornell was no toymaker: he was an idolator of innocence. He could have easily rebuked those who misunderstood him with the words of one of his most important spiritual brothers, Hans Christian Andersen. At the end of his life, Andersen was to be honored with a sculpture in his likeness, and in one of his rare bursts of impatience at the lifelong misunderstanding of his art, he wrote to Jonas Collin on June 6, 1875:

Saabye visited me again last night. My blood boiled, and so I spoke my mind in no uncertain terms, saying that none of the sculptors knew me, that none of their designs suggested that they had seen and known what was characteristic of me, that I could never read aloud when anybody was sitting behind me or close to me, still less when I had children on my knees or young Copenhageners leaning against me, that it was a mere phrase to call me the "children's poet." My goal was to be a poet for all ages, and children could not represent me. . . .[2]

Similarly, Cornell bridled when his work was taken for mere amusement. How deeply he resented the idea of "toys for adults" can be seen in a letter to J. B. Neumann:

From the way that you spoke of Prof. Einstein, I got the impression that this gentlemen is a friend of yours. And so I have been wondering if it might be in the realm of possibility to put before him a few of the new sand boxes both for his pleasure and possibly a word or two of appraisal or commendation.

As long as I have been making the objects my feeling has been a more serious one than of mere "amusement" a category into which they have been shoved too often in the 57th Street galleries. Should I be fortunate enough to obtain an honest line

[2] Monica Stirling, *The Life and Times of Hans Christian Andersen* (New York: Harcourt, Brace & World, 1965).

or two from the prof. I should feel as though not so many years have been wasted in making "amusing" objects, and consequently I should feel endlessly grateful to you.[3]

The encounter with Einstein seems never to have occurred, but Cornell's need for a sympathetic adult response persisted, and he was to try many times to find the right reaction from estimable individuals throughout the world.

The first approval Cornell knew as a creator came from his artistic peers, the Surrealists, but over the years it became increasingly apparent both to him and to them that he was not a Surrealist at all, but a true eccentric whose sources of inspiration were remote from the extravagant ironies of Surrealism. There is a paucity of information about Cornell's artistic development. He never revealed more than fragments of his life, and almost nothing of his stylistic development (although for those who knew how to listen, there was a vivid account of his spiritual development in his repeated references to certain key readings).

He had said that he had been inspired by Max Ernst's celebrated montage album, *La Femme 100 Têtes*. In the early 1930s—from 1932 as he sometimes gave the date—he adapted Ernst's montage technique, and familiarized himself with the philosophical leitmotifs of the movement. At the beginning he seemed to want to belong to a movement, and sometimes described himself as a Surrealist. In answer to a 1938 questionnaire sent him by the class agent of the Class of 1921 of Phillips Academy at Andover—from which he had graduated as a science, as opposed to a classics, senior, and where the only reference to him in the yearbook was that his nickname was "Joe"—he listed himself as a textile designer but noted that he was "working in the Surrealist vein" on constructions and film scenarios. (His sojourn at Andover had not indicated his artistic future. Bartlett Hayes, Jr., art historian and museum director, recalls chiefly that "he had a shock of black hair, was something of an extrovert by con-

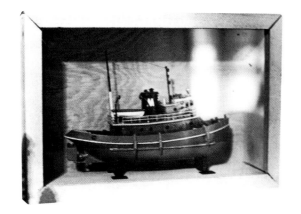

Boat model in Cornell's dining room

[3] Letter to J. B. Neumann, dated October 25, 1946, in the Archives of American Art.

Sandbox, ca. 1940. When the box is shaken, the colored sand shifts and produces new patterns. 7

trast with his later personality, and if I remember rightly, played on the Soccer team of which I was also a member. In short, I remember him as an active, vigorous schoolboy. . . .") '

After graduating from Andover, Cornell worked as a textile salesman in his family's business, plying New York's loft district and becoming familiar with the then numerous antique and second-hand bookshops. He remembered this period with affection, remarking on his bibliomania and the vast resources of lower New York. It is quite possible that he encountered Surrealist publications well before he came into contact with Surrealist works at the Julien Levy Gallery in 1932. While Ernst was the immediate spur, it was probably his previous browsing that prepared Cornell's entry into the visual arts. On the surface, Cornell was faithful to Surrealist preoccupations, and Saul Steinberg has remarked that "any discussion of Cornell will always lead to Duchamp," characterizing both Cornell and René Magritte as "good soldiers." But beneath appearances lies a whole other tradition—a tradition upon which the twentieth-century Surrealists drew, but which finally they controverted for artistic purposes. Cornell's utilization of prime Surrealist documents was markedly idiosyncratic.

Nearly all the young people who came into contact with Cornell, and all of his friends, are familiar with the key documents. He always tested people's receptivity by recommending readings. Over the years the lists changed only slightly, and he himself referred constantly, in letters and conversations, to certain images and ideas. The readings were nearly always of nineteenth-century provenance, and one figure, Gérard de Nerval, seemed to haunt him above all others. This has encouraged the view that he was a creature of the Surrealist movement since it was André Breton who first insisted on Nerval's importance in the Surrealist pantheon. In Nerval, who had characterized his own late arcane poems as *supernaturaliste*, Breton found the perfect foil for his evolving poetic-psychiatric theories. He noted in the First Surrealist Manifesto of 1924 that he might have em-

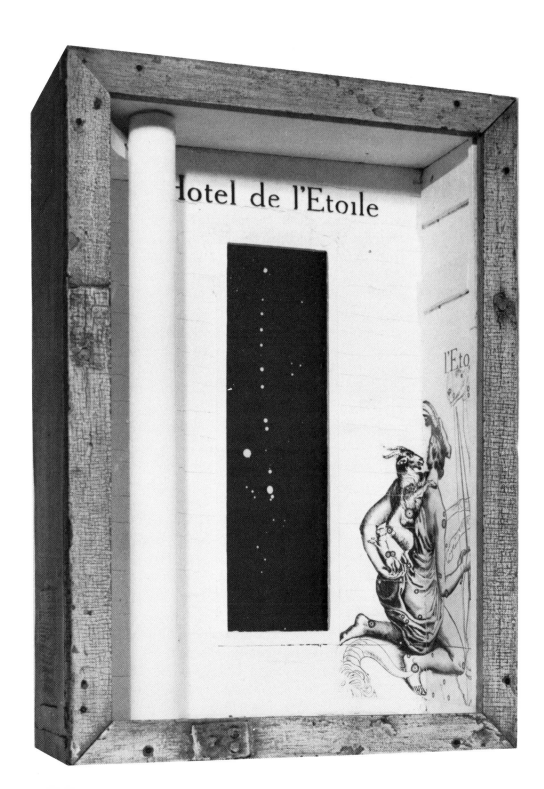

Night Skies Auriga, 1954 9

ployed Nerval's term just as easily as he had the term coined by Apollinaire: Surrealism.

It has never been established how much French Cornell could read without difficulty. Unquestionably he understood some important verbal constructions, and it is possible that he could read, although not speak, the language with the help of a dictionary. Perhaps he encountered Breton's exhortations to read Nerval, and that other *exalté* Novalis, before he ever set foot in the Levy Gallery. It is also possible that it was through Breton's writings that Cornell became interested in Freud. But if Breton was the agent, Cornell's own psyche was the reagent, and had been so prepared from his early youth. Although it was a Surrealist habit to try to capture the flow of dreams, one suspects that Cornell, long before he ever heard of Surrealism, was busy excavating his nocturnal imagery. He often mentioned his long, and sometimes terrifying, dreams. Frequently he would attempt to write them out on the yellow legal pad, and sometimes complained that he had "lost" a particularly vivid sequence. Like Nerval, he could say, "Je n'ai jamais eprouvé que le sommeil fut un repos." Cornell suffered from insomnia, and reported that he slept only fitfully even at the best of times. His headaches, which sometimes occurred during visits and would send him out of the room for lengthy periods to lie down with his arm over his eyes, seemed part of a repeated, often nightmarish retreat from the real time of day.

Cornell's affinities with Gérard de Nerval, however, were not based solely on Nerval's emphasis on the importance of dreams. It was not the deranged victim of white nights that drew Cornell so much as the authentic Romantic soul, imbued with what the Germans call *Sehnsucht*, or longing for other times (Nerval, it must be remembered, was responsible for translating many Romantic German texts, above all Goethe and Heine), other, purer loves, and the blessed naïveté that was the Romantic artist's great resource. Everything mythic, everything that related to other times, attracted Cornell. Still more perhaps, Nerval mingled with others in Cornell's "backstage," as he

Cornell's catalogue cover for the first Surrealist exhibition at the Julien Levy Gallery, New York, January 9–29, 1932

sometimes called his imagination, in his fateful attraction to the theater via actresses. Nerval's unhappy attachment to Jenny Colon, a young and not particularly gifted actress who he himself tells us could never understand him, and who once, as he relates in *Sylvie*, dismissed him by saying, "You are simply looking for drama, that's all, and the end eludes you," would certainly have moved Cornell. He could have said as Nerval did on hearing Jenny Colon's reproof, "These words were a flash of light. The strange enthusiasms I had felt for so long, the dreams, tears, despairs, and tenderness . . . weren't they then love? Then where is love?"

Cornell's identification with the unrequited lover, particularly the lover of presences on the stage (as opposed to their real presences which often irritate or disappoint such idealistic Lotharios), extended not only to Nerval, but to Andersen, whose courtship of Jenny Lind was sadly unfulfilled. Not only did Cornell identify with Nerval the lover of an actress, but also with the orthodox Romantic Nerval who spoke of child love, and first love, as in *Sylvie*. Nineteenth-century victims of first love are legion and Cornell seemed to know every one of them intimately. They included Novalis, whose love for a child, Sophie von Kuhn (her age is variously reported, sometimes as young as twelve), was the touchstone for the poetry of his short life; Schumann, who fell in love with Clara while she was in her early teens; Berlioz, whose first love smote him when he was twelve and whose second was for an actress; and countless other figures acting out, in one way or another, the Dantesque quest. While all the objects of these romances possessed a certain degree of what Nerval called sweet reality, they were liberally endowed with that other attribute—unattainability. And, they were all, in one way or another, ill-fated, with the lovers destined for early death, madness, or ordinary gnawing frustration (as in the case of Andersen, and probably Cornell himself).

Nerval was not simply Cornell's youthful mentor in the ways of art and the dream. Cornell lived with Nerval, re-experienced his own life through the French writer, and sought analogous

imagery in his work. His references, particularly those to *Aurélia*, were so frequent that any of his correspondents could recognize the importance of this poetic father-brother in Cornell's circular spiritual life.

The genesis of *Aurélia*, as we come to know it through the earlier work *Sylvie*, would have been important to Cornell, for the very first line of *Sylvie* sets the stage, literally: "I came out of a theatre where I used to spend every evening. . . ."[4] In the opening words of the second paragraph he supplies the key to the archetypal lover of actresses: "In her I felt myself alive. . . ." The second soul that is the staged portrayal is always, for these nineteenth-century lovers of theater, the important experience. Numerous memoirs of the period detail the disastrous or ludicrous affairs undertaken by these idealistic lovers of the mask, and some even candidly admit their disappointment in the off-stage persona. The excitement was always in the projection, in the "in her I felt myself alive." As Nerval himself ruefully remarked in *Sylvie*, "Seen at close quarters, the real woman revolted our ingenuous souls. She had to be a queen or a goddess; above all she had to be unapproachable."

In the second part of *Sylvie*, which relates Nerval's childhood love for an unapproachable girl, he describes the hypnagogic state that was to interest Cornell all his life:

Lost in a kind of half-sleep, all my youth passed through my memory again. This state, when the spirit still resists the strange combinations of dreams, often allows us to compress in a few moments the most salient pictures of a long period of life.

In early nineteenth-century poetry there were several similar accounts of this working method, notably by Coleridge and Poe. Cornell need never have discovered Breton to recognize from his own psychic experience the nature of this image-bearing reverie. When, after his first breakdown and sojourn in an asylum, Nerval began to compose the extraordinary text of

[4] *Selected Writings of Gérard de Nerval*, trans. Geoffrey Wagner (New York: Grove Press, 1957).

Aurélia, he was still capable of separating the dream from the hypnagogic reverie. Again the first lines are crucial:

Our dreams are a second life. I have never been able to penetrate without a shudder those ivory or horned gates which separate us from the invisible world. The first moments of sleep are an image of death; a hazy torpor grips our thoughts and it becomes impossible for us to determine the exact instant when the "I," under another form, continues the task of existence.

In this state he enters, slowly, a scene that will gradually dissolve into a dream, or a description of the first stages of a psychotic episode (for he has already told us he will attempt to describe his "illness"). By the third chapter, he is ready to assert:

Here began what I shall call the overflowing of the dream into real life. From that moment on, everything took on at times a double aspect—and did so, too, without my powers of reasoning ever losing their logic or my memory blurring the least details of what happened to me. Only my actions were apparently insensate, subject to what is called hallucination, according to human reason. . . .

Cornell was acutely interested in the "double aspect" of existence, and sought supporting theory in many different kinds of literature. The Swedenborgian concept was close to him, as it was to Nerval, and the theory of correspondences, put forward in various guises by a host of advocates throughout the nineteenth century, was the cornerstone of Symbolism. It was as a Symbolist rather than a Surrealist that Cornell experienced his life and work.[5]

The aspects of spiritual existence that can be seen in grand millennial or mythic perspective were set forth by Nerval in a fable that he then ascribes to his psychotic state. Yet, the fable,

[5] It is interesting that the sole book by an artist rather than a poet recommended by him was Marsden Hartley's *Adventures in the Arts*. Hartley had lived the last of the Symbolist café life in Paris at the Closerie de Lilas and was deeply marked by Symbolist preoccupations. His love of myths and fairy tales, his belief in artistic mysteries, and his faith in the poetry of the Unknown endeared him to Cornell, whose reflexes were Symbolist through and through.

in which he, like Dante, seeks pure origins, is written knowingly, in full control, and in the mode of the late eighteenth century. Here he is assured that there is immortality, that we "retain the replicas of the world we once inhabited," and that "oblivion" does not exist. "Matter can no more perish than mind . . . our past and future are intimately connected." These ideas, which occur frequently in Cornell's other great love, Novalis, are echoed in the strange religious texts by Mary Baker Eddy that Cornell pondered. Moreover, Cornell's obsession with Thomas De Quincey's "palimpsest" effect, is central to *Aurélia*, where, in chapter 6, Nerval describes three women representing relatives and friends of his youth:

Each seemed to have the features of several of them. Their facial contours changed like the flames of a lamp, and all the time something of one was passing to the other. Their smiles, the color of their eyes and hair, their figures and familiar gestures, all these were exchanged as if they had lived the same life, and each was made up of all three, like those figures painters take from a number of models in order to achieve perfect beauty.

Over the years Cornell was preoccupied with many Beatrices, some living, some dead. His terms of adoration, his little offerings in letters, his verbal descriptions of them invariably indicated that "all the time something of one was passing to the other." If he repeated a phrase to one or the other, or if he sought to arrange a relationship, he was addressing both himself and them. "In everyone is a spectator and an actor, one who speaks and one who answers" (*Aurélia*—chapter 9).

Cornell was perturbed by the duality of his experience, and scoured literature for consoling explanations. Many acquaintances were tentatively questioned about their own dreams, and some were directed to Freud, or rather to chapter 6 in *The Interpretation of Dreams*, which deals specifically with "condensation" in dreams, the very process described with such meticulous attention to detail in both *Sylvie* and *Aurélia*. Freud's discussion is singularly tentative, and inflected with a deep re-

spect for the elusive artistic experiences that resisted his analysis.[6] In fact, Freud sets forth his discussion of dream-thoughts by quoting from Goethe's *Faust*:

. . . a thousand threads one treadle throws,
Where fly the shuttles hither and thither,
Unseen the threads are knit together,
And on infinite combination grows.

For Cornell, his pencil hovering over his legal pad, his "work," like the dream's work, was to capture the dream-thoughts clustered around a nodal point in the dream, and he was, like Faust, almost maddened by the "infinite combination." His specific and repeated recourse to the few pages in Freud dealing with condensation may well have served as moments of relief— moments in which he could compose his tableaux or his collages, confident that he had translated Freud's two languages:

The dream-thoughts and the dream-content are presented to us like two versions of the same subject-matter in two different languages. Or, more properly, the dream-content seems like a transcript of the dream-thoughts into another mode of expression, whose characters and syntactic laws it is our business to discover by comparing the original and the translation.

Cornell took all this very seriously, and frequently sought to interpret his own dreams according to their syntax. The experiences he recognized in Nerval and Novalis, as well as other Romantic writers, were approached by Freud with uncharacteristic hesitancy. But occasionally there were explicit passages that Cornell would commit almost to memory. Freud's notation on hypnagogic imagery, for instance:

The chief evidence in favour of the power of subjective sensory excitations to instigate dreams is provided by what are known as "hypnagogic hallucinations" or to use Johannes Müller's term (1826), "imaginative visual phenomena." These are images, often very vivid and rapidly changing, which are apt to appear— quite habitually in some people—during the period of falling

[6] Sigmund Freud, *The Interpretation of Dreams*, trans. James Strachey (New York: Macmillan, 1953).

asleep; and they may also persist for a time after the eyes have been opened.[7]

(When once I mentioned Richard Wilbur's essay on Poe with its discussion of hypnagogic imagery, Cornell responded immediately: "I have lots of material on that.")

Phrases from Freud, such as "For as we know, visual images constitute the principal component in our dreams," or "Dreams are, of course, a mass of these composite structures," or "The dream-work . . . does not think, calculate, or judge in any way at all; it restricts itself to giving things a new form," resounded in Cornell's imagination. His frequent insistence that his work sprang from "real experience" must be understood not in the terms of Breton, who programmatically sought to give his extravagant dreams equal status with waking reality, but rather in the terms of Freud, who basically recognized the separation of dreams and active life, but thought that real experience was accreted in the dream. His discussion of the "X" factor looks back to the early nineteenth century rather than forward to the fevers of the First World War. On speaking of the composite figures in the dream (those very figures Nerval gave us in the three superimposed women) Freud says: "The content of the dream merely says as it were: 'all these things have an element X in common.'" And further on:

Each element in the content of a dream is "overdetermined" by material in the dream-thoughts; it is not derived from a *single* element in the dream-thoughts, but may be traced back to a whole number.

Cornell's reading of *Aurélia* was not influenced by Breton's emphasis on the monstrous, or his concern with psychosis, but sprang rather from his own natural predilection for the motifs of nineteenth-century Romanticism. Even his conception of metamorphosis refers to other eras, and not to the grotesqueries indulged in by the Surrealists. It is curious that in one of his many references to *Aurélia* in relation to his own works, he

[7] Ibid., chap. 1.

cites an instance that his own imagination had transformed. In answer to a questionnaire sent out by the Whitney Museum in preparation for its 1960–61 Annual, Cornell gave a statement on a box titled alternatively *Étoile* or *Hôtel des Trois Rois*:

Étoile in title alluding of course to the star of the Magi of which the postered Medici prince in the "box" [was] an integral part in the mural rendering of Gozzoli intaglio cranes* with their connotation of the flight into Egypt. . . .

A quality of Gérard de Nerval achieved perhaps remembering the poster with flowers that comes to life in *Aurelea* [*sic*] "dream overflowing into life." * from another Renaissance hand.

The probable passage in *Aurélia* reads:

The opening of a casino was being advertised and the details of its arrangements were being announced in posters. The typographical borders of these posters were composed of garlands of flowers so well drawn and colored they seemed real.

On the other hand, there was a passage that Cornell cherished enough to cite by page and paragraph to young admirers, in which the dream overflowing into life is indeed metamorphic hallucination.

The real struggle was to avoid what Nerval called inattention or spiritual confusion. One must not miss those moments of exaltation in which the "bond between the internal and external worlds" was *experienced*, and not just thought. It was Cornell's need for such lived spiritual experience that brought him to both Nerval and Novalis. His boxed images, which he never thought of as "sculpture," conform in origin to works of the poet, and to the meaning of poetry as conceived by mystical or Romantic poets. Cornell's favorite book by Novalis was *Heinrich von Ofterdingen*, a strange novel by the youthful genius that combines fable and theory. In Novalis's discussion of the art of poetry can be found the enduring convictions of Cornell:

There is nothing of the art of poetry to be met with anywhere externally. Nor does this art work with tools or hands; the eye

and ear perceive nothing of it; for the mere hearing of words is not the real effect of this secret art. It is altogether a matter of the soul, and as those other artists delight the outer senses with pleasurable sensations, so the poet fills the inner sanctuary of the spirit with new, wonderful, and pleasing thoughts. He knows how to stir those secret powers in us at will, and by means of words he enables us to perceive a glorious unknown world. Within us out of deep caverns there rise ancient and future times, countless people, *marvelous* regions, and the strangest occurrences snatching us away from the familiar present. One hears alien words and yet knows what they are intended to mean. The sayings of poets exert magical power; they make even common words take on enticing sounds and intoxicate the spellbound listener. . . .[8]

Moreover, the preoccupation with the "double" experience is clearly enunciated when Novalis writes:

An obscure recollection amid the transparent present reflects the images of the world in sharp outlines, and thus one enjoys a double world which in that very way sloughs off its crude and violent nature and turns into the magical poesy and fables of our senses.

Although Cornell occasionally said ruefully that "mystery cannot be put into words," he seemed to seek the poetic principle in his readings, and he was much more concerned to find a family of kindred spirits for himself—a transhistorical family—than to determine plastic solutions to the dream-inspired problems he perpetually carried about in his psyche. There was, as he often said, a period that seemed to him congenial to his temperament—a period beginning in the late eighteenth century and persisting throughout the nineteenth, and which embraced the Romantic movement. He was deeply convinced that his natural spiritual home was there, back in the reaches of Romantic history. This is indicated in his specific lists of key books, his dossiers on nineteenth-century personalities, and his own collection of typically Romantic objects, such as an album containing locks

[8] Novalis, *Henry von Ofterdingen*, trans. Palmer Hilty (New York: Frederick Ungar, 1964).

of hair, another documenting some stranger's grand tour of Europe, and still another of pressed flowers; it was also baldly stated on numerous occasions: "I have a feeling of freshness for an era that's past, the romantic era, when there was more unity: Taglioni, Berlioz, Delacroix, Chopin, Liszt—all of one piece."[9]

All of one piece—one grand circular field of vision filled with cross-references and gratuitous encounters, rich in the associations that Cornell ceaselessly conjured up. For him, association was not merely an acquired technique for creating, but a natural reflex. Conversations with him were always elliptical. If he mentioned one subject, it soon brought up another. If his interlocutor introduced a subject, it very often provoked an immediate association from the past, sometimes amusingly so, as when George Kott spoke of the magazine *Broom* and Cornell launched into a description of the Lindbergh parade.[10] At times, Cornell would associate an object, or one of his own works, with a "good" or a "bad" day, recalling all the details. It is easy to understand, given Cornell's addiction to free association, why he always said: "Memory is more important to me than my boxes." His memory included transhistorical experiences which he had made his own through intimate identification. His "family" included poets, composers, singers, and dancers of the nineteenth century.

Cornell craved music. At times while working and listening to records he would be so transported that he forgot the presence of his assistants. Kott remembers how one "good" day, when Cornell was working well and listening to some Romantic music, he suddenly exclaimed aloud, "It's exactly like a dream." Others remember his efforts to re-inspire himself by recalling some singularly "good" moments by certain fragments of music. His love for Proust may well have derived from such temperamental affinities. In his letters there are frequent allusions to

[9] Jack Kroll, *Newsweek*, op. cit.
[10] George Kott, a young sculptor, was Cornell's assistant for most of the year 1970.

records, ranging from Beethoven symphonies such as Herbert von Karajan's recording of the Third, of which he wrote, "I caught a Mallarméan nuance," to Debussy, Satie, and Stravinsky. Or he would write to a friend whom he hadn't seen in months, to say that hearing a certain Mahler record brought a *ricordanza* of a specific encounter they had had; or that a Chopin piano piece had retrieved a certain moment or a certain exchange, sometimes years before.

Of all the composers to whom Cornell submitted emotionally, Schumann seems to have been his most frequent resource. His obsession with *Carnaval* was known to all his friends. There is so much with which Cornell could identify in Schumann's personality that it seems only natural that he regarded Schumann as part of his "family." Schumann was immersed from an early age in the world of extravagant fairy tales and intense daydreams epitomized by Novalis. His childhood was devoted to reading, and what he read was the literature of *Naturphilosophie* endemic to his homeland. Filled with tender fantasies of other times, the feeling of longing peculiar to German Romantic literature, Schumann had cherished above all the writings of Jean Paul, in whose complete works he underlined many passages, such as:

> Since flowers live and sleep, they must also dream,
> like children and animals. Surely all creatures dream.

Schumann fulfilled the Romantic urge to keep journals and diaries, reflecting the need to experience the "double" existence of which Novalis spoke. He began at an early age, and when he married Clara, they kept a journal together. In these journals there were frequently quotations and paraphrases of his favorite poets. The recurrent themes are the sense of loss (of vernal paradise), the importance of naïveté (the purity of childhood), the essential soul of nature as corresponding to individual human souls, and the creative significance of dream and reverie. "No one knows himself so long as he remains merely himself and not at the same time himself and another," Novalis had written.

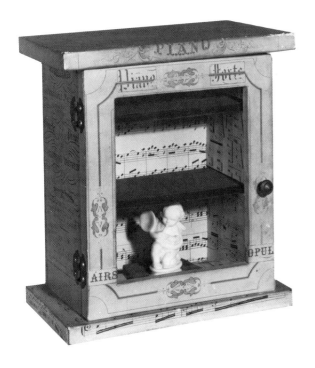

Piano Forte, ca. 1948

These journals of Schumann (and of most of his contemporaries of similar temperament) described the attempt to be the "other" that could know the self.

How faithful Schumann was to his poetic sources can be seen in his journals, where he noted, among other things, "The spring itself is on my doorstep looking at me—it is a child with celestial blue eyes." Blue, particularly celestial blue, haunted the Romantics. Novalis's hero, Heinrich von Ofterdingen, had sought the magical blue flower, as had other creatures of the early Romantic poets. Blue was Cornell's color, celestial or night-blue for dreaming. The imagery of blue skies and blue flowers, gleaned from his extensive reading, kept appearing in his correspondence. For instance, he once wrote a cryptic message to a child on blue paper. When questioned about the meaning, he wrote an additional note saying: "I have never shaped up too much of this kind of experience except in such ephemerae as the blue note which I do not like even to mention for pulling a flower to pieces." The characteristic Romantic reflex against analysis appears not only here, but in another letter in which he quotes G. Poulet on Proust: ". . . a primitive complex which analysis would irremediably lose. . . ."

Schumann also decried the tendency toward analytic response to art. Against the demands of consciousness he always placed the dream. "Why," he wrote in his journal, "should consciousness always rob me of dreams and happiness?" In 1831, he noted that "Poetry of the imagination is made up of all it receives of the obscure and the unconscious." His need, as expressed in his journals, was to find a poetic fusion of music and the word that would open to him the experience of infinity. "For me music is always the language in which one can converse with the beyond."

Schumann's notes are often expressed in the condensed, poetic mode by which discontinuities serve suggestiveness. Such a diary entry as "Ave Maria . . . evening . . . the large garden . . . the dear child . . . the moon. . . ." is typical. Cornell's notations, while frequently more obscure, are liberally adorned with sug-

gestive hiatuses. Both Schumann and Cornell were addicted to words as poetic talismans, and both sought to interject the word into their art form. Schumann's note to himself: "Above all write for the voice. When one is convinced of being a musician, it is the quickest way of bursting into flower," indicates how much he drew upon the word, for the voice to him was more than an instrument: it could speak words. Schumann's concentration on *lieder* certainly grew from his natural dependence on poetry, a dependence which in his childhood made him believe that he was destined to be a poet and not a musician at all. He shared with the Romantic generation an impulse to fuse the arts in the *Gesamtkunstwerk*, and found the boundaries of the individual arts surpassable.

The cultivated musician |he wrote| may study a Madonna by Raphael, the painter, a symphony by Mozart, with equal advantage. Yet more: in sculpture the actor's art becomes fixed; the actor in turn transforms the sculptor's work into living forms; the painter turns a poem into a painting; the musician sets a picture to music.

When he addressed himself to the problem of the *lied*, he found the tensions between the word and the musical sound invigorating. As an intermediary form drawing as much upon the expressive increment of the word as upon the abstract power of music, the *lied* challenged Schumann's deepest responses. Even as a child, he reported, he had set scores on his piano rack upside down in order "to enjoy the strangely tortuous note-edifices." His play with aspects of music considered extrinsic, such as "note-edifices," made him a natural adept of the *lied* form, in which there is always the fundamental struggle between word and music.

Schumann's intense attraction to language was also apparent in his affection for what he called his "sphinxes"—those musical-literary anagrams such as the *Abegg Variations* and the *Six Organ Fugues on the Name of Bach*, in which letters from the alphabet served as notes for his composition. Nor did he stop with simple variations. He was drawn to elaborate conundrums based on

letters and words in which he delighted in mystification. In an article on the Danish composer Gade, he wrote:

The four letters of his name, strangely enough, stand for the four open strings of the violin . . . by means of four clefs his name may be written with a *single* note. Adepts at the Cabala will easily solve the puzzle.

The *lied* is an obvious receptacle for Schumann's literary impulses, a form in which the tenuous balance between two contrasting artistic energies must produce a perpetually intermediate result. Similarly, the Cornell box, with its fragments of printed materials, and its enumeration of suggestive objects, maintains a tension between the verbal and the visual. Suggestive objects—that is, objects that are named and whose names bestir association—are juxtaposed with elements provoking unnamed associations, such as glass fragments, mirrors, and astronomical charts. Like the *lied*, the Cornell box sojourns in a *terra incognita* between two art forms, the poetic and the plastic. Even the voice is in his work, for the voice is the instrument of poetry, and few of Cornell's works forsake the poem.

Voices obsessed Cornell. He spoke constantly of his "mystique of lost voices." His "lost Atlantis" was, as he sometimes said, the place where all the great voices in history remained, that unattainable place that he sought to enter by his own peculiar incantations: His affinities with Schumann extended to a capacity to be moved to ecstasy by the human voice. Cornell knew Schumann's letter of November 6, 1829, to Wieck:

In the concert hall in Leipzig I have sometimes shuddered with delight, experiencing a holy terror at the genius of Sound, but in Italy I have also learnt to love it, and I have known one evening in my life when I had the feeling God was before me and allowed me for an instant freely and in silence to contemplate His face. . . . That was in Milan, listening to Rossini and Pasta.

Pasta was one of Cornell's divas, whose appeal for Delacroix and Stendhal he frequently mentioned. (Actually he didn't care for

Music Box, ca. 1947

Stendhal's writings, only for his allusions to Pasta.) Schumann's vivid response to a great singer was grist to Cornell's mill and matched his own adoration of such legendary divas as Malibran, about whom he published at his own expense a nineteenth-century appreciation (see page 135). Here, in his circular way, he echoed another member of his adopted family, Andersen (whose poems had been set to music by Schumann, and with whom Schumann corresponded). The response of the Danish writer to the great contralto blended in Cornell's associating imagination with his own image of the dancer Fanny Cerrito, since Andersen's note on Malibran is also the response of a northerner to Naples:

This I class among my most sublime impressions in the world of art. Hers is not one of those brilliant voices that startle you, but rather a heart dissolved in melody . . . when I left the theatre, Vesuvius was flinging fire in the sky, the sea reflected it, the moon shone clear as day, and a great three-master flew into the harbor . . . here, here is my country . . . when I die I will haunt the lovely Neapolitan night. . . .[11]

A few years later, after Malibran's tragic death at the age of twenty-eight (mourned by Cornell in the pamphlet *Maria*), Andersen visits Naples again, writing:

I thought of Malibran-García, the bird of song, in whose tones I had found expression of all that my mind now felt for Italy's wonders and beauty. Italy and Malibran were in my mind related, like the words and melody of a cherished song; I could not separate them—and now she was dead—she, who in so much of what we admire was so like Byron, found *her* death in the land which gave *him* life.[12]

Naples, largely by being the birthplace of the ballerina Fanny Cerrito, whom Cornell championed among the nineteenth-century stars, was one of his magical touchstones. One of his most assiduously tended "dossiers" was titled "The Bay of Naples,"

[11] Stirling, op. cit.
[12] Ibid.

and its changing contents included, at various times, views of Vesuvius, photographs of windows, reproductions of works by Chirico, old Italian mezzotints that resembled Chiricos, and engravings of Cerrito.

All of Cornell's prima donnas and ballerinas were intertwined in his imagination, and subsisted in a network of references and cross references. He adored mythologizing their history (as did most of their biographers who often portrayed them as naive offstage, with childlike responses and a kind of purity associated with fairy maidens rather than flesh-and-blood women). Andersen wrote of Jenny Lind, "On stage she was a great artist who dazzled all those about her; at home, in her drawing-room, she was a modest young girl with the mind and piety of a child." Cornell echoes him in his own description of Hedy Lamarr, speaking of her "gracious humility and spirituality" and a "naïveté, an innocence, a desire to please" (pp. 151, 152). Andersen had seen in Jenny Lind a great need to be loved and a feeling of being unwanted, and Cornell found the same in many young movie stars, above all Marilyn Monroe.

Cornell's knowledge of the history of nineteenth-century dance won him a job on *Dance Index*, where he was able to indulge his passion for collecting "ephemera" and memorabilia of the—or rather *his*—Golden Age. Years of haunting the Fourth Avenue second-hand book and print dealers had resulted in an extraordinary collection of old engravings, texts, and souvenirs of the period. When Donald Windham was editor, he invited Cornell to do an entire issue devoted to his heroines. Cornell gathered both contemporary texts and illustrations for his montage, a vivid reconstruction of the period. He did not fail to mention his disapprobation of dance historians who had not done justice to his favorite, Fanny Cerrito. Mythologizing, as always, Cornell probably chose Cerrito because he could shelter her in his imagination; because to him, she seemed neglected and helpless, and, of course, alive. There were, he pointed out, several books about those dancers regarded as the triumvirate of the Romantic

The Forgotten Game, 1950

Homage to the Romantic Ballet, 1942. Made at a time when Cornell incorporated anecdotes into his objects, this box contains the following legend: "On a moonlight night in the winter of 1855 the carriage of Maria Taglioni was halted by a Russian highwayman, and that ethereal creature commanded to dance for this audience of one upon a panther's skin spread over the snow beneath the stars. From this little actuality arose the legend that, to keep alive the memory of this adventure so precious to her, Taglioni formed the habit of placing a piece of ice in her jewel casket or dressing table drawer where melting among the sparkling stones, there was evoked a hint of the starlit heavens over the ice-covered landscape."

Ballet—Taglioni, Elssler, and Carlotta Grisi—but none about Cerrito. This, of course, suited Cornell's "creative research" project, which became a ceaseless quest for adequate materials to put into his precious Cerrito dossier.

Perhaps to some [he wrote in *Dance Index*], her youthful naiad figure may have emerged distinct from the shadows of her sister ballerinas; indeed, to us with such vividness and conviction as to come to life in the present in such a way as to transform many a commonplace experience with an unexpected and over-whelming measure of her gracious art.[13]

This was Cornell at his most sincere. Cerrito's reality cannot be doubted. In the same issue, he announced his hope—never to be realized—of publishing a boxed "homage-album" about her, which would include: "a museum of contemporary descriptions, action poses, portraits, press notices; 'compensation,' costume fragments, photographs, 'reconstructed' memorabilia, etc." The naiad Cerrito, however, fluttered through Cornell's days, never settling long enough for him to catch her likeness, and the "album" homage remained always in formation.

His Cerrito obsession was familiar to many friends, and often to passing acquaintances. He spoke of it sometimes humorously, sometimes in deadly earnest. When he showed his dossier, he would always wait eagerly for some specific response, which, I'm certain, he never received. In 1957, he told Howard Griffin that two things had changed his life, one a pet shop with white walls, and the other when he saw Fanny Cerrito on top of the Manhattan Storage Warehouse.[14] If this was said in jest, his other references to Cerrito were usually quite serious. One of his assistants saw the Cerrito dossier in 1961, and mentioned seeing photographs of her. There was one showing her in the Colosseum, sitting alone on the steps. There had been a man sitting next to her, but Cornell had cut him out of the picture.

[13] *Dance Index*, vol. III, nos. 7, 8, July, August 1944.
[14] Howard Griffin, "Auriga, Andromeda, Cameleopardia," *Art News*, LVI, no. 8, December 1957.

Later, Cornell was to have photo-enlargements made of this scene, which he associated with certain of Chirico's perspective views. In the last year of his life, Cornell welcomed a young student with the small head, high cheekbones, columnar neck, and bearing of a dancer. He showed her the Cerrito dossier, and told her that of all ballerinas, he most loved Cerrito. This new friend, Esta Greenfield, reported seeing a series of photostats of old street-scene engravings with women standing in the street. The figures were very small, but he had made progressive enlargements until he could point to a single one and say, "That's her." He said it very seriously, but when he noticed his visitor's incredulity and she asked how he knew, he gave a rare smile and answered, "She told me so."

(As an example of how Cornell could not help mythologizing, Miss Greenfield's account of her first visit is typical. He asked her name, and requested her to give him a sample of her handwriting. This he put carefully in an envelope, inquiring if she liked her name. Not very much, she said. Several visits later, Cornell brought out the envelope and offered her a choice of two new names—Esta Verschamps or Esta Vert Chant.)

The Cerrito memory was fed particularly by the texts of Théophile Gautier. In letters to various people, Cornell at different times quoted Gautier. For instance, he wrote to Irving Blum, his dealer in Los Angeles, "Of Cerrito Gautier wrote 'Undines, Sylphides and salamanders will not cavil at her rendering of them.' "[15] This in turn is reminiscent of a passage in *Aurélia*, part VIII, which speaks of new metamorphoses. "There were Divas, Peris, undines and salamanders. Whenever one of the creatures died, it was immediately born again in a more beautiful form and sang the glory of the gods."

To add to this roundelay of Cornell's expansive free associations, there are repeated references that intermingle. In the early 1960s, he wrote in a letter to a child:

Napoli via Cerrito/Philoxène Boyer via Gautier

[15] Irving Blum correspondence, February 14, 1960.

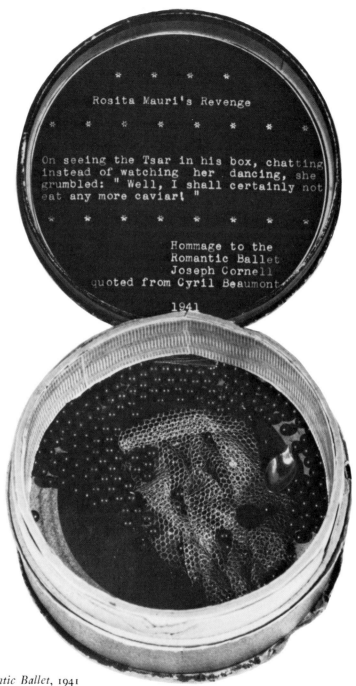

Homage to the Romantic Ballet, 1941

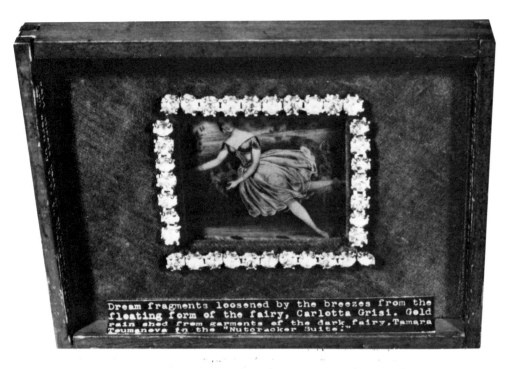

Dream fragments loosened by the breezes from the
floating form of the fairy, Carlotta Grisi. Gold
rain shed from garments of the dark fairy, Tamara
Toumanova in the "Nutcracker Suite."

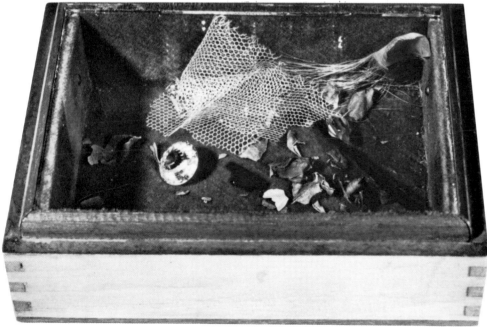

In the late fall of 1973, he wrote to the same child of reading in Gautier's *Portraits Contemporains*:

a sketch of one of his cercle [*sic*] Philoxène Boyer, who saw "la jeune sylphide italienne" avec l'accent napolitaine.

Philoxène Boyer, it turns out, was an extravagant dilettante who had spent his fortune entertaining artists. He was known as a great improviser and lecturer but, as Gautier laments, never managed to commit his insights to paper. "Il se ruina par admiration," Gautier tells us, and cites the death notice in *Le Moniteur* for November 19, 1867: "Avec Philoxène Boyer, le dernier admirateur est mort." It is easy to understand Cornell's interest in this relatively obscure figure, this great admirer who was ruined by admiration. What is curious and inexplicable is Cornell's allusion to Boyer's having seen Cerrito, for in Gautier's account in *Portraits* (which incidentally was never translated into English), there is no mention at all of Cerrito, *la jeune sylphide italienne*. Such obscurities abound in Cornell's maze.

Gautier, the poet who had sown his wild oats with Nerval, eventually settled down to a workaday job as an art and drama critic. His accounts of dance events are among the most vivid and evocative in history. Cornell was familiar with all the texts and drew heavily on Gautier for his special issue of *Dance Index*. He obviously took a keen personal delight in the competitive tenor of the Romantic Ballet, and enjoyed Gautier's descriptions of the two prime rivals, Taglioni and Fanny Elssler. Gautier relished characterizing their little peculiarities and differences in style, and at times veered toward one or the other with cruel volatility. On two occasions he had made similar comparisons, calling Taglioni "aerial" and "virginal" while comparing Elssler to Terpsichore, the pagan muse of dance. He admired Elssler for understanding the dance as he himself saw it. "Dancing after all has no other object than to show beautiful bodies in graceful poses and develop lines which are pleasing to the eye. It is silent rhythm, music to be seen. Dancing is ill suited to expressing metaphysical ideas; it expresses only the

passions—love, desire with all its coquetries, the aggressive male and the gently resisting woman. These are the subjects of all primitive dances."[16] Later, he again contrasted Taglioni and Elssler, as Christian and pagan. Taglioni and Elssler both had to face in turn the triumph of the young Neapolitan Cerrito. It was a moment of particular drama when at the command of Queen Victoria, the rival ballerinas had to perform a *pas de deux*. Best of all, as Cornell suggested with the cover for his issue of *Dance Index*, was to have all three competing on the same stage. "Le Quatuor dansé à Londres par Taglioni, Charlotte Grisi, Cerrito et Fanny Elssler," as reproduced in an old French album, spurred his researches, and he was able to turn up many obscure responses to the exceptionally dramatic event. He was an indefatigable seeker. When he met the young dancer David Mann, who later became an art dealer, he was able to charm him into making a gift of several autograph letters of Carlotta Grisi, an authentic *carte de visite*, and an old photograph; from Paul Magriel, who with Lincoln Kirstein had founded the dance and theater archives at the Museum of Modern Art in 1939, he extracted a rare Taglioni print. These were ultimately inserted in Cornell's dossiers and used in the Romantic Ballet issue of *Dance Index*. The photograph, he promised Mann, would be used in a box for him. The box never materialized, but once Cornell told him, "Your box has been started, and like new buildings, I have put white X's on the windows."

Cornell's meditations on the lives, personalities, and even personal effects of these sacred personages, his devotion to their particular glories (such as Cerrito's in the ballet *Ondine*, a figure he was to commemorate many times), were fed into his journals, correspondence, and above all, his offerings to their memories: the boxes and collages. The array of bouquets, wreaths, and sometimes jewels and cashmere shawls thrown upon the stage at the triumphant moments in their lives were matched by

[16] Ivor Guest, *Fanny Elssler* (Middletown, Conn.: Wesleyan University Press, 1970).

Cornell in his miniature offerings, all precious, carefully selected, and intended to be remembered. The ballerinas (like the opera singers and movie stars both past and present that thronged Cornell's inner stage) were always transformed by him, as by his Romantic forebears, into mythical creatures: naiads, dryads, hamadryads (as Berlioz saw his child love), and nymphs. Even when he approached living heroines, Cornell ultimately retreated into myth. In 1946 he staged an exhibition called *Portraits of Women* at the Hugo Gallery, in which he commemorated a number of his Golden Age favorites. There he exhibited his homage to Taglioni, in a setting of draped velvet, and with a large lithographic portrait above, bathed in blue light. There he celebrated Malibran by a small box in which a stuffed bird on a spring quivered to life when the interior music box played an air from *La Traviata*. And there he prepared for a dramatic encounter: at the time of his exhibition, the French ballerina Jeanmaire was performing in New York. Cornell persuaded his dealer to hold a reception for her. He took over the small back room of the gallery and transformed it into a Cornell habitat, filled with flowers, live songbirds in cages, draperies and objects —a boxed offering to a prima ballerina. When the evening arrived, he nervously awaited her grand entrance, but when Jeanmaire moved toward his homage, Cornell refused to be introduced.

Real-life encounters only served to push Cornell back into his beloved past. The living ballerinas had to be re-created as Cornell's archetypal image of Beatrice, much as Nerval's Jenny Colon was a figure, as the poet wrote, in his personal *Vita Nuova*. Cornell's interest in Dante was almost exclusively vested in the image of Beatrice. He read Dante commentaries carefully, and liked especially Charles Williams's interpretation in *The Figure of Beatrice*.[17] Cornell's vision of Beatrice was not *chevaleresque*. He did not forget that his mythologized creatures had another life, a real life of mundane realities, any more than did Nerval,

[17] Charles Williams, *The Figure of Beatrice* (New York: Farrar, Straus & Cudahy, 1961).

whose self-irony runs throughout *Aurélia*. As a close observer of small detail, as an artist sifting through his visual experiences for the most telling clue to the whole, he was always careful to preserve the real impetus of his imaginings. His reveries of naiads and sylphs were nourished not only by reading, but through his sorties in the streets and subways of New York. If he saw a shopgirl, waitress, or young student who had the look of "innocence, a desire to please," as he said of Lamarr, he paused to fix her features, or even followed her, as he very often said Apollinaire did. The montage in his imagination of the ideal virtuous beauty was composed of real encounters.

For this reason, Williams's interpretation of the figure of Beatrice would have been particularly congenial to Cornell, who recommended to several young readers that they acquire the book. Dante admits that Beatrice is "la gloriosa donna della mia mente," but, as Williams stresses, she was no symbol. Rather, she was an image (Dante spoke repeatedly of "la sua immagine" in *La Vita Nuova*). She might well be the "bella donna" who moves "come ninfe," the glorious woman of his mind, but, as Williams insists, she emerges always anew from Dante's original encounter with a real being whose image remains with him throughout his life. His was no vain pursuit of a symbol. Williams offers a significant quotation from the *Purgatorio* (XXIV):

I am one who, when Love breathes in me, note it, and expound it after whatever manner he dictates.

Williams maintains that for Dante, Love was no mere symbolic reference to some highly intellectualized scheme of life, but the source of his creative life. Love, he says, was for Dante a *quality* and not a symbol. Williams's interpretation would seem to find support in Dante's own words in the *Paradiso* (XXXIII):

I was like one who sees in a dream, and when the dream is gone the passion stamped [*impressa*] by it remains, and the other comes not again to mind; even so my vision has almost entirely disappeared, but the sweetness born of it distils still in my heart.

Cornell's love for Cerrito, as well as his love for the living balle-

rina Allegra Kent, began with the passion of seeing, as in a dream, and survived on the sweetness born of it. The *quality* of Love was what lured Cornell into the realm of creation. No work of his came merely from the intellect. Dante, who laid great stress on the "intelletto" and made Beatrice speak of "lo gran mar dell'essere," repeatedly brought his reader back to the initial shock of encounter. The poets Dante, Baudelaire, Nerval, and De Quincey all experienced fleeting encounters with real (if sometimes unknown) women whom they then *transformed* into creatures of imagination. Mythologizing never leaves behind the original, for origins are the arch realities. The whole literature of Romantic nostalgia for the fleeting vision of love was dear to Cornell. The initial encounter and the lifelong yearning and sense of absence in poems by Baudelaire, Mallarmé, Apollinaire, and many others were re-experienced by Cornell. The apparitional and long-vanished had peculiar appeal to him. He was always drawn to writers who spoke of such experiences. Andersen, for example, saw a portrait of a long-dead woman and wrote to a friend, "It is the first woman's face that has touched my heart, I felt sad at the thought of this beautiful form having turned to dust." Another writer whom Cornell mentioned constantly, Alain-Fournier, composed his novel *Le Grand Meaulnes* (published in English in 1929 as *The Wanderer*) with the image of an adolescent encounter on a Parisian boulevard always before him. Perpetually mourning his brief glimpse of happiness in love, Alain-Fournier wrote in 1907 that "behind every moment of life I seek the life of my Paradise; behind every landscape I feel the landscape of my Paradise."[18] His young wanderer, Meaulnes, inexorably seeks this paradise in the novel, while Cornell sought it all his life in his own magical enactments.

In his encounters Cornell drew no line between the great divas of the past and the simple waitresses or Hollywood actresses of his own time. The list of his enthusiasms among actresses is very long (Jeanne Eagles, Sheree North, Judy Tyler,

[18] Havelock Ellis, *From Rousseau to Proust* (New York: Houghton Mifflin, 1935).

Patty Duke, Yvette Mimieux, and scores of others preoccupied his imagination at different periods, and, like other American intellectuals, he was obsessed with the legend of Marilyn Monroe). Various of his projects were inspired by a fusion of these images. He did not merely scan the newspapers and movie magazines for news of them, but often tried to establish a real contact. When he was interviewed at the opening of the exhibition for children at the Cooper Union in the last year of his life, the reporter noted that the brownies and cherry soda had been expressly provided for him by those who knew of his passion for sweets, and asked if he liked cherry soda.[19] Inveterate associator that he was, he answered: "In a very mystical way. They have them in the underground in those big conveying machines—it brings back memories . . . cherry and lime also remind me of Sheree North—a starlet they were going to build up to Marilyn Monroe roles, but it didn't happen. I sent her a small box once, but never heard from her."

The bouquets Cornell sent to his starlets—his own enigmatic works—often met with no response, to his great sorrow. Years after writing his Hedy Lamarr article, he lamented "20 yrs. ago the avant-grade VIEW published a piece I did on Miss La Marr [sic] which is quite a tale in itself like Paolo and Francesca turning up on your doorstep. . . ." Then he spoke of other things and in a postscript added: "The piece in VIEW got to Miss La Marr through one of the M.G.M. heads but I never knew whether or not it appealed to her. Just in case there may have been an adverse reaction not totally obliterated I suggest that it not be mentioned until the consideration of the object is final. J. C."[20]

In his mind, all the offerings to stars were one, as a letter written on August 11, 1965, indicates:

I experienced a totally unexpected revelation in the wake of the tragic passing of Marilyn Monroe, that benumbing feeling, in

[19] Grace Glueck, *New York Times*, February 11, 1972.
[20] Blum correspondence, July 20, 1959.

the wake of which flowed the "Memorials" to Judy Tyler and in just as serious a vein the one of the blue glass and bird in deep shadow (with red) "for Sheree North." When the publicity had died down I hope to despatch [*sic*] to you a couple of pieces, "In Memoriam," not for sale necessarily, and which may possibly be augmented to a little group, a living memorial. There are no words at the moment to convey the spontaneity and naturalness of this unfoldment although it may take time for the working out. Please add a couple of the interviews of LIFE Aug. 3. (M. M.) to my dossier for future reference in this connection. . . .

Three days later he writes again:

I have just despatched some copy about "M. M." possibilities, and in aftermath I am wondering if it is even coherent or grammatical so nebulous a business has it become, diffusive, rambling, etc. At all costs it must be kept at the farthest remove from the inevitable "everybody wants to get into the act" kind of thing.

One of the articles he wished placed in his "dossier" was written by Clifford Odets, whom Cornell asked his dealer to invite to see the work-in-progress offering to "M. M." "I would not expect of Mr. Odets anything—only if he might come to your gallery privately and have a favorable reaction"—adding that it was Odets's article that spurred him to this "extra effort." (Characteristically, and without much hope, Cornell sought the "other" response to confirm his own.)

Odets's article offers some curious parallels with the writings that had so stamped Cornell's imagination.[21] The theme of guilt toward a dead woman, found in both De Quincey's memoir *Ann of Oxford Street*, and in Nerval's *Aurélia*, coupled with an undertone of hysteria and an almost tribal lament, give Odets's piece a quality that would immediately have moved Cornell. From the first sentence, with its conventional mythologizing tone, Odets cast his article in a recognizable Romantic mode:

[21] Clifford Odets, "To Whom It May Concern: Marilyn Monroe," *Show Magazine*, October, 1962.

"One night some short weeks ago, for the first time in her not always happy life, Marilyn Monroe's soul sat down alone to a quiet supper from which it did not rise. . . ." He went on to speak of her ascent to fame, based on her freshness and "the almost unthinking, ardent courage and vibrancy of her youth." And then of her descent into hell:

Marilyn, it must be said, traveled always with a "dark companion" by her side. Astronomers explain the erratic and unpredictable behavior of certain brilliant stars by telling us that they are accompanied in their journeys by an invisible "dark companion" which exerts strong gravitational pull on its more brilliant peer. Marilyn's dark companion, it would seem, was a Dickensian pattern of early foster homes, of rejection and parental deprivation enough to stagger even infidels. It had left her timid and shy, shaken and lonely beyond description. . . .

Cornell liked Odets's allusion to another of his family heroes, Debussy, whom Odets quotes as writing in a letter, "Weeping—an utterly natural act by which we are suddenly united to the whole of humanity." And no doubt he approved of Odets's sentimental denouement, which prepares, in an inflated bardic style, for the forthcoming legends and myths:

If they tell you that she died of sleeping pills you must know that she died of a wasting grief, of a slow bleeding at the soul. It was her homelessness which made her elusive and fugitive. As for the legends that will grow up about Marilyn, Yeats has another appropriate remark: "The tree has to die before it can be made into a cross."

Cornell's own responses to the short and sometimes tragic lives of his *donne della mente* were apposite. Amongst his most frequently cited passages in *Aurélia* is the description of Nerval's reaction to the news of the death of Jenny Colon. In it the guilt of the romancer shows clearly, as does the mythologizing reflex:

At first I only heard that she was ill. Owing to my state of mind I only felt a vague unhappiness mixed with hope. I believed that

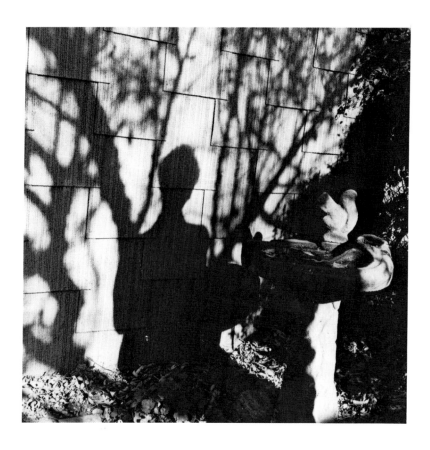

I myself had only a short while longer to live, and I was now assured of the existence of a world in which hearts in love meet again. Besides, she belonged to me much more in her death than in her life. . . . A selfish enough thought for which my reason later paid with bitter remorse.

De Quincey, remembering Ann, and pointing out that at first he had hoped she lived, but later preferred to think of her as laid in her grave, also speaks finally of his "inexpiable guilt."

Not all of Cornell's psyche was occupied by the phantoms of nineteenth-century *Sehnsucht*. A good part of him was rooted in his American past, in his pride in family tradition ("I'm the sixth Joseph Cornell"), and in a certain profound communing

38 The birdbath in Cornell's garden, early 1960s

with Americans in his "family." A homely American nostalgia, as opposed to *Sehnsucht* with its literary implications, was mixed with his deeper sense of identification with a singular American poet, Emily Dickinson.

It may be that his adolescence in New England, while a student at Andover, brought him to Dickinson. Amherst, from which Dickinson never strayed after her twenties, and which she emphatically regarded as her universe, was within Cornell's compass. One can imagine his visit to the Dickinson home, filled with nineteenth-century Americana and corresponding so specifically to phrases in the poetry. One can see him walking along the hedge beyond which, Dickinson wrote, she never went, "I do not cross my father's ground to any house or town. . . ." Never, that is, beyond the family circle and its immediate ambiance, though, as she wrote to Higginson, "My mother does not care for thoughts," and though, as she demonstrated in her correspondence, she reached far out into the world through the word. Cornell's "circumference" was Times Square, which as he often explained in his later life, was as far as he could go from the family home. His mother, to whom he was devoted, also did not care much for thought. His correspondence was voluminous, so enormous in fact that he took to putting unopened letters into files, and occasionally got one of his assistants to open or answer them. At times his helpers discovered unopened letters as much as five years old.

Cornell's identification with Dickinson led him to acquire a considerable library that included old editions of her works, the complete edition, and numerous critical commentaries. He kept her works by his bedside. He very probably knew the poems by heart. Her rhythms had possessed his psyche.

The natural affinities between these two American souls were apparent to him. Dickinson's retreat into the family compass, and her ambivalent attitude toward the retreat as expressed in letters to Higginson and others whom she counted on to understand her literary aspirations, were among the many similiarities. There were also small habits and reflexes that Cornell would have

recognized as his own, much as Baudelaire recognized himself in Poe.

For instance, Emily Dickinson's unorthodox attitude toward her working materials:

Many are written on the backs of brown paper bags, or on discarded bills, programs, and invitations; on tiny scraps of stationery pinned together . . . on soiled or mildewed subscription blanks. . . . There are pink scraps, blue and yellow scraps, one of them a wrapper of *Chocolat Meunier*; poems on the reverse of recipes in her own writing, on household shopping lists, on the cut-off margins of newspapers. . . . Emily liked the best the inside of used envelopes. . . .[22]

The pack-rat instinct, which urged Dickinson to tie together these scraps and fragments of her soul's expression, and lay them carefully away in the trunk where they were found after her death, would have been instantly recognized by Cornell. As

[22] *Bolts of Memory*, ed. Mabel Loomis Todd and Millicent Todd Bingham (New York: Harper & Bros, 1945).

The bedroom window

Archibald MacLeish has remarked, she committed "that live voice of hers to a private box full of snippets of paper." Since things were for her isolated, and worthy of deep attention in themselves, and words were to her like things (as things to Cornell were like words), it is not surprising that she could respond with affection to the things upon which she wrote her voice, especially when they had been consecrated by time and usage. "This little sheet of paper," she wrote late in her life in a letter to her cousin, "has lain for several years in my Shakespeare, and though it is blotted and antiquated is endeared by its resting place." (Once in one of Cornell's many abortive attempts to put his house in order, he discovered some long-forgotten Ingres paper "under the eaves," and although it was heavily waterstained, he was enraptured and immediately made a red-stained box under its inspiration.)

The collection and secretive laying away of disparate, homely materials—the incipient *petites manies* of all recluses—was always, in the case of these poetic creators, a storing-up of associations. Cornell's other "family" friend, Andersen, shared the same instinct. Edmund Gosse described Andersen's acquisitions in the realm of small things:

The passion for hoarding up little treasures of every kind—pebbles that friends had picked up, leaves that had been plucked on a certain day, odd mementoes of travel and incident, was always strong in Andersen. He hated to destroy anything, and he dragged around with him, from one lodging to another, a constantly increasing store of what irritable friends were apt to consider rubbish. In like manner, he could not endure to tear up paper with writing upon it, even if that writing were derogatory to his dignity. . . .[23]

Dickinson's compartmentalizing—the tying up, pinning together, and laying away in drawers, small caskets, and trunks; in short, the creation of private treasure—was never the parsimonious act of the good housewife that she undoubtedly was, but always the double act that both promised and threatened revelation at later

[23] Stirling, op. cit.

Family portraits

41

42 The kitchen windowsill

times. "Then I lift the lid to my box of Phantoms, and lay another in, unto the Resurrection—"[24]

In the caesurae between the mute objects laid within the box the Dickinson breath was held, and her silences—those strange silences and spaces within the very heart of her poems—were, one feels sure, most eloquent to Cornell. There is a noticeable affinity between his own and Dickinson's prose style, an affinity that cannot be laid to unconscious imitation by Cornell. He spoke, even on the telephone, with the pauses, sequence of periods, and great white spaces with which both he and his nineteenth-century idol could not help expressing the vagaries of their thoughts. Dickinson's love of the cryptic, her lavish use of trailing half-thoughts, or condensed half-offerings, becomes increasingly insistent throughout her life. Her numerous letters, particularly the later ones, are embroidered with dashes (unusual in the nineteenth century) and filled with the kind of suggestive but never quite graspable arcanums so familiar in Cornell's letters. He recognized the soul that adored conundrums, the soul that worked, as he said frequently, in a "rebuslike" way, and saw his own work on the boxes as the fruit of a similar urge. Dickinson's "rebus" technique—her isolation of words, and even her peculiarities of diction that led to the changing of nouns into adjectives or participles into nouns to the distress of her contemporaries—was so intimately expressive to Cornell that it is not beyond the realm of possibility that certain of his works were visual analogues to his experience of Dickinson's work. Certainly riddles—both grand and playful—were shared delights.[25] And behind the riddles lay the discovery, as Dickinson put it, that "it is strange that the most intangible thing is the most adhesive."

Dickinson's withdrawal from the world to the sanctuary of her father's hedge was far less complete than her contemporaries

[24] Letter to John L. Graves, c. 1856.
[25] A rebus is "a representation of words or syllables by pictures of objects or by symbols whose names resemble the intended words or syllables in sound; a riddle made up of pictures or symbols," in a dictionary definition which finally dissolves itself into a conundrum!

43

imagined. It is true that she often portrayed herself as a recluse, and explained to Higginson, who had written her in August 1862 urging her to be more accessible to the world: "Of 'shunning Men and Women'—they talk of Hallowed things, aloud—and embarrass my Dog—" But she coquetted with the world nonetheless. She might refer on occasion to "the prisoner of Chillon," and she found common cause with the Brontë sisters—who also interested Cornell greatly—but she extended her offerings with one hand and took them back with another, always hoping for some intangible return.

In this ambivalence, Cornell and Dickinson are well-matched. There was in both a certainty and pride in creative distinctness, shadowed by a nagging sense of never having quite realized or seized the crucial images. Disingenuousness characterized certain of their dealings with the suspect world-at-large. Dickinson, like Cornell, always showed her work with a tense expectancy of the longed-for "right" response, while pretending to herself that she did not care. When she first wrote to Higginson, soliciting a response—much in the way Cornell longed for a response from Einstein—she told him she had written only a few poems, and those only recently, while in fact she had written hundreds. Yet her plea rings true:

Are you too deeply occupied to say if my verse is alive?

The mind is so near itself it cannot see distinctly, and I have none to ask.

Should you think it breathed, and had you the leisure to tell me, I should feel quick gratitude.

Cornell is remembered by many acquaintances, whom he beckoned to his sanctuary on Utopia Parkway, as seeking their opinion (although it was probably their response he sought), and some have even spoken of their discomfort when he appeared to take their comments to heart and even, on occasion, made changes as dictated by these visitors from the world-at-large. Yet, like Dickinson, Cornell made epistolary sorties that were cannily, even arrogantly, designed to bring the world to

him. The need for confirmation was incessant. But so was the need to preserve inviolable the little compartmented treasures of the mind. Both contrived careful strategies to preserve the naïveté from which they felt their genius sprang. As Dickinson wrote in a poem of 1871:

> Wonder—is not precisely knowing
> And not precisely knowing not—

In a curious confession, Dickinson remarked that she had not learned to tell the time until the age of fifteen. Her attitude toward time, undoubtedly somewhat influenced by New England transcendentalism, corresponded closely with Cornell's. Their thrust was away from the linear prison of mundane history:

> There is no first or last in Forever.
> It is Centre there all the time.
> To believe is enough and the
> right of supposing.

Time was a grand sphere for Dickinson, which she strove to encompass, and in her acutely poetic wisdom, understood to be identical with space: "Moving on in the dark like loaded boats at night, though there is no course, there is boundlessness. Expanse cannot be lost."

But coupled with this transhistorical and sometimes unearthly sense of time and expanse was a specific and very earthly sense of place: *her* place, with its boxes, rooms, house, hedge, meadow, tree, and the numerous small creatures inhabiting it. Dickinson could find simplicity and verisimilitude when she described Nature. At times, she verged on the sentimental or trivial, but she was most often an appreciative and accurate observer of animal habits and the seasons. In letters to children especially, she offered unrivaled observations on nature, but sometimes also childlike descriptions to adults in her family. (Her letters to her relatives were numerous, although they lived across the lawn.) This, too, Cornell shared with Dickinson. He was a bird watcher, a feeder of squirrels, a lover of the flight of pigeons, an observer of the seasons, an admirer of trees. Sometimes his

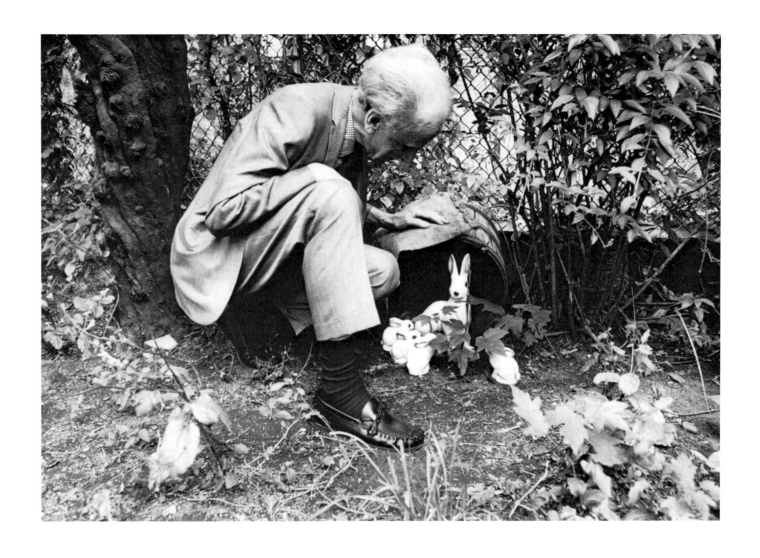

Portrait of Cornell in his garden taken by Duane
Michals at the artist's request

letters were as simple as Dickinson's, as this greeting to one of his dealers:

Some extra peanuts were thrown to the bluejays—a more generous scattering of sunflower seeds for the squirrels, a coagulated hunk of dark brown sugar for the starlings. . . .[26]

Often he sent postcards to the children of his acquaintances with pictures of animals, particularly kittens, and he carefully collected small feathers and pressed flowers for inclusion in his dossiers and letters. The place on Utopia Parkway, with its pitiably minuscule garden, assumed in his imagination the compass of the Dickinson estate. The garden furniture was cherished, the birdbath consecrated, the little trite replicas of squirrels or rabbits carefully preserved. Everyone who visited in the warm season heard about the quince tree, bought as a sprig at Bloomingdale's in 1930 for seventy-nine cents, and nurtured by Cornell's mother until it bore fruits for making jelly.

The garden, and the small creatures in the "other" experience, were transformed. The quince tree was metamorphosed in Cornell's imagination into the mythical home of the hamadryad. The birds became images of perching legends and myths. (For Dickinson, feathered creatures were no less transformable: "Hope is the thing with feathers that perches on the soul.") The real—such as Cornell's searching for and finding a scientific recording of "Sounds of Insects"—and the mythical were mingled by both artists in deliberate acts of imaginative will. (Again, there is a curious parallel with Andersen who described in his notes for the story "The Dryad" how he came to write it. He had been in Paris marveling at the wonders of the Exposition of 1867. "I saw one day a withered chestnut tree in the square outside the hotel where I lived. On a wagon close by was a young, fresh tree brought in from the country that very same morning to replace the discarded one. The idea of a story about the Paris World's Fair was related to me by way of this young tree. The Dryad beckoned me. . . .")

[26] Robert Schoelkopf correspondence, February 26, 1963.

Both sides of a postcard from Cornell to the author

47

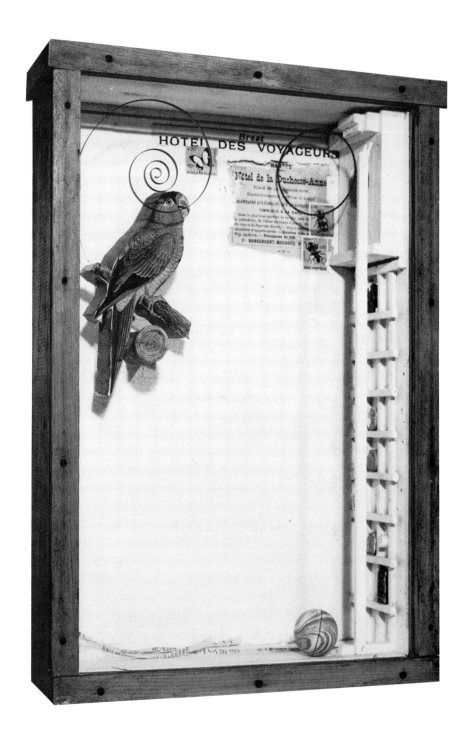

48 *Hôtel de la Duchesse Anne, 1957*

Both Dickinson and Cornell transformed their everyday experience in elliptical terms, returning to familiar objects and feelings and reshaping them, and leaving open spaces (in the case of Cornell's boxes, the tops were nearly always provisorily screwed down and often opened for changes) for escape into infinity. An unnamed religiosity threaded through their works, along with an undercurrent of nightmare. Their experiences with death and tragedy were transmuted. Dickinson said, "After great pain, a formal feeling comes," and spoke of the "stiffness" of the heart.

Perhaps Cornell felt kinship with Dickinson because she always began again, trying to comprehend her intimations of the illusory in Time. All poets are destined to grapple with time, and many in the nineteenth century had formulated specific attitudes. But Dickinson hesitated and left a great dash after her various approaches to time, preserving the "right of supposing" intact. Cornell wavered also, clinging to the "once-upon-a-time" mythological opening to the vastness and possible repetition of time. His acts of retrieval were serious, as serious as the ahistorical tales of the tribe. The past was an actual thing to him, and he was always attracted to tales in which it was personified.

Andersen's eloquent tales are at a considerable remove from the rather commonplace works of Robert Nathan, an American author born in 1894. Yet Nathan's *Portrait of Jenny* was one of the important books in Cornell's mind.[27] He repeatedly referred friends to it, particularly young people, over a period of at least thirty years. His insistence on the importance of this short, "supernatural" novel is not difficult to understand. It is a book saturated with the experience of *déjà vu*, much as *Aurélia* and Cornell's other prized texts dealing with phantom girls. It is also explicitly an avowal of discomfort in the present, but its nostalgia is remote from the poeticized nostalgia of Novalis and Nerval. The story takes place in New York City, and the

[27] *Six Novels of the Supernatural*, ed. Edward Wagenknecht (New York: The Viking Press, 1944).

protagonist is an artist. If Nathan's prose is fed by any tradition, it is an American one, perhaps tinged with a reminiscence of Poe.

In the opening pages, Nathan sets a scene familiar to Cornell. The story begins in Central Park, where "the damp mist of the winter evening drifted around me," as the artist, discouraged by his work and his poverty, wanders and muses. He thinks of his cold and hunger, but tells himself:

There is another kind of suffering for the artist which is worse than anything a winter, or poverty, can do; it is more like a winter of the mind, in which the life of his genius, the living sap of his work, seems frozen and motionless, caught—perhaps forever—in a season of death, and who knows if spring will ever come again to set it free?

Into this winter of the soul wanders a small child. The artist walks with her, and even in the first pages the reader is given to understand that she is a phantom, which, as the artist says, he looks at over "a gulf of more than air—a gulf over which no soul had ever passed before, either to go or return." This child, Jenny, turns up frequently during the next months, each time older and closer to maturity. The reader can only suppose that the artist has encountered a child who lived before his time, and that he is reliving *her* time—a time vaguely familiar to him, of course—as well as his own. The "palimpsest" effect is expressly stated. Nathan colors his tale with vignettes of city life, and particularly with a realistic description of an art gallery—a small one in Greenwich Village—and the way it functions. The artist, of course, attempts to paint a portrait of Jenny in which nostalgia for the other time is expressed, and whose quality is said to be superior to his normal contemporary works (as the *other* time was felt to be more desirable). Nathan's romanticism, so much closer to the American taste for the pretty tale and the safety of other times—to what the artist refers to lovingly as "the old-fashioned"—than to the French prototypes, matches Cornell's simple romanticism. Above all, Nathan's suggestion of the possibility of mystery in the universe appealed to Cornell:

One must sometimes believe what one cannot understand. That is the method of the scientist as well as the mystic; faced with a universe which must be endless and infinite, he accepts it, although he cannot really imagine it.

The methods of scientists and mystics never ceased to interest Cornell. He turned repeatedly to works on the history of science, seeking confirmation for his own mystical feelings of time and space, and perhaps the notion of an afterlife. Implicit in all his recommended readings in science, and in his affection for the early Romantics, was a traditional suspicion of rationalist decisions. The opening to the vast horizons of cyclical time must be left free, and too often the workaday scientist appeared to have sealed the door. Cornell looked everywhere for confirmations of the kinds of experience he knew, not only to works of science, but to the Bible as well. His attitudes toward the harsher pronouncements of science (materialist denials of spiritual life) derived from the eighteenth century of Novalis. In *Heinrich von Ofterdingen*, Novalis carries on an unceasing dialogue with himself, seeking to explain both his attraction to scientific method and his desire to escape from its certainties. The whole fantasy is an elaborate defense against what Novalis, and most Romantic poets, felt to be the deleterious effects on the poet by reason untempered by imagination. It is an appeal for the recognition of intuition as a prime source of information about the world. Heinrich asks:

Should not that detached childlike simplicity hit upon the right path through the labyrinth of our mundane affairs more certainly than a shrewdness misled and hemmed in by concern for private advantage and blinded by the inexhaustible sum of new contingencies and complications? I do not know, but it seems to me I see two roads leading to the knowledge of human history. The one, wearisome and without visible goal, with countless twists and turns—the way of experience; the other, hardly more than a single leap—the way of intuition. He who takes the first road has to figure out one thing from another by laborious calculation, while he who takes the second immediately pene-

trates to the essence of every event and object and is able to contemplate these essences in their vital complex interrelationship and easily compare them with everything else like numbers on a slate.

The Romantic response to the worrying revelations of reason is always extravagant. An undercurrent of childish impatience with what Novalis called "laborious calculation" can be found running throughout Romantic literature.

Most Romantics—including Cornell—were somewhat embarrassed by their urge to escape from the ardors of reasoning. In Cornell's case, he compensated by accepting the tone of reasonableness with which certain authors, as romantic as himself, pretended to examine the problem of creativity scientifically.

The Symbolists' reflex—to preserve at all costs the naïveté that permitted the artist to contemplate essences without the hindrance of educated reason—exercised itself in Cornell's search for authority. Novalis, Arthur Koestler, Max Planck, Albert Einstein—each was a point in Cornell's ellipsis, and served at least as much as actual experience to reinforce his creative activity. His fear of analysis, shared by all Romantic poets, expressed itself in his search for an authoritative *scientist* who could allow for the limitations of analysis. Nerval had written of his "supernaturalist" poems (the great *Chimères*) that they "would lose their charm in being explained, if the thing were even possible." And Cornell often expressed his reluctance to "explain" the meaning of his boxes for the same reason, although he usually substituted the word "mystery" for Nerval's "charm."

In Arthur Koestler, Cornell found his ideal authority. Attacks on Koestler as a popularizer left Cornell unmoved. He found what he sought there, and in Koestler's *Sleepwalkers*, Cornell's interests converge.[28] Koestler purports to offer a history of Cosmology, seeing the origins of each historical cosmic view in the creative act. In his preface he takes a position which allows Cornell, a religious man, to enter into his speculations:

[28] Arthur Koestler, *The Sleepwalkers* (New York: Macmillan, 1959).

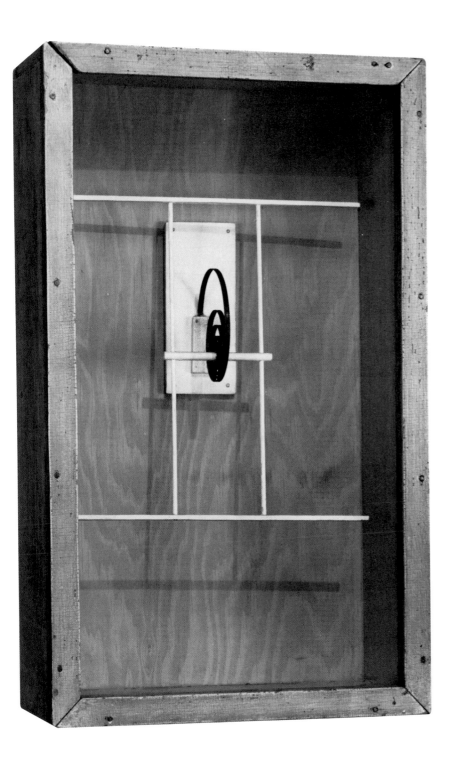

Homage to Blériot, 1956 53

First there are the twin threads of Science and Religion, starting with the undistinguishable unity of the mystic and the savant in the Pythagorean Brotherhood. . . .

This unity, he makes clear throughout the book, is desirable. His premise, summarized in the epilogue, confirms all of Cornell's instinctive suppositions:

Every creative act—in science, art or religion—involves a regression to a more primitive level, a new innocence of perception liberated from the cataract of accepted beliefs. It is a process of *reculer pour mieux sauter*, of disintegration preceding the new synthesis, comparable to the dark night of the soul through which the mystic must pass.

Undoubtedly one of the important aspects of Koestler's book for Cornell was his concentration on the astronomer Kepler. Koestler was drawn to Kepler not only for the scientific advancements he carried out, but for his audacious personality, his lively writing style, and his self-irony. Kepler was the ideal scientist for a novelist. And for Cornell, Kepler was the stargazer whose humor and quixotic turnings could be imagined as akin to his own.

Kepler set out to solve the "cosmic mystery." He recognized the character of obsession, the *idée fixe*, underlying his research methods. He relished creative agonies. He clearly pursued his mysteries with the ardor of an artist pursuing his visions, and like the artist, he did not regret the years of deep absorption: "Yet it gives me pleasure to remember how many detours I had to make, along how many walls I had to grope in the darkness of my ignorance until I found the door which lets in the light of the truth."

For Cornell, Koestler's vision of Kepler's search—"his religious-scientific quest for a harmonious universe governed by perfect crystal shapes or chords"—coincided with his own vision of the cosmos as expressed in his works as well as his choice of texts. Kepler's habit of publishing "ephemerides," or detailed information about the motions of the planets for a given year, and Cornell's own use of the word "ephemera" corre-

sponded. Kepler's epitaph, written by himself, summed up the Romantic position with all its pride and pathos:

> I measured the skies, now the shadows I measure
> Skybound was the mind, earthbound the body rests.

Cornell also sought a modern scientific spirit which could confirm his own, and he found it in the writings of the physicist Max Planck. Planck's *The New Science* was so important to him that when for a second time he visited an advanced seminar at the Cooper Union, he came carrying the book and had someone read out certain marked passages. His visit gave him an opportunity to offer to the young scholars a part of his legacy: his special reading list. Years before, he had given the same text to various assistants at Utopia Parkway, urging them to think about it. Planck's concern with the Spirit, his readiness to cite God, and his ethical position were of tremendous moral significance to Cornell. The conclusion Planck reaches in this important section (pp. 211–15) reflects Cornell's deepest convictions:

And so we arrive at a point where science acknowledges the boundary beyond which it may not pass, while it points to those farther regions which lie outside the sphere of its activities.

While Planck stopped just before the quest of "those farther regions," Cornell, infatuated by mysteries, could not. The meaning of magic, and the desire to believe in immortality and perhaps even reincarnation, were too important to him. His need to find support led him even to a source as unlikely as Mary Baker Eddy. Cornell professed himself a Christian Scientist, but was always rather reticent about discussing the nature of his belief. He obviously shunned the more foolish practical aspects (he was not averse to medical attention, for instance), yet he owned and studied numerous Christian Science pamphlets. He was well aware that his interest in Christian Science might draw ridicule and was careful not to expose it indiscriminately. All the same, when the list of readings for the college students had to be made,

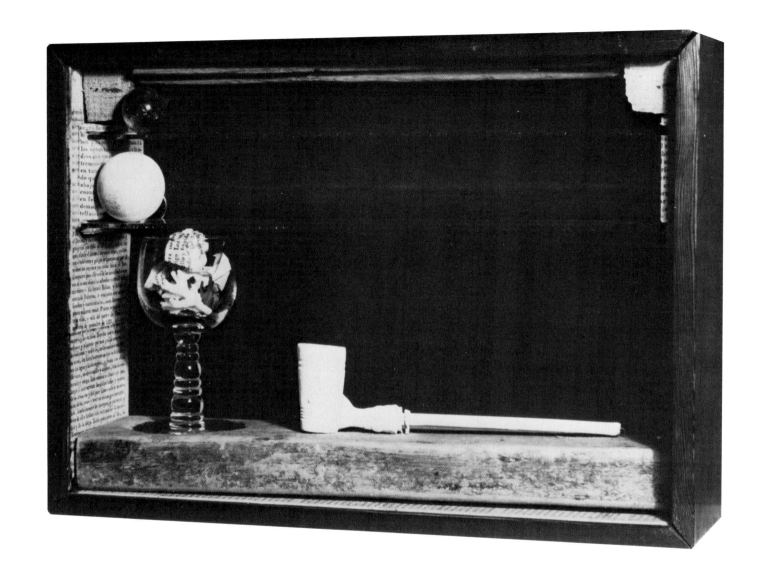

Soap Bubble Set, 1948

he asked shyly if he might not add Mary Baker Eddy's writings. But he was careful not to associate his works directly with his faith. A reporter from the *Christian Science Monitor* interviewed him at the Cooper Union exhibition and asked him about the role of religion in his work. "He describes the influence of his religious faith upon his art as an 'imponderable area.'" Yet

he confided to her that one of his dossiers consisted of clippings from the *Christian Science Monitor* dating from 1926.[29]

It would seem that in Mary Baker Eddy's writings Cornell sought mainly references to eternal life, and curious anecdotes about agelessness and the cancellation of death (see page 205). His need to believe that the past could be retrieved, and perhaps even magically reinvested with life, was all-surpassing. There are touching proofs in the letters he wrote to friends upon the death of his invalid brother, Robert, in 1965. "Our common confidence in the truths of Christian Science, I am certain is bearing fruit in a magnificent way," he wrote. "There is no real sense of separation." He was by instinct prepared to accept Mrs. Eddy's insistence that "the infinite never began nor will it ever end." He was by temperament given to the kinds of fantasies in which the Boston matron indulged—fantasies of eternal life, of remaining forever young, of miraculous cyclical renewals. "Years had not made her old," she wrote in one of her fairytale anecdotes, "because she had taken no cognizance of passing time nor thought of herself as growing old."[30] Cornell, like Mrs. Eddy, was extremely reluctant to use calendars or to date his own works, although he was given to consecrating certain dates. But those dates were endowed with a transhistorical significance, and did not mark positions on the calendar in the stream of his life. The most important date for him was Christmas, as he was born on Christmas Eve, and he was highly superstitious about the season.[31]

Nearly every exhibition he arranged was carefully gauged to coincide with his birthday (which, as one dealer has said, made

[29] Diana Loercher, *Christian Science Monitor*, February, 1972.

[30] Cornell's sister, Mrs. Betty Benton, makes the comment that Cornell "would have rejected the references to Mrs. Eddy and what is termed her 'fantasies.' The great Christian Science religion was not founded on 'indulgence' in 'fantasies.' Joseph's love of Christian Science was fundamental not fantastic."

[31] According to Mrs. Benton, "Joseph would have absolutely repudiated the word 'superstitious' as applied to him. He loved the Christmas season because of his childhood when our father was alive. He and my mother made our birthdays and holidays magical."

it very nice for art dealers since his work was by nature eminently saleable as "gifts").

One part of his soul—the part he dedicated to the Cornell of his childhood—stubbornly clung to a naïve belief in the magic of holidays. At Christmastime visitors to Utopia Parkway would always find decorations—often very old—around the house, even when, in his last years, Cornell was alone. There were toys for the children in hospitals, but also toys he cherished for other associative reasons. He liked to play house from time to time, and once, when the young Esta Greenfield came, he had bought Raggedy Ann paper plates and napkins for a luncheon feast. All these little events in his grand charade were dedicated to his ineffable belief in immortality and magic. The range of levels in his quest of retrieval—whether retrieval of the trivia of his own childhood, or of the great voices in the lost Atlantis of nineteenth-century Europe—was great. Yet, the thread—the magical thread of tradition, as he called it—was miraculously intact at the end of his elliptical life.

Cornell's epigraph for his publication *The Bel Canto Pet* read "the light of other days." This light both inspired and eluded him. He sought it everywhere, above all in the poetry of other days. His working habits could be said to correspond very nearly to the habits of those nineteenth-century poets who, while breaking with conventions of syntax or punctuation, nevertheless worked within a frame. Nerval, Baudelaire, Mallarmé—all retained the strict sonnet form for their most mysterious images of infinitude. Similarly, Cornell always commenced by creating his frame, the box, and only then would drift into his procedure of association, putting in and taking out, much as a poet invests his poems with words that later may be changed or eliminated.

Cornell's incantatory method led him to the kind of sonorous play with words that the Romantics of the nineteenth century prized. He mentioned Maeterlinck on occasion, and one is tempted to think he was attracted to the same aspect of Maeterlinck's poetry that enchanted Kandinsky: the repetition

of an evocative and familiar word, such as "hair," until it takes on a mysterious quality going beyond its object. Cornell's repeated use of objects such as clay pipes or balls is comparable. He also played with words in a rather Joycean fashion. For instance, to avoid dating letters, he sometimes wrote "eterniday" or "snowsday" in the upper corner. Cornell could ask, with Mallarmé: "Have words unknown—evil remnants of a meaningless phrase—ever sung upon your lips?" He had periods in which the sound of a certain word would capture his fancy and would use it repeatedly in letters—for instance, "esplanade." The objects in his boxes very often emerged from his interior wordplay, the words frequently drawn from the residual store his incessant expeditions to the French poets provided. His readings were so interwoven with his creative life that it is impossible to describe specifically the part they played in his work. All the same, anyone who has saturated himself with Nerval, Gautier, Baudelaire, and finally—and above all—Mallarmé will recognize their spiritual diction, and often their motifs, in Cornell's boxes.

Cornell deliberately, and with great attention, provided himself with a great and "other" tradition. He interpreted "his" tradition broadly. One of his last profound enthusiasms in his reading was for Wallace Fowlie's book on Rimbaud, and specifically the chapter on "Angelism."[32] Fowlie's lyrical and sometimes sentimental tone accorded with Cornell's. He agreed with Fowlie that "poetry is one of the principal methods of preparation by which man tries to change his being into an angelic being. . . . Pure song would be the accomplishment of pure spirit." And Cornell must have recognized his own old quarrel with materialism in Fowlie's statement, so similar to Koestler's, that:

In his fundamental poetic drive, Rimbaud is opposed to the efforts of the intellectual whose main function is the reduction of the unusual and the supernatural. If the intellectual's regime

[32] Wallace Fowlie, *Rimbaud* (Chicago: University of Chicago Press, 1966).

is prolonged, it converts religion, for example, into morality, or hygiene. . . .

Fowlie's view of Rimbaud's angelism can be condensed to his discussion of the lines in the poet's *Mémoire*:

> . . . Lui, comme
> mille anges blancs qui se séparent sur la route,
> s'éloigne par-delà la montagne!

On these lines, Fowlie writes: "For himself, therefore, his flight was angelic, motivated by a great thirst for purity and freedom, for a spiritual liberation."

The great heir of Rimbaud's angelism was surely Mallarmé ("Je puis dire que je dois à Rimbaud tout ce que je suis intellectuellement et moralement"). For Cornell, who constantly pondered this poet and liked the adjective "Mallarméan," there was always affirmation to be found in the web of Mallarmé's poetry. The earliest message—"Whatever is sacred, whatever is to remain sacred, must be clothed in mystery"—was also the last. With circular consistency, Mallarmé began and ended with a reverence for mystery that he phrased and rephrased throughout his life. In one of his most simple statements (letter to Léo d'Orfer, June 27, 1884), he summed it up:

Poetry, when human language has been reduced to its essential rhythm, is the expression of the mysterious meaning of the various aspects of our existence.

But it was not in such pithy definitions, occasionally offered by Mallarmé to his followers, that his real message was contained, but in the evocations of mystery in his poetry. Certainly he had accepted from Rimbaud the analogy between the alchemist and the poet or artist. He used the expression "patient as an alchemist" to describe his efforts toward the supreme, subsuming work he dreamed of. ("The whole of my admiration goes to the great Mage, inconsolable and obstinate seeker of a mystery that he doesn't even know exists and which he will pursue forever nevertheless, from the pain of his lucid despair, because that

would have been the truth.") The magician: how clearly Cornell saw himself in this role, with his mental alembics, his colored matter (sand), and his patient reiterations! Yet, like Mallarmé, he imagined that the mystery he enclosed in his imaginary theaters would be easily accessible to the "dreamy ones," the ones he designated in his mind as the pure in heart. Mallarmé did not regard his work as prohibitively obscure, though he did understand baffled responses to his arcane poetry. Anthony Hartley cites a passage filled with Romantic confidence in the naïve response:[33]

If you obey the invitation of this vast white space left deliberately at the top of the page as if to produce a separation from everything, from what has already been read elsewhere, if you arrive with a fresh, virginal soul, then you will perceive that I am deeply and scrupulously respectful of syntax, that my writing is devoid of obscurity, that my sentence is what it has to be and be for ever. . . .

In the works of Mallarmé, Cornell surely found many correspondences that do not bear impaling. But he also found deep affinities, which drift to the surface and are easily discerned. For instance, Mallarmé's habit of accumulating slips of paper and odd notes—those very notes that he asked his wife and daughter to burn—which visitors saw scattered in profusion on his desk. Or Mallarmé's attitude toward his Work, his Book, an eternal work in progress. His poems, he said, were "*en vue de mieux*," his projections in many different poems and essays beyond the present—in other words, the work of the poet. Cornell's "*à suivre*" (or "details to follow"), and his frequent promises of some future mysterious event in his work, are in the Mallarméan tradition. Mallarmé's frank insistence on the Dream, and his way of thinking of dreams—later stated by Freud when he said "the dream is not known in its final state"—was Cornell's way also.

Even in his tastes, Cornell paralleled Mallarmé. In his autobiographical note for Verlaine, Mallarmé wrote, "I have gone

[33] *Mallarmé*, ed. Anthony Hartley (Baltimore: Penguin Books, 1965).

out occasionally whenever there was a ballet to be seen or an organ to be heard: these are my two artistic passions. . . ." Music and dance were Cornell's two artistic passions also, and possibly more deeply significant to him than the plastic arts themselves. He was no haunter of museums. His readings were rarely in art history. In his emotional hunger he had recourse to music and writings about music, and for artistic inspiration, he sought imagery in the theater, and more particularly the ballet. There can be no doubt that he was intimately familiar with Mallarmé's prose notes on the ballet. Perhaps he contrasted the views of Gautier, who felt that the dance had no other object than to show beautiful bodies in graceful poses and develop lines pleasing to the eye, with Mallarmé's more complex view: "The chief goal of the dance, apart from its mechanics, is a mobile, unending, ubiquitous synthesis of the attitudes of each dance group, a synthesis which they must fraction ad infinitum." Mallarmé's vision of the ballerina was an ethereal one:

I mean that the ballerina *is not a girl dancing*; that considering the juxtaposition of those group motifs, *she is not a girl*, but rather a metaphor which symbolizes some elemental aspect of earthly form: sword, cup, flower, etc., and that *she does not dance* but rather, with miraculous lunges and abbreviations, writing with her body, she *suggests* things which the written work could *express* only in several pages of dialogue or descriptive prose.[34]

Cornell, who once discovered in his Fourth Avenue foragings a rare print of a 1905 film of Loïe Fuller's "Fire Dance," would have thrilled to the beautiful opening lines of Mallarmé's essay "Ballets":

La Cornalba delights me; she seems almost naked in her dance. For in an effortless rise and fall, this creature now in flight, now drowsed in veils, is summoned into the air and seems to hang there, purely Italian in the soft stretching of her body. . . .[35]

[34] *Mallarmé: Selected Prose Poems, Essays and Letters*, trans. Bradford Cook (Baltimore: Johns Hopkins Press, 1956).
[35] Ibid.

Dance Index

a new magazine devoted to dancing

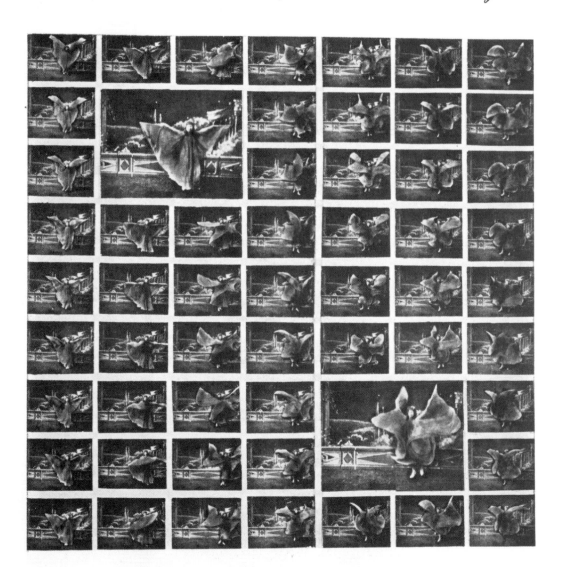

Loie Fuller montage
designed by Cornell
for the cover of
Dance Index, March 1942 63

The ballerina and the ballet, while the source of genuine aesthetic pleasure to both Mallarmé and Cornell, became, in their works in progress, transformed, "fractioned," metamorphosed. In his eclogue "L'Après-Midi d'un faune" Mallarmé choreographs music, movement, and light. The faun in all his movements reflects Mallarmé's preoccupation with the ballet, as does the origin of the poem itself, which was intended for the theater. No wonder that Mallarmé's admirer and friend, Claude Debussy, felt so deeply moved as to compose his symphonic poem, eventually staged as a ballet by Nijinsky. The close relationship between Debussy and Mallarmé was followed by Cornell, whose special interest in the composer could be noted in his library.

The allegiance to the theater so deeply ingrained in all of Cornell's "family" becomes, in Mallarmé, something even more acute. More than once he alluded to "the theater of the mind" in which his poems unfold. Specifically, he wrote in his essay on Hamlet that "this work of Shakespeare is so well patterned on the theater of the mind alone—this being the prototype of all others—that it makes no difference whether or not it is adapted for modern production." Of his "L'Après-Midi d'un faune," he wrote to Cazalis in 1865, "This poem encloses a very noble and beautiful idea, but the verses are terribly difficult to write, because I am making it absolutely theatrical, impossible for the theater, but needing theater." The elaborate and involuted thoughts on the symbol of the theater, and the role of the actor (who, as Mallarmé said, must be in symbolic relationship to himself) can be transposed to Cornell's shadow boxes, products of his mind communing with itself and with all the symbols he has encountered in his literary pilgrimages. The deep roots he struck in the whole of the nineteenth-century tradition were constantly fed by the allusions to theater found in the poets. The ring of the Mallarméan voice is always faintly discernible, as in this statement by Cornell:

Shadow boxes become poetic theatres or settings wherein are metamorphosed the elements of a childhood pastime. The fragile,

shimmering globules become the shimmering but more enduring planets—a connotation of moon and tides—the association of water less subtle, as when driftwood pieces make up a proscenium to set off the dazzling white of seafoam and billowy cloud crystallized in a pipe of fancy.[36]

Cornell's poetic theaters enclose the mysteries of metamorphosis of the poet's antechamber. His reflex to enclose, to remove from real space, was as constant as Mallarmé's. Cornell had a large cache of miniature blue, yellow, and white boxes, often stored one within the other. Both Cornell and Mallarmé spoke repeatedly in their works of the isolated chamber. Mallarmé's nostalgia for the well-enclosed secrets of the past was expressed in his essay "Art for All," where he apostrophizes: "Oh, golden clasps of ancient missals!" His frequent allusions to treasure and treasure chests always symbolized his poetry and its containing form, the "spiritual casket." Cornell's ambiguous and ubiquitous word "sanctuary" is found frequently in Mallarmé's poems, suggesting a vaultlike enclosure. Had Cornell memorized the important letter of December 5, 1865, about the "Faun"? "Oh, I *shall* extract this poem—this magnificent jewel—from the sanctuary of my thought!" At any rate, the sanctuary image was as intimate for Cornell as it was for Mallarmé.

There are still other ways in which Cornell would have found himself enmeshed in Mallarmé's dream. If certain words are the incantatory keys to Mallarmé's central preoccupations, so certain images in Cornell's works are correspondingly revealing. The image, for Cornell, is a composite that tends to a single and particular effect. The effect is given largely by the kind of lightkey he establishes when first he stains his boxes, or paints and gessoes their interiors. His overwhelming preference was for blue, either the summer blue of the sky or night blue. As Mallarmé expanded the simple word *azur* to encompass a host of nuanced meditations on the nature of the cosmos, so Cornell sought to use *his* azure. The last line of Mallarmé's poem "Azur" is explicit: "*I am haunted*. The Azure! The Azure! The Azure!

[36] Catalogue, Copley Galleries exhibition, September 28, 1948.

The Azure!" Cornell too was haunted, and his azure, like Mallarmé's, symbolized a host of reveries. When the color darkened, it dwelt in the idea of constellations, of the stars pricking out their images in an infinite, deep blue state.

The turning of azure into midnight blue, and of the broad light of infinite day into the vaulted enclosure of infinite night, was without any question an intimately familiar experience for Cornell—one he tried to capture and characterize in various forms. Of all the images offered by his family of poets, Mallarmé's were best accommodated in the chambers of Cornell's inner experience. When the poet Octavio Paz visited him in December 1971, Cornell eagerly discussed the strange sonnet for which Mallarmé had invented the word "ptyx," which, as he wrote to a lexicographer friend, he hoped did not really exist in any language since it was evoked by the poem itself. Paz had written extensively on this particular sonnet, and he and his wife Marie-José were able to respond, as few could, to Cornell's urgent questions. It was apparent that he knew the literature around Mallarmé's poem, and also Mallarmé's discussion of the sonnet—a discussion revealing many facets and images that paralleled Cornell's visual works:

For instance a window open at night, with the two shutters fastened back; a room with nobody in it, despite the air of stability given by the shutters fastened back, and in a night made of absence and questioning, without furniture except for the plausible shape of vague console-tables, a warlike, dying frame of a mirror hung at the back, with its stellar and incomprehensible reflection of the Great Bear, which alone connects this dwelling abandoned by the world to the sky.[37]

In this, conjunctions innumerable. The echo of Poe; the image of a vault-like theater; windows (always equivalent to the theater proscenium); mirrors, with the complex narcissism they imply, and the "double" experience; and finally, the constellation—never far from Cornell's thoughts.

66

[37] Letter of July 18, 1868, to Henri Cazalis.

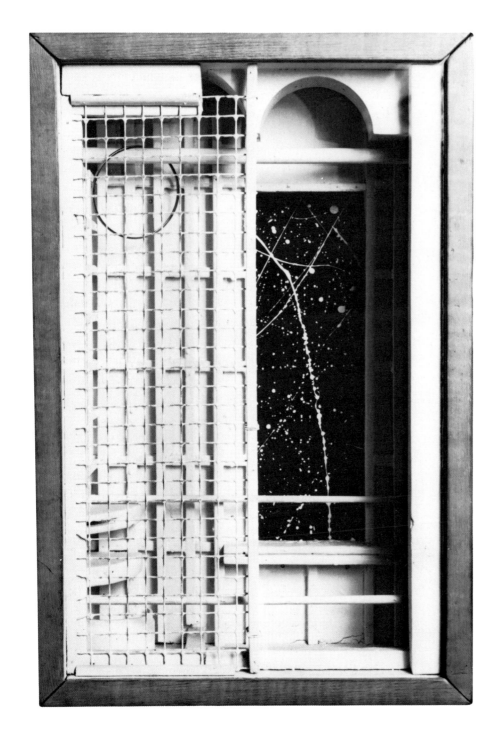

Observatory
(Corona Borealis Casement), 1950 67

In absorbing the Symbolist tradition and making it his own, Cornell was like an actor in Mallarmé's metaphysical sense. Breton once said of a fellow poet that he could speak Surrealist at will. Of Cornell, it may be said that he could speak Symbolist at will.

The voice emerges in one of Cornell's few published writings, *M. Phot*, the film script written in the mid-1930s and published in 1936 by Julien Levy in his book *Surrealism*.[38] This shooting-script fantasy was obviously inspired by Cornell's viewing of early Surrealist films. Yet in the writing, the deeper and—at least to him—more real tradition of Symbolism finally overwhelms the Surrealist aim.

The action is located in the "other" time, 1871. As in a Novalis tale, its key image is of a child playing a harp. The salient images are blurred like old photographs, and they cleave to the orthodox Symbolist canon (the "provenance" is always important, as Cornell stressed in a cryptic Christmas greeting in 1963 with the single message: "Provenance as time capsule"). There are recurrent mirrors, a photographer with his magic box, glass and other refractory materials, a bird (the pheasant), and a horse-drawn coach (which abounds in the literature of ballerinas) with glass windows through which urchins (angels) peer. Not surprisingly, the climax takes place in a glass and china shop, where the only Surrealist violence occurs. Throughout *M. Phot*, in which a protagonist is linked with his piano, the strains of specific music enhance the atmosphere—music far from the Surrealist ideal. Reynaldo Hahn's lovely *"si mes vers avaient des ailes"* is indicated, as is *Tales from the Vienna Woods*, and "that section of Stravinsky's 'Fire-Bird' which so marvelously suggests the bird's flight into the distance," and "Tchaikowsky's 'Dance de la Fée Dragée,' charmingly appropriate." Despite the inclusion of "an infectious galop of 1870 vintage," the scene, as he writes, "is one of inexpressibly serene and satisfying beauty. Fade-out." In fact, the dénouement of the script presents a scene

[38] Julien Levy, *Surrealism* (New York: Black Sun Press, 1936).

with snow falling and baskets of clean laundry scattered in an aisle and stretching into the distance, which suggests that Cornell's musing on angelism began long before Fowlie's text, and that the Rimbaud associations with clean laundry and angels had been written in his psyche since his youth. *M. Phot* is a fairy tale, a Symbolist effusion cloaked in Surrealist disguise. In several of Cornell's realized films, the same imagery and tone prevail—the fabulous quality and the yearning predominate.

The photographic image in general represented for Cornell an act of retrieval. Even in his early boxed daguerrotypes, with their ingenious arrangements of interior mirrors, he would camouflage the images of living personages by blurring and darkening them to suggest other eras. He commemorated many of his enthusiasms for outstanding women in these boxed memorabilia, among them the poet Mina Loy, whose earliest publication bore a title that certainly interested Cornell—*Lunar Baedeker*. (It was Mina Loy who introduced him in 1943 to one of his most important literary experiences, *Le Grand Meaulnes*, source of numerous variations in his boxes of the enchanted château theme.) A reviewer of Cornell's first major one-man show at the Julien Levy Gallery in 1939 found that "Mr. Cornell's star production is an evocative early presentiment of Greta Garbo framed dreamily with 'shots from some of her famous roles.' "

The search for dream and fable, a "placement" in distant time, continued even when Cornell took to the streets of New York for his short lyrical films. One of his earliest cameramen, Rudi Burckhardt, recalls that Cornell always sought a cartouche effect, always had to frame things as if they were boxes. Burckhardt accompanied Cornell to Flushing to film autumn leaves, to Mulberry Street in New York's Little Italy to film children, and to Union Square to film monuments. Always Cornell strove for closure and dreamlike distancing. In his famous montage of old Hollywood film clips, *Rose Hobart*, which some critics regard as an important pioneering development of the compilation film form, Cornell added distance and magic by

70 Two stills from Cornell's film *Rose Hobart*, 1939

using blue tints. And, in his static boxes, where, for instance, the image of a young prince is repeated as in a film strip, the glass is always tinted for the same effect.

Cornell's need to explore "things of a spiritual order" impelled him to develop various techniques for suggesting his *état d'âme*. The talismanic objects that he repeatedly set within his frame were for him, as words were for Novalis, intended to "fill the inner sanctuary of the spirit with new, wonderful and pleasing thoughts." Cornell's objects cannot stand alone. They must, as Mallarmé would have said, suggest the *contemplation* of things, and arouse the reverie of the viewer. Even when Cornell dealt with the moving image in his films, he focused on objects as though to wring from them their innermost meanings, which, as his hazy images suggest, are veiled. "To *name* an object," wrote Mallarmé, "is largely to destroy poetic enjoyment, which comes from gradual divination. The ideal is to suggest the object. It is the perfect use of this mystery which constitutes a symbol." From the late 1930s on, the same objects appeared in Cornell's boxes, always dissolving themselves in the particular mystery he set out to capture. These objects were utilized as nouns were used by his poetic forebears—as contributions to a total effect. His attitude toward particular objects was casual—so many nouns to be activated by the poem. He said he worked in a rebus-like way. Cornell's objects merge into the general metaphors they are intended to evoke.

His history as a maker of poetic objects is as elliptical as his souvenir-laden imagination. He began as an illuminated archivist, and at the close of his life he told a reporter that he had again turned his attention to the mass of portfolios that he called "explorations." The last explorations were the same as the first: clippings, engravings, and mementoes of nineteenth-century luminaries. At the beginning of his artistic life, sometime in the very late 1920s and early 1930s, Cornell acquired a reputation as a forager. His collection of old engravings and photographs enabled him to earn small sums of money by using his expertise

122　Pola Negri in *Hotel Imperial*, directed by Moritz Stiller, 1926

123　Gloria Swanson in *Sadie Thompson*, 1927

Stars of the 'Twenties

Illustrations provided by Cornell for Gilbert
72　Seldes's *Movies for the Millions*, published in 1937

to supply publishers with illustrations. No doubt his collection of old catalogues and engravings was well developed before he ever encountered Max Ernst's *Femme 100 Têtes* (which, according to the French author Marcel Jean, he had seen in 1929 before he found it again at Levy's gallery). Out of his folios and dossiers, Cornell could draw the materials for his first montages in the manner of Ernst. The idiom, however, derived from his nineteenth-century family. Ernst's emphasis on horror finds little echo in Cornell. Cornell's imagery is saturated with nostalgia, as the 1931 collage indicates: a schooner with its sails billowing forth like a giant rose and enclosing a spider web. The spider is not sinister, the sea is calm, and the schooner may be a reference to Cornell's pride and memory of his family's earlier days as proprietors of Hudson River vessels.

Cornell's admiration for Max Ernst remained constant, although the two men had little in common. When Ernst visited Cornell in the late 1940s, together with Dorothea Tanning and two other couples, Cornell was gratified. But when the time came to show his work, he invited only the three women to the garage where his work was stored, and offered Ernst and the two other men each copies of Gérard de Nerval to keep them occupied.[39] He sensed, as did Ernst, that there was a fundamental spiritual gulf between their sensibilities. Cornell's encounter with Ernst and the other Surrealists clustered around Julien Levy spurred him to efforts to echo their wholly un-naïve accents, but from the beginning his own dialect differed. The work Levy reproduced in his book in 1936 was a clear enunciation of Surrealist manners, deriving from the Surrealist obsession with Lautréamont's *Chants de Maldoror*, particularly the much repeated phrase "beautiful as the chance encounter of a sewing machine and an umbrella on the dissecting table." But Cornell's encounter had little of the fierce impact of Ernst's montages. His machine has a flower in its handwheel, a nineteenth-century corseted mannequin in the grip of the machine, and such in-

[39] Reminiscence of Jeanne Reynal, who was present.

congruous Americana as an ear of corn, a homely oil can, and an awl.

Cornell's early essays in poetic juxtaposition were most often couched in the language of Victoriana or Americana. His resistance to Surrealist excess was evident from the beginning. Closer to the *Wunderkammer* than to the chamber of horrors that so amused the Surrealists, Cornell's imagination harbored mementoes and anecdotes embellished by time. The ubiquitous little glass bells in Victorian homes enclosed cargoes of memory. Shadow boxes lined with velvet fetched up memories of dim sitting rooms and readings in the romantic lives of young lovers. Others were like specimen boxes for botanists and lepidopterists. There were small caskets and powder boxes for the palm of the hand, and all kinds of receptacles for pills, snuff, and small jewels that once graced nineteenth-century vanity tables. These were the sources of Cornell's inspiration even though his techniques were developed under the tutelage of the Surrealists. He turned these small objects, as Parker Tyler wrote of the 1939 exhibition, into an "analytical reconstruction of a poetic association in terms of the toy and the permanent and inescapable value of bric-à-brac, clippings, jetsam."[40] Tyler called Cornell "master of the world as a *bilboquet*." Much as Cornell bridled at the association with toys, much as he might have shrunk from being called a master of the cup-and-ball game, he presented himself to the world of Fifty-seventh Street in 1939 as a man who salvaged the objects of pleasure of the past for a revealed pleasure in the present. Unlike the Surrealists, he could not transform a doll into a shocking souvenir of atrocity. His dolls, often relics of other centuries, were showered with confetti or nestled in the branches of a wood. He saw them in a nostalgic rather than a sinister light, as he proved when he composed the children's

[40] Catalogue foreword for December 6–31 exhibition at the Julien Levy Gallery, 1939.

page of *View* magazine around a photograph of a doll covered with confetti. His own boxed doll in a bed of twigs remained with him for years. Shortly before his death, a young admirer visiting Utopia Parkway saw it lying on his bed, and Duane Michals photographed Cornell with it (see page 76). Also in that photograph is the grasshopper, intended for an homage to Jacqueline Bisset, who appeared in the film *The Grasshopper*.

Despite his concourse with the artists of his time, they never seemed to impinge more than superficially on his private vision. Of all the Surrealists around Levy's gallery, it was probably Marcel Duchamp who most appreciated Cornell, and with whom Cornell had a genuine friendship. Duchamp regarded Cornell as an authentic poet. He was attentive to the works, and frequently brought other artists to see them. When he needed replicas of his *Valise*, the ingenious boxed effigy of his collected works, he asked Cornell to build them. Cornell kept a box of his own filled with curiosa intended for Duchamp but somehow they were never tendered. Certainly his exchanges with Duchamp would have enlarged his sphere of reference, and possibly affected the way he composed his own boxes. Many critics have noticed the similarities between a work such as Cornell's *Homage to the Romantic Ballet*, in which he strews a mirrored casket with crystal cubes, and Duchamp's box of sugar cubes, *Why Not Sneeze?* Cornell would have seen the Duchamp work when they both exhibited in the Dada and Surrealism show at the Museum of Modern Art in 1936. It has also been noticed that Cornell enjoyed wordplay and puns in much the same vein as did Duchamp. Cornell's puns, however, were rarely sophisticated. If he wrote in a letter that he wished to "finangle" something, carefully adding "sic" after the pun, he was quite pleased with himself. His wordplay almost never went beyond the obvious.

Certain experimental ventures undertaken by Cornell were very probably inspired by Duchamp's example. Duchamp's own extension of the Symbolist preoccupation with the role of

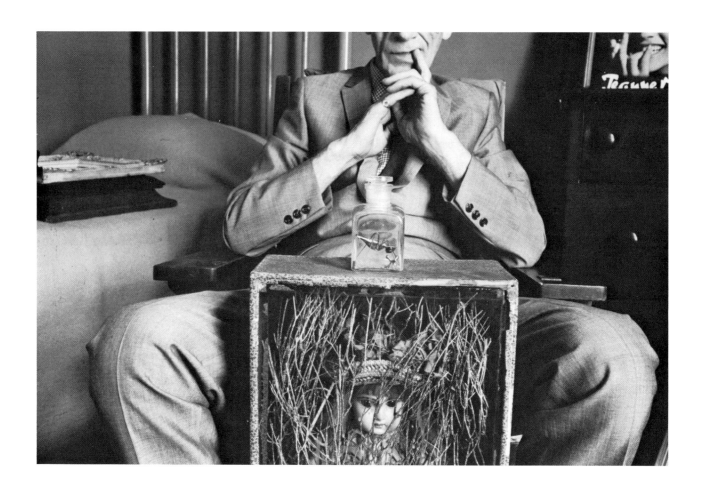

76 Photograph of Cornell by Duane Michals

chance ("a throw of the dice will never abolish chance" was an observation that underlay much of Duchamp's mystification) found echoes in Cornell, who always seemed to be searching for a conjoining principle in chance encounters. The dossiers around such themes as "Salamandre" or "Pasta" were loosely kept, and occasionally Cornell would ask friends, particularly young people, to make an arrangement of the materials, to "see what can be done" with them. When he had an exhibition at Bennington College on the dovecote motif, he sent a box of disparate but for him related materials to the college with an invitation to the students to assemble it, montage-fashion, for the exhibition. This was enthusiastically carried out by five students.

These experiments may well have been inspired by Duchamp, and certainly Cornell shared with the French artist a love for sudden juxtapositions of perfectly ordinary and even vulgar objects. But seashells, pressed flowers, and butterflies were in the final analysis closer to Cornell's vision than were Duchamp's ironies. Cornell shared, for instance, the Surrealists' passion for waxworks, shooting galleries, and those mysterious caged fortunetellers in funfairs, but his associations were radically different. He never forgot having seen as a child a mechanical chess player in a turban, and frequently mentioned it, along with the penny-arcade atmosphere of Times Square and the subway stations with their gum machines. These associations went back to his youth when, fresh out of preparatory school, he plied the streets of New York as a textile salesman. His memory of the amusing sights of the city was always precise. With Esta Greenfield he played a game of seeing who could remember the sequence of illuminated signs in Times Square. But Cornell's love for neon signs, funfairs, and pinball machines was never tinged with the cruelties of Surrealist games. In December 1946, he wrote in the Hugo Gallery catalogue:

. . . impressions intriguingly diverse . . . that, in order to hold fast one might assemble, assort, and arrange into a cabinet . . . the contraption kind of the amusement resorts with endless

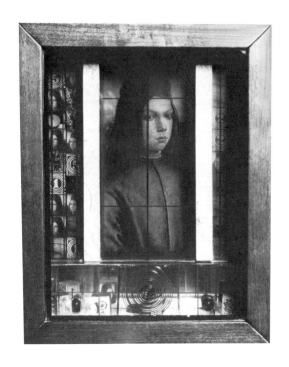

Medici Slot Machine (Bernardino Pinturicchio), 1943

77

ingenuity of effect, worked by coin and plunger, or brightly colored pin-balls. . . .

This was less in the spirit of Surrealism than in that of the *Tales of Hoffmann*. Even in one of the very few Cornell works suggesting violence, *Habitat Group for a Shooting Gallery*, with its array of brilliantly plumed parrots and parakeets and its references to a friendly Paris of other times, all shattered by the crash of the bullet through the glass, the tone is mild—far from Breton's idea that beauty must be convulsive or not at all.

There was one Surrealist, however, whom Cornell admired unreservedly. He was René Magritte. When Cornell's invalid brother, Robert, died, it was a Magritte painting that Cornell chose for his memorial image. Robert, whom Cornell tended assiduously, and for whom Cornell gathered amusing games and images, was a model-train enthusiast. Cornell, for his memorial, selected Magritte's *Time Transfixed* of 1932, in which Magritte had painted a steam engine floating before a severe fireplace. He set a reproduction of the painting within a cracked frame and surrounded it with garlanded angels and shrouded forms. In the Magritte painting, the dimension of time is stressed by a black clock on the mantelpiece, and this in turn refers back to Magritte's own master, Giorgio de Chirico, who had so often alluded to trains and the transit of time by means of a transfixed clock. Cornell would not have missed the chain of associations. He had always been interested in Chirico, who was associated in his imagination with Italy, as Italy was with Naples, and Naples with Cerrito. Cornell, like Magritte, followed Chirico in refusing interpretations of his images. Mystification was sacred. Although Cornell sometimes appended a text to some work, the text, as in the case of the Whitney box, was usually yet another lure to the speculating imagination receiving it. Most often he was abruptly laconic, as when he answered an inquiry from the Chicago Art Institute concerning a sand box in its possession: "Frankly, I do not remember even the approximate date of it, and as for 'explanation' I could not do better at the moment than to designate it as a 'sand-painting box.'" Those who asked

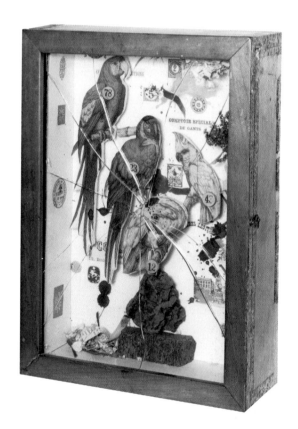

78 *Habitat Group for a Shooting Gallery*, 1943

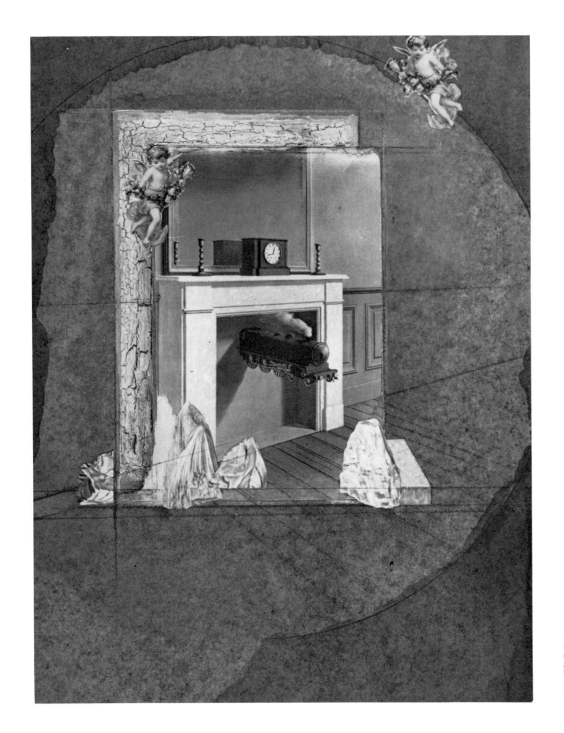

Memorial collage to Robert
Cornell, the artist's invalid
brother, incorporating a re-
production of Magritte's
Time Transfixed 79

Magritte for "explanations" were usually rebuffed in the same curt way. The Belgian artist maintained that the mystery of his works lay in the visible language on their surface. He vehemently denied that his paintings contained symbols, although he was aware of their inevitable symbolic content. Rather, he wished them to be read as rebus-like riddles—mystifying, and emerging from a dream context very closely responding to the passage in Freud so appreciated by Cornell: "The dream work . . . does not think, calculate or judge in any way at all; it restricts itself to giving things a new form." Magritte said his paintings were nothing other than "visible poetry" and, like Cornell, drew upon a rich store of remembered verbal poetry for his imagery.

There were other affinities for Cornell to savor. Magritte had a tendency to keep a repertory of favored images that he inserted again and again into his compositions, always in mitigating contexts. Birds, for instance, appear constantly. Magritte was also obsessed with chambers, often enclosing his conundrums within the confines of a room. He loved doors and windows and armoires, and anything that would open out or shut out. He indicated at times that he saw his works as related to theater, sometimes painting curtains and backdrops for his fantasies. His language, like Cornell's, assimilated elements from others, including the old masters. In one of his best-known paintings there is a precise rendition of Botticelli's *Primavera* gracing the shadowy back of one of Magritte's bowler-hatted *voyeurs*. The allusions to art history are not erudite glosses, but rather the incorporation of handy images complete with established associations.

Cornell's preoccupation with Magritte never abated. When he met the Belgian-American lawyer and collector Harry Torczyner, he immediately evinced interest in seeing Torczyner's collection of Magritte paintings. When Torczyner traveled to Belgium, Cornell always asked him to bring back reproductions of Magritte's work (and also of Delvaux's), as well as a special brand of cookies. Cornell used to visit Torczyner's Fifth Avenue office fairly often—probably on those occasions when he foraged

Robert Cornell's model trains

in Times Square and ate in his favorite cafeteria nearby—where he could contemplate several capital Magritte works, among them *The Golden Legend* with its fleet of levitated loaves of French bread seen through a window, and a painting in which Magritte floats a massive stone in the sky. He was familiar, too, with Magritte's painting of a lone tree and used it in several of his own collages.

Cornell never tried to approach Magritte directly, as he sometimes did with other admired artists. But he did once ask Torczyner to get him a photograph of Mme. Magritte at the age of sixteen, and later sent her a small collage with a bird in it. He also acknowledged his friendship with Torczyner in a collage using the Magritte image of a bowler-hatted man and Belgian stamps in an homage bearing the punning title *Torch Bearer*. The same imagery was later adopted without a title for a 1972 heliogravure print donated to an institution for drug therapy.

Cornell's encounters with the visual artists of his time occurred sporadically. He usually became acquainted with the artists of the galleries that exhibited him, first Julien Levy, and later, during the 1940s, those at Peggy Guggenheim's Art of This Century Gallery. Occasionally he reached out to others, known to him through his reading. He knew and talked with Mondrian, who considered him a charming poet. But one suspects that Cornell's attraction to Mondrian was based as much on the Dutch painter's known interest in Theosophy as it was on his work. Mondrian's views on the cosmos were well publicized by the time he reached New York—views that were sympathetic to Kepler's harmonious universe. Cornell might have seen the calm order of Kepler in Mondrian's paintings, but it is doubtful that he assimilated any of Mondrian's visual theories. For Cornell, Mondrian's "pure plastic realities," so totally abstract, would have been obscure language. It is true that around the time he came to know Mondrian in the 1940s he began to compose relatively vacant boxes, often based on a grid formation, but these were not so much the result of

Photo of Georgette Magritte at sixteen, requested by Cornell of Henry Torczyner

81

Mondrian's influence as they were Cornell's retrieval of obsolete forms having gridlike character: old type-boxes, dovecotes, and the compartmented cabinets used by collectors of insects and flora and fauna. The source is absolutely clear in a work of the early 1940s, *Butterfly Habitat.*

Within the artistic community, Cornell was generally a wistful spectator, but his secret longing to participate inspired a number of relationships with the artists who emerged during the 1950s as the New York School. He followed the art magazines closely. He initiated meetings and correspondence with several prominent artists in the group and watched the development of such painters as Motherwell, de Kooning, and Matta with intense interest and something of the *voyeur*'s stealth. He once said that "the Egan period was the only time I really belonged," and that period was the time of his most regular intercourse with artists other than the Surrealists in New York.

None of these associations had much bearing on his work. He sought out visual artists in much the same way as he tried to meet intellectuals such as critics, novelists, and poets. Usually he would startle them with a sudden appearance in the mail. His gnomic missives often left his readers baffled, and many went unanswered. But the visual artists approached by mail usually responded. When the young painter Grace Hartigan received the message "Beware of Gifts Bearing Greeks" (a message he favored in the late 1950s and addressed to several others as well), she responded immediately. "I was touched at such concern from someone I didn't know. I'd seen boxes of his magic for about six years by then." In return, she sent him a collage "filled with hearts and puns on Heart-again." He answered with a package of mysterious items and a letter in his most arch and coquettish vein, remarking that her sentiments had been "filed in rebus department—we trust correctly," and offering a riddle for her to solve. The "trifles" he enclosed he called a Valentine. According to Hartigan, the "trifles" included old letters in Greek (many others at this time also received old Greek letters on tissue paper that Cornell must have found in a cache in some

A Valentine Object for Grace Hartigan, 1950s

Dear Miss Hartigan,

Beware the gifts bearing

Greeks (ommitted) . . .

Message from Cornell to the painter
Grace Hartigan, late 1950s

84 *Butterfly Habitat*, ca. 1940

second-hand store), cartoons, puzzles, and illustrations, all on the heart or Greek theme. When Hartigan finally telephoned to say that she'd like to meet him, Cornell was remote and said he never saw anyone. This typical withdrawal was reversed about a year later, but although he summoned her, she had by that time left New York.

Cornell approached admired writers more easily than he did other artists, since it was natural to use the written word. For a few years, while both he and Marianne Moore were being published in the pages of *View*, he sustained a correspondence with her. There were many references on both sides to Miss Moore's poem on the extinct beast, the pangolin, on which Cornell had apparently elaborated in a gift. "Like the powdered rhinoceros horn of the ancients," she wrote on March 26, 1943, "your pulverizings, recompoundings, and prescribings are as curative as actual." A year later, on April 11, 1944, Miss Moore acknowledges an envoy of old books:

The cover—the very label of the bookseller—of the "prize to Miss Farish" would make any valentine seem dull. What a color is that ancient magenta with the serpent star, the hermit-crab, the yawning dolphin and weedy trident embossed with loving care! I truly am the custodian not owner of these books. I notice in the pages on Scandinavia, mention of a "xerpar" and of "dew-claws," and something about skates six feet long. And who would not venerate the drinking pangolin, in the British list of animals "now or lately living. . . ."

As I have said, these books—these inspired by-paths of romance—are your own—especially this lady in the figured dress, with flowing hair and shade-hat with long limber feather. All came safe, and when I have explored them (I may be deliberate about this), I shall be restoring them to you. The wormholes, above all, belong in a collector's tower. Do not make me a criminal.

When Cornell applied for a Guggenheim grant, Miss Moore warmly supported his petition, writing on September 19, 1945, that she regarded him as a virtuoso. "His use of early masters and engravers, the sense of design in his wall-paper specimens,

86 Untitled heliogravure, 1972

and of romance in his choice of woodcuts, his consistent rigor of selection, constitute, it seems to me, a phase of poetry." Like Duchamp and Mondrian, Miss Moore regarded Cornell as something of a poet. Her praise remained ensconced in his imaginary dossier of those who understood him, and occasionally he would, with genuine diffidence, recall his correspondence with her.

Another of the writers Cornell approached by mail was Susan Sontag. Cornell had cut out her photograph on a book jacket, as he often did, and composed a work around it. Dark-eyed and romantic-looking, Sontag attracted Cornell visually as well as intellectually. She responded and entered into an intermittent correspondence with him. For about two years he continued to send little messages and collages. Finally he telephoned and invited her to Utopia Parkway, where he gave her one of his boxes. Later he gave her other works, including his André Breton homage, but, characteristically, asked her to return some of them about a year later. No gift from Cornell was ever permanent, but was rather like a calling card, or a child put out for temporary adoption.

Cornell's sporadic sorties into the art world, and his occasional hunger for the company of other artists, were probably not nearly so important to him as his secret family of artists of the past. He drew on many sources for his images, ranging from Italian Renaissance masters to Holbein, but his greatest and most consistent inspiration was Vermeer. Here resided a true affinity, not merely an archivist's source of imagery. Gozzoli, Moroni, Piero di Cosimo, and others provided Cornell with touchstones, but Vermeer was the remote friend whose sensibilities matched his own. He was probably, as Cornell once wrote to a living friend, "gyroscopic" in Cornell's life.

The obvious parallels can be drawn rapidly, although the deeper connections remain inaccessible. On the immediately visible level, there is Vermeer's basic form—the box. The box is glassed. We peer into it and see yet another glass, for Vermeer rarely failed to show us the window on the left side of his

A phantom window
photographed by Terry Schutté

painted enclosures. The rooms (or room, for there is a proto-
typical room in which all of Vermeer's quiet reveries are housed)
are graced with reflecting surfaces such as pictures, brass objects,
glass, and mirrors. The mirror is almost always present, if only
implied. In the Dresden *Young Woman at the Window* the
window is the mirror, and the phantom image of the reflected
woman is the focal point of the painting. Cornell's interest in
these phantom reflections was well known. He owned a snap-
shot of such a window, mirroring forth the fugitive features of
a young girl, which he sometimes showed to friends. It is the old
theme of the double, the other, the second life so well ensconced
in Cornell's imagination. Still more familiar, perhaps, is Ver-
meer's way of placing his mirrors in sharp perspective on the
left wall, so that only their frames can be seen. In the superb
Berlin *Pearl Necklace* a woman faces the left wall, on which
Vermeer indicates both a leaded window and the frame of a
mirror. Vermeer creates a vast space between the woman and
the mirror, yet the real space she occupies is clearly a very narrow
strip between the back wall and the invisible glass curtain through
which we are privileged to regard her. In countless boxes Cor-
nell lined the narrow inner walls with mirrors, or fragments of
mirrors. He obeyed the injunctions of what art historians call
the "crystalline" composition of Vermeer, suggesting an idealist,
Pythagorean tradition to which he and many nineteenth-century
Symbolists were drawn. Finally, Vermeer's attitude toward ob-
jects, which he introduced with a surpassing care, appealed to
Cornell. The exceptional beauty of Vermeer's favorite objects
with their specific lusters is not the subject of his paintings.
Vermeer, unlike his contemporaries, stressed the hidden rhymes
among his objects. No single brass tack or pearl or glass can be
said to be the source of Vermeer's compositional intention, for
they are all carefully chosen elements in an overwhelming
reverie of contemplation. The effect, not the object itself, is
Vermeer's offering to art, and it is this that distinguishes him
from the other *petits maîtres* of the Netherlands.

The imagery Cornell derived from his experience of Vermeer

Vermeer: *Young Woman at the Window*

Chocolat Menier, 1952

was of quite another order than that obtaind from other old masters. It emerged from the deepest level, just as the imagery derived from his experience with poets was rarely conscious. When he composed a box incorporating a label for Chocolat Meunier, he almost certainly remembered that Emily Dickinson had composed a poem on the back of a Chocolat Meunier wrapper. If in his *Hôtel* series he included the Hôtel d'Angleterre and the Hôtel du Nord, it is probably because he was musing about Hans Andersen who was known to have made his headquarters in those two Copenhagen hotels When he does a hotel box such as *Hôtel Bon Port* and includes in the title "for Ann," the image of Ann of Oxford Street was surely floating behind the visible evidence of his associations. Similarly, when he used old Baedeker maps as background for his tableaux, in his mind's eye there reposed Vermeer's many paintings in which the back wall is adorned with maps.

Certain of Cornell's props were as germane to his creation as certain words that recur with talismanic frequency in his favorite poets. Possibly as early as 1934, in the *Soap Bubble Set* at the Wadsworth Atheneum, the basic props for numerous future boxes were present. Cornell himself called the Hartford box "a real 'first-born' of the type of case that was to become my accepted milieu." In this prototypical box there are four weights hanging at the top, a narrow compartment to the left containing a wineglass holding an egg, and another to the right with a column bearing a child's sculptured head. In the center is a shelf holding a clay pipe and, on the back wall, a geological map of the moon.

From conversations with Cornell and published interviews, it is possible to adduce many associations adhering to the clay pipe. In the Wadsworth Atheneum box, the first and most durable association is established by Cornell's inclusion of the head of a child. Although in later versions the effigy of the child disappears, Cornell nevertheless continued to associate clay pipes with his earliest childhood memories. He was given to autobiographical hinting. His own childhood in Nyack, in a nine-

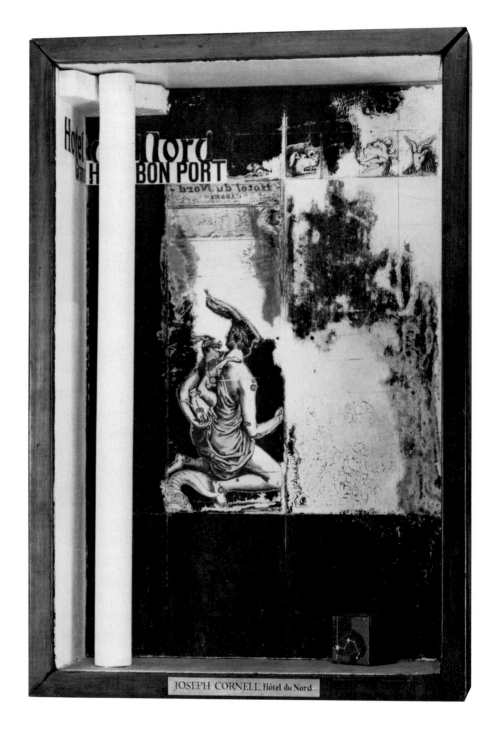

92 *Hôtel du Nord*, ca. 1953

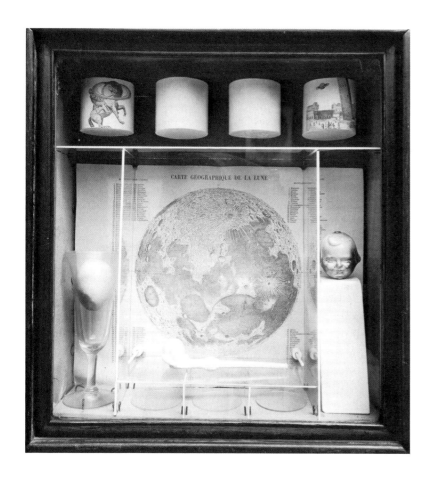

teenth-century house overlooking the Hudson, frequently came back to him in the form of memories of harmonious play on a sweeping lawn, of picnics, of the cast-iron deer on the lawn in the morning mist (which he commemorated in a collage called *Nyack 1910*), and, in general, of a lost paradise. Soap-bubble pipes meant childhood. But they also meant soap bubbles, which for Cornell symbolized cosmic reverie. One of his favorite books was *Soap Bubbles, Their Colours and the Forces Which Mold Them* by C. V. Boys. The first edition in 1911 contained wonderful old steel engravings and an introduction that Cornell deeply enjoyed: "You cannot pour water from a jug or tea from a tea-pot; you cannot even do anything with a liquid of

Soap Bubble Set, 1936

93

any kind, without setting in action the forces to which I am about to draw your attention."

Other associations bestirred for Cornell by the clay pipe were connected with his Dutch ancestry. For him the clay pipe was a memento of the old Dutch settlement of New Amsterdam. The fact that it had to be a *Dutch* clay pipe to satisfy his reverie is confirmed by his answer to a child who asked about the pipe, and to whom he related his delight in finding a *real* Dutch clay pipe at the 1939 World's Fair. His great concern was always to keep his shoebox treasure-chests filled with the specific talismans he needed. In his last years he complained that it was difficult to find what he required, since everything was made of plastic— which has no past. When he did find something important, such as a supply of old watch faces, he bought them in bulk and carefully stored them for future use.

Other necessary props appear in one of his most frequently discussed and reproduced boxes of the early 1940s, the *Medici Slot Machine*. Along with the *Portrait of a Young Prince of the Este Family* by Moroni, an image he used frequently thereafter, there are spheres, a compass, and a spiral, all repeatedly presented in other works, as well as a child's jacks. Mirrors line the side walls and lower compartments. The tinted glass is traversed by black lines suggesting the sighting devices of astronomers. And the side panels use repeated images in the manner of filmstrips. Here Cornell's vocabulary for a whole vein of his subsequent work is set out, and it was to vary little in the future. Only the *effects* vary.

Props and effects are both necessary in the unfinished "other life" of Cornell's dream. They are inevitably the products of a mind musing on certain abstract themes. Often they are the themes mined from his intimacy with the poets. While many twentieth-century artists have dealt with the notion of the void, of nothingness, of empty space, Cornell's treatments are more specifically characterizations of *absence*. There is a vast difference between emptiness and absence, and it is this difference he sought to portray in such haunting works as the 1949 *Deserted*

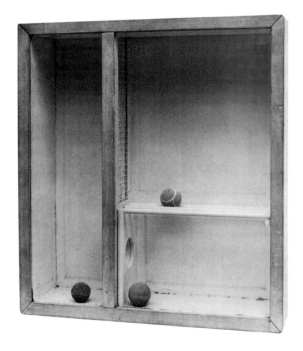

The Cage, undated

Perch. The box is suffused by a thin atmosphere of abandonment. Faded newsprint on the cracked and scarred back wall bespeaks the past. The laddered side wall tells us of a dovecote, and on the upper corner, the suspended spiral invokes past time, whose quivering has been stilled only a moment before. The spiral in this, and others of Cornell's boxes that incorporate spiral forms, is simply the steel spring of a clock, but in Cornell's system of associations it goes beyond mere measured time. If the atmosphere itself is not enough to suggest an abandoned place in another time, there is a wispy feather on the floor. The absence alludes—as does Dickinson when she writes to her cousin John of "an empty house in which a bird resided,"[41] and Nerval when he speaks of the sudden flight of a wild swan in *Sylvie*—to another time. Not a vacancy in time, but rather a flow of events that at the very moment the artist stops to recall them ceases and gives way to the seething *Rien*, that symbolic Nothing so filled with activities of the spirit, as in Mallarmé's poem, that it becomes Everything.

Throughout his works, Cornell thematically pursued his pre-occupation with time. There are specific allusions in many of the boxes and collages. Watch faces and clock springs abound, as do glasses and sand. In a number of boxes, colored sand literally runs into a goblet and overflows when turned. Cornell's repeated use of a wineglass in connection with sand recalls Mallarmé's recurrent allusions to the *coupe*, the *verre*, and the *vase*, vessels in which Time and Art pursue each other into the Void. For Cornell, reflecting surfaces with their connotations of mirrors always meant an immersion in the slow spill of time.

> RIEN, cette écume, vièrge vers
> A ne désigner que la coupe

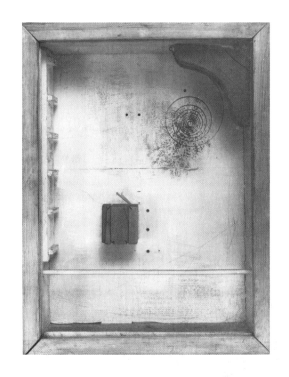

—

[41] "You remember the crumbling wall that divides us from Mrs. Sweetser—and the crumbling elms and evergreens—and *other* crumbling things—that spring, and fade, and cast their bloom with a simple twelvemonth—well—they are here, and the skies fairer far than Italy, in blue eye look down—up—see!—away—a league from here, on the way to Heaven! . . . Much that is gay have I to show, if you were with me, John, upon this April grass—there there are *sadder* features—here and there *wings* half gone to dust, that fluttered so, last year—a mouldering plume, an empty house, in which a bird resided. . . ."

Deserted Perch, 1949

Montage of
Cornell signatures

NOTHING, this foam, a virgin line of poetry
Only to describe a champagne glass

Cornell's incantatory use of his objects to allay the effects of time is in the purely Symbolist mode.

In his earlier works, Cornell's backward glances bring us directly to the specific time he cherished. Even the titles were descriptive. For example, in a small antique container—perhaps once a powder box—he places such strips of suggestive text as "I saw in the castle" or "a candle in his hands," and calls it *Mémoires inédites de Mme la Comtesse de G. sur le dix-huitième siècle*. When the box is handled—at it was meant to be—the mounted strips of text slide, and other tantalizing fragments from the countess's unpublished memoirs emerge, incorporating time within the act of perception to evince Time. In 1940 Cornell fashioned his ambitious homage to a prima ballerina of the 1890s, *L'Égypte de Mlle Cléo de Merode*. Set in a solid oak box, perhaps a nineteenth-century writing box, the work consists largely of twelve corked bottles containing such substances as rose petals,

Soap Bubble Set, 1948

shells, and pigments. A red jar is labeled "*temps fabuleux*" (fabulous times), and a purple jar "A thousand and one nights." Beneath the glass floor supporting his offering, Cornell has strewn red sand that slides suggestively at the merest touch. The principle of the inventory of associations with nineteenth-century delights is carried out again three years later in *Museum*, where Cornell aligned fifteen glass containers in a sturdy box, each one holding a clue, such as pink powder, tiny seashells, or fragments of colored glass. This time the corks are shrouded in slate-black cloth, suggesting their expiration in time, but also the direct increment of mystery. (Still another possible association is with photographs of shrouded objects by the American Surrealist Man Ray, with whom Cornell exhibited at the Levy gallery.) These, and the celebrated *Homage to the Romantic Ballet* of 1942, which includes a legend about Taglioni on its inside cover, are Cornell's specific citations of other times. Later, in the 1950s, his references to the past are more oblique but always present.

Time plays its role even in those of Cornell's works that indicate his interest in Nature—a genuine interest that led him to press flowers, collect feathers, and feed birds. His attitudes expand to incorporate the germs of the past, gathering up the views of that century that spawned *Naturphilosophie*. Almost an entire exhibition at the Egan Gallery, bearing the general title *Aviary*, incorporated echoes of time. In addition to the jigsaw images of parrots, parakeets, and cockatoos, Cornell nearly always included one of his standard symbols for time, such as the spiral clock spring. Several of the boxes contained mementoes from his imaginary travels in the form of antique hotel advertisements. Others were equipped with real drawers that could be pulled out. A drawer, like a coffer, jewel case, or chest, is always a reference to enclosed memories of pastness, as the critic and philosopher Gaston Bachelard has so eloquently remarked. In Cornell's boxes, the drawers contain souvenirs and fragments of printed materials that always carry connotations of a time run out, a time to be recovered. The birds installed above these drawers seemed to bestir Cornell's reveries and were inextricably

L'Égypte de Mlle Cléo de Merode Cours Élémentaire d'Histoire Naturelle, 1940

bound to his obsession with the lamination of time—time of the seasons as well as that of the psyche.

It is true that in the bird boxes he begins with his experience of real birds. Not the gorgeous cockatoos, but the humble city birds that fed in his diminutive garden. He soon gives way, however, to reverie, and invests his birds with the symbolism provided by his long immersion in poetry. Cornell's birds have nothing of the monstrous potential suggested by Max Ernst. In the *Femme 100 Têtes* album there are several such menacing images, which Cornell certainly studied. But Cornell's metaphors tended to be simple and direct. The sphere representing birds in his most abstract works in the *Dovecotes* series is no more than a reduction to essence, there being no creature in nature more nearly round than a small bird. When his other metaphors call up more complex traditions, they are always to be traced to his nineteenth-century sources. Using the bird to connote absence, as he does in both *Chocolat Meunier* and *Deserted Perch*, is in the time-honored nineteenth-century tradition. Even more, Cornell's obsession with Malibran and her bird-song, which to his permanent sorrow can never be truly retrieved, stands behind his aviary works. The once-in-a-lifetime experience that lingers in Cornell's lost Atlantis hovers behind the coulisses in the bird boxes. His articulation of this shadowy experience is necessarily oblique, as oblique as the Mallarmé poem that nearly parallels it in the first two verses, *Petit Air II*:

Indomptablement a du	Indomitably had to
Comme mon espoir s'y lance	As my hope hurls itself
Eclater là-haut perdu	Burst up there lost
Avec furie et silence.	With fury and silence.
Voix étrangère au bosquet	Voice foreign to the grove
Ou par nul écho suivie	Or followed by no echo
L'oiseau qu'on n'ouit jamais	The bird one never heard
Une autre fois en la vie. . . .	A second time in life. . . .[42]

[42] Wallace Fowlie translation, in *Mallarmé* (Chicago: University of Chicago Press, 1953).

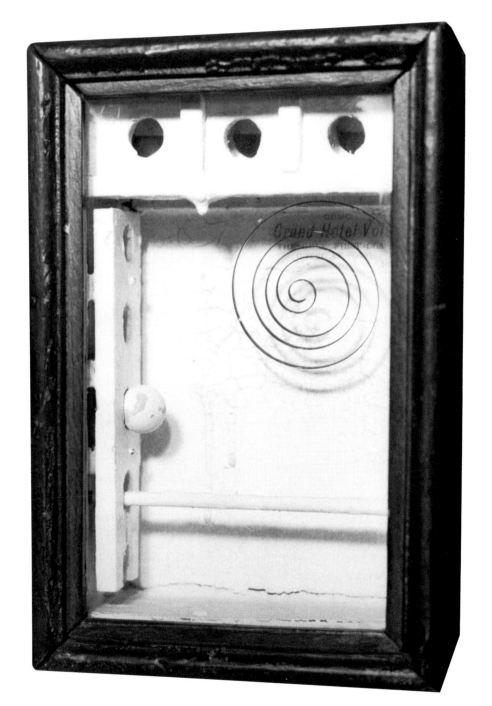

Terry's Colombier, ca. 1964,
front and back

When Cornell was not using nature references to allude to time, he drew upon the quick associations any romantic would have with playbills, advertisements, and old pages from Baedeker guides. Displacement, both psychologically and in real time, is his object in such collages as *L'Abeille*, in which the soaring gull is associated with one of his favorite hotel insignia, or his other reference to *L'Abeille*—the collage with the "Mail-Coach to Waterloo" advertisement. Still another cross-reference may be suggested in the idea of the mail coach that one of Cornell's "family" authors, Thomas De Quincey, celebrated in his essay "The English Mail-Coach." All such collages and boxes pay tribute to Cornell's obsession with the past.

He devised simple and ingenious techniques to do the work of time. In his cellar studio he carefully tinted old newspapers. He gessoed the back walls of his boxes and then took them up to the kitchen oven to bake, patiently awaiting the cracking produced by the heat. He dyed the sides of his boxes and blotted

102 *L'Abeille (pour Jacques Brel le Magnifique), 1966*

them pale, making liberal use of paint-remover to erase the bloom of freshness and leave only the melancholy traces of once robust colors. When he used texts from antique books to paper the sides and backs of his boxes, he took great care to show their jaundiced age. While he often permitted his assistants to paint or tint the interiors of his boxes, he always worked the backs himself, sometimes over a period of years. The hints and clues these rear images contain were as important to him as the interior image. So were the signatures, often rendered in mirror writing. These signatures were kept in a cardboard box, labeled as were the boxes full of watch faces, cork balls, or flotsam. The actor in Cornell, the "other," tried each signature as though it were a mask. (Curious that his ancestral friend Emily Dickinson may have had the same habit, judging by the fact that when she began writing to the critic Higginson, she did not sign her letters but enclosed a small envelope with her penciled signature.) Cornell's signatures varied considerably. At times they resembled the leisurely hand of the ancestors, at others they were a brisk modern flourish. He tended to emphasize the calligraphic value of his signature, as though the two identifications—with the past and with the present—were of substantially different natures. On the occasions when he included a date, it was often accompanied by a cryptic reference to the significance of the particular day or the circumstance that had released the imaginative act. Sometimes he would retrieve one of his works from the world and remove the date, to the great consternation of cataloguers.

His calendar was of a different order from the world's. Imbued with Kepler's vision of the harmonious universe, he sought to make the two basic measures of human time—night and day— into an intuitive statement of the cosmos. Night he commemorated in those works of the 1950s that allude to observatories, constellations, and the abandoned lobbies of mythologized hotels. Day he celebrated in a large set of variations on the sun. His 1950 exhibition at the Egan Gallery was titled *Night Songs and Other New Work*, perhaps a reminder of his affection for

L'Abeille-Enseigne I, ca. 1966

103

Both sides of *Hôtel des Voyageurs*
(for Nikki Thiras), ca. 1966

Novalis's *Hymns to the Night*. Throughout the 1950s, Cornell returned repeatedly to the cold, galactic skies of the poet. Spare, crisp images of white pilasters against midnight-blue skies recur, as do darkened windows—apertures of the soul through which expansive mysteries move off into infinity. Cornell's obsession with windows was enacted intensively in these years. He sought photographic images of darkened windows, preferably with the hazy lineaments of some person or thing behind. He admired the French photographer Atget, and occasionally asked friends, such as the photographer Terry Schutté, if they could make photographs through closed windows. In the night skies series, there are repeated references to the reflecting window, with its illusory cargo of stars and constellations. No astronomer could have fully encompassed these meditations on the skies.

Cornell's preoccupation with constellations led him to foraging expeditions to second-hand bookstores where he might find books with old astronomers' charts that could be extracted and enlarged in photocopies. He also sought cheap children's editions on the stars, which he would cut up, affixing fragments here and there on the backs of collages, in the corners of his boxes, and on the margins of letters to friends. The nature of his explorations of the night skies within his works leads to associations remote from the visual arts. Rather, Cornell was interested in the metaphorical order nourished by Mallarmé, who pondered the wonders of the celestial theater even in his early work. Numerous allusions to the constellations appear before the heroic attempt in *Un coup de dés* to parallel the logic of the constellations. One associates Cornell's exceptional spareness in the night boxes with Mallarmé's vision. "The poem," Mallarmé wrote to André Gide in 1897, "is now being printed in the form in which I conceived of it, including the pagination, which will be its true originality. Certain words in large type will need an entire blank page. I am sure it is going to be very effective. The constellation, obedient to the strictest laws, will move as fatefully as constellations do— at least insofar as it can be in a printed book. . . ."

One can envision Cornell treating a single form, such as a

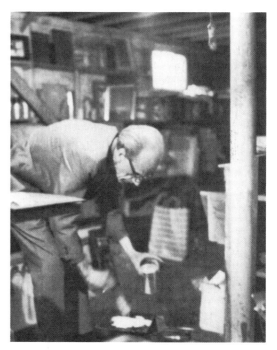

Two views of Cornell's workshop
and Cornell at work

gleaming white column in the middle distance of one of the
night boxes, as Mallarmé treated certain words in large type
that needed an entire blank page. The quality of white, and the
space it created, was of great importance. He took care to assure
the precise quality of reflection. As early as 1938, when the
Wadsworth Atheneum had just acquired his *Soap Bubble Set*,
the first work of his to enter a museum, Cornell wrote to the
director: "A great deal of its effectiveness depends, I think, on
the shining whiteness of the paint. I applied at least six coats of
the best enamel obtainable, and under glass it will retain its
lustre indefinitely."

Although Cornell was engrossed in the total effect of his night
images, he made use of the associations clustered around specific
constellations, and had certain favorites such as Cassiopeia, the
mother of Andromeda, who was banished to the northern skies
and is known as the Lady of the Throne or of the Chair. An ex-
hibition at the Stable Gallery in December 1955 titled *Winter
Night Skies* celebrated Auriga, Andromeda, and Cameleopardalis

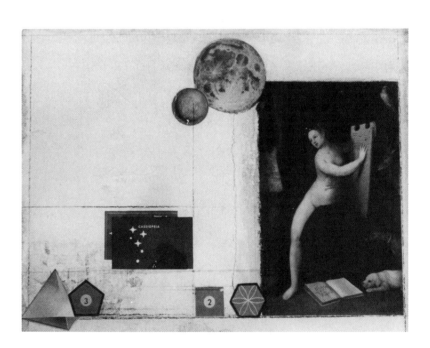

Cassiopeia (Dosso Dossi), 1966
(Part of the *Mathematics in Nature* series)

108

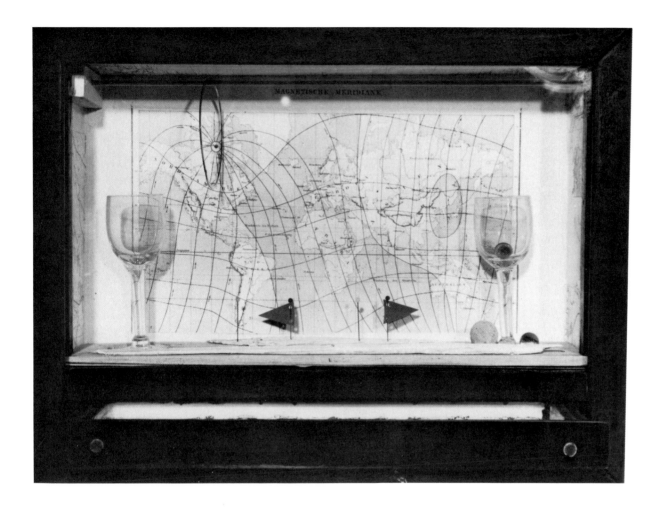

among others. For the catalogue, Cornell selected a text to set
his viewers musing:

The mythology of Auriga is not clear, but the ancients seem to
have been of one mind in regarding the constellations as repre-
senting the figure of a man carrying a goat and her two kids in
his arms. Auriga was also looked upon as a beneficent con-
stellation, and the goat kids were believed to be on the watch
to rescue shipwrecked sailors. As Capella, which represents the
fabled goat, shines nearly overhead in winter, and would
ordinarily be the first bright star to beam down through the

Trade Winds Storm Warning, 1958

breaking clouds of a storm at that season, it is not difficult to imagine how it got its reputation as a seaman's friend.

Auriga as a constellation, was invented long before the time of the Greeks, and was intended prophetically to represent that Good Shepherd who was to come and rescue the sinful world.

"Astronomy with an Opera-glass"—GARRETT P. SERVISS

As Cornell said in his 1948 statement, he associated the soap bubble with the movements of the cosmos ("The fragile, shimmering globules become the shimmering but more enduring planets—a connotation of moon and tides—the association of water less subtle . . ."). His night skies, with their star charts and wind or tide charts, form a natural continuation of this earlier preoccupation with soap bubbles. On occasion, the deep blue of the night skies series was combined with the Dutch clay pipe, the wineglasses, and bits of flotsam painted gleaming white, catching up his old symbols in his new intuitions of the universe.

Cornell's day, like his night, carried him to the skies. The smiling tin sun dominating so many of his later boxes beams down on an unending universe of natural and cosmic symbols: cork balls (spheres, bubbles, the cosmos) and sliding brass rings that imply the movement of time. Fragments of colored sky

Sun Box, 1960s

charts appear regularly, as does his special device for suggesting imaginary voyages, the freshly minted exotic postage stamp. (Cornell used to buy glassine envelopes full of foreign stamps for use in his boxes. Sometimes he would send a batch of some fifty such stamps to the children of his friends.) Instead of the sharp blue of winter, these day-boxes were often composed in sparkling whites and yellows. Yet the natural cycle is always preserved as Cornell carries over the same images from one box to another.

Central to Cornell's *oeuvre* is the idea of repetition. His repetition is not the intellectualized notion of serialization, but more like the ritual repetition of the alchemist. His constant reiterations of themes, by means of his chosen objects, are like Mallarmé's reiterations of crucial words—like the unwritten Book to which all Mallarmé's thoughts gravitated. Cornell began and ended with his Dream, and his dream, as he found confirmed by Freud, was always in an unfinished state. He saw himself as an "explorer" of the mysteries of the universe. Of all the articles written on him, there was only one that Cornell unreservedly approved, and that was by Fairfield Porter who had caught the right tone.[43] Porter quotes Albert Beguin on Nerval: "Like all true poets, he invites us to see things in a light in which we do not know them, but which turns out to be almost that one in which we have always hoped one day to see them bathed." He says of Cornell: "He implies nature through its effects, the effect of time, another human abstraction, or of number, with a suggestion of vast distance and quality. So far is the distance (astronomical), so great is the number of grains of sand (impractical to count), so many the combinations of those numbers as the box is shaken. . . ." Porter concludes, "Infinity, in short, is not a matter of physical size."

Cornell saw himself in these terms, the terms of the nineteenth-century Symbolist.

[43] Fairfield Porter, "Joseph Cornell," *Art and Literature*, no. 8, Paris, Spring 1966.

FOUR

POEMS FOR CORNELL

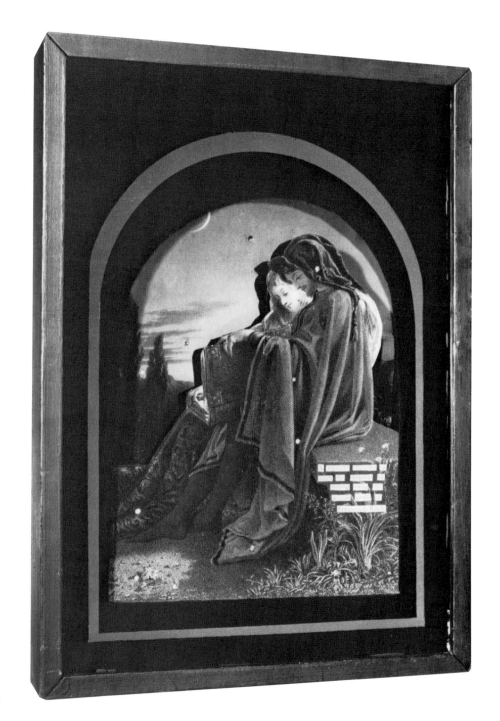

114 *Francesca da Rimini,* 1940

Objetos y Apariciones

A Joseph Cornell

Exaedros de madera y de vidrio
apenas más grandes que una caja de zapatos.
En ellos caben la noche y sus lámparas.

Monumentos a cada momento
hechos con los desechos de cada momento:
jaulas de infinito.

Canicas, botones, dedales, dados,
alfileres, timbres, cuentas de vidrio:
cuentos del tiempo.

Memoria teje y desteje los ecos:
en las cuatro esquinas de la caja
juegan al aleleví damas sin sombra.

El fuego enterrado en el espejo,
el agua dormida en el ágata:
solos de Jenny Lind y Jenny Colon.

"Hay que hacer un cuadro," dijo Degas,
"como se hace un crimen." Pero tú construíste
cajas donde las cosas se aligeran de sus nombres.

Slot machine de visiones,
vaso de reencuentro de las reminiscencias,
hotel de grillos y de constelaciones.

Fragmentos mínimos, incoherentes:
al revés de la Historia, creadora de ruinas,
tú hiciste con tus ruinas creaciones.

Teatro de los espíritus:
los objetos juegan al aro
con las leyes de la identidad.

Grand Hotel Couronne: en una redoma
el tres de tréboles y, toda ojos,
Almendrita en los jardines de un reflejo.

Un peine es un harpa
pulsada por la mirada de una niña
muda de nacimiento.

El reflector del ojo mental
disipa el espectáculo:
dios solitario sobre un mundo extinto.

Las apariciones son patentes.
Sus cuerpos pesan menos que la luz.
Duran lo que dura esta frase.

Joseph Cornell: en el interior de tus cajas
mis palabras se volvieron visibles un instante.

CAMBRIDGE, MASSACHUSETTS
A 12 DE ENERO DE 1974

OCTAVIO PAZ
TRANSLATED BY
ELIZABETH BISHOP

Objects and Apparitions

For Joseph Cornell

Hexagons of wood and glass,
scarcely bigger than a shoebox,
with room in them for night and all its lights.

Monuments to every moment,
refuse of every moment, used:
cages for infinity.

Marbles, buttons, thimbles, dice,
pins, stamps, and glass beads:
tales of the time.

Memory weaves, unweaves the echoes:
in the four corners of the box
shadowless ladies play at hide-and-seek.

Fire buried in the mirror,
water sleeping in the agate:
solos of Jenny Colonne and Jenny Lind.

"One has to commit a painting," said Degas,
"the way one commits a crime." But you constructed
boxes where things hurry away from their names.

Slot machine of visions,
condensation flask for conversations,
hotel of crickets and constellations.

Minimal, incoherent fragments:
the opposite of History, creator of ruins,
out of your ruins you have made creations.

Theater of the spirits:
objects putting the laws
of identity through hoops.

The "Grand Hotel de la Couronne": in a vial,
the three of clubs and, very surprised,
Thumbelina in gardens of reflection.

A comb is a harp strummed by the glance
of a little girl
born dumb.

The reflector of the inner eye
scatters the spectacle:
God all alone above an extinct world.

The apparitions are manifest,
their bodies weigh less than light,
lasting as long as this phrase lasts.

Joseph Cornell: inside your boxes
my words became visible for a moment.

CAMBRIDGE, MASSACHUSETTS
12 JANUARY 1974

Pantoum

Homage to Saint-Simon, Ravel,
and Joseph Cornell

Eyes shining without mystery
Footprints eager for the past
Through the vague snow of many clay pipes,
And what is in store?

Footprints eager for the past.
The usual obtuse blanket.
And what is in store
For those dearest to the king?

The usual obtuse blanket
Of legless regrets and amplifications
For those dearest to the king.
Yes, sirs, connoisseurs of oblivion.

Of legless regrets and amplifications,
That is why a watchdog is shy.
Yes, sirs, connoisseurs of oblivion,
These days are short, brittle; there is only one night.

That is why a watchdog is shy,
Why the court, trapped in a silver storm, is dying.
These days are short, brittle; there is only one night
And that soon gotten over.

Why the court, trapped in a silver storm, is dying!
Some blunt pretense to safety we have
And that soon gotten over
For they must have motion.

Some blunt pretense to safety we have:
Eyes shining without mystery
For they must have motion
Through the vague snow of many clay pipes.

CA. 1953

Time Transfixed, ca. 1964

The Crystal Cage

for Joseph Cornell

To climb the belltower,
step after step,
in the grainy light,
without breathing harder;
to spy on each landing
a basket of gifts,
a snowbox of wonders:
oranges, plums, pieces
of colored glass,
a postcard from Niagara Falls,
balloons, the Southern Cross,
child Mozart at the clavichord,
or is it your twisted brother?
Three days you fasted
to bring you angels;
your square-toed shoes,
friends of your plodding,
are turning weightless.
When the pear-shaped, brindled cat
who lives under the belfry
jumps into your arms
you are not surprised
by the love-look in her amber eyes,
or by the blissful secrets
she confides to you

in oval, pellucid tones.
What if the iron overhead
suddenly starts pounding?
What if, outside,
a terrible storm is raging?

The Crystal Cage
for Joseph Cornell

To climb the belltower,
step after step,
in the graining light,
without breathing harder;
to spay on each landing
a basket of gifts,
a snowbox of wonders:
oranges, plums, pieces
of colored glass,
a postcard from Niagara Falls,
balloons, the Southern Cross,
child Mozart at the clavichord,
or is it your twisted brother?
Three days you fasted
to bring you angels;
your square-toed shoes,
friends of your plotting,
are turning weightless.
When the pear-shaped, brindled cat
who lives under the belfry
jumps into your arms
you are not surprised
by the love-look in her amber eyes,
or by the blissful secrets
she confides to you
in oval, pellucid tones.
What if the iron overhead
suddenly starts pounding?
What if, outside,
a terrible storm is raging?

Stanley Kunitz

Kunitz collage 123

RICHARD HOWARD

Closet Drama

An Aporia for Joseph Cornell

Any apartment lobby is a necropolis,
every dresser drawer a forbidden city—
so much you taught me, intimated, warned:
colors are trite, edges not to be trusted,
textures, behind glass, refuse to explain
a world where fate and God Himself have grown
so famous only because they have nothing to say.
The tiny is the last resort of the tremendous.

Toy towns, I guess you could call them, where
the toy has at last outgrown the child and faced
up to, or down, the fakery of its own function:
once it accommodates evil (by which I mean
change, others, time) the toy becomes art,
an idol. And we are all idolators, Cornell.
You made it seem easy enough to try. I tried
to worship with you, twenty years ago:

TO OBTAIN COLD WATER TURN HANDLE
INDIFFERENTLY TO LEFT OR RIGHT Now
this, I fancy, must be the sea, or
what you call the sea in such parts,
not having been, as you tell me, to
Brighton. For the ORGAN OF CORTI,
see under CORTI, as one might well

believe. Likeminded, our hostess
displayed her curious rash in a room
where His Eminence invariably slept.
At which he drew his sword, stabbing
as if to kill me, crying "Mad!" Oh I
screamed, of course, but the portals
closed ever so firmly upon him, his
shadow Never To Be Seen Again . . .

 No,

your method was no help to me, I lacked
the sustenance of legend, subject things
implicit in our lives so long that they turn
beautiful: a ball, a chart, the binding of
a smuggler's bible, the complacent zeal
of ivory opera glasses. Even in absence
these totems persist, persuade. The tombs
of temple prostitutes are object lessons,

and you have learned them: to the living, without
definition, but to you, each a thing in itself,
pregnant with sudden meanings, evidences of
the only god whose name we know, Mutation.
I cannot speak, while you can only show
the way to silence, wonder, awe. Voices die
out of place—writing happens to happen in time.
In your boxes, Cornell, time happens: there.

In Cornell's workshop

FOUR

HOMAGES FROM CORNELL

Fanny Cerrito

From a Special Issue of
Dance Index, July–August 1944

Designed and Edited
by Joseph Cornell

The San Carlo Theatre of Naples where Cerrito made her debut, 1835, in "L'Oroscopo."

But at Milan it was another story. The divine Taglioni and Mlle. Ceritto took turns dancing at La Scala. Here was something to really get worked up about. The enthusiasm shown night after night surpasses the powers of the imagination, and I shall resist the temptation of describing it before seeing it. The firm structure of the hall attests the highest tribute to its architect, for it has withstood the most dreadful ordeals of this dilletantism during three whole months. Fortunately it all happened in Northern Italy where the German influence may have contributed a degree of restraint.

At Florence the public was divided between two dancers, one tall, the other petite. It was another war of the Montagues and Capulets. Bouquets gave place to super-bouquets, then wreaths, and there was apprehension lest the two subjects perish—smothered under a deluge of flowers. Luxury ran riot; a follower of the tall dancer threw silver-wreathed leaves. Friends of the smaller hurled leaves of gold. One evening a bundle all tied up landed on the stage: it was a velvet robe. Nothing daunted the other faction answered the next evening with a Cashmere shawl. It was already rumored in the city that a certain lord baron, leader of one group, was conniving ways and means of letting in upon the proscenium a four horse coach with driver, which doubtless would have been countered with an actual castle complete with turrets and moats. The end of the dramatic year put a stop to this magnificent crescendo.

Paul De Musset *"Voyage en Italie,* (*ca.* 1943)

120

Fanny Cerrito

In the course of the renaissance of ballet in recent years at least two books apiece have been devoted to each of those dancers who form what is generally regarded as the triumvirate of the Romantic Ballet,—Taglioni, Elssler, and Carlotta Grisi. None about Cerrito. But perhaps to some her youthful naiad figure may have emerged distinct from the shadows of her sister ballerinas; indeed, to us with such vividness and conviction as to come to life in the present in such a way as to transform many a common place experience with an unexpected and overwhelming measure of her gracious art.

Limitations of space allow the presentation of but a fraction of a boxed homage-album to this dancer, eventually to house, besides a modern treatment, a museum of contemporary descriptions, action poses, portraits, press notices; "compensation" costume fragments, photographs, "reconstructed" memorabilia, etc. Museum excerpts only are presented here.

> To conjure, even for a moment, the wistfulness which is the past is like trying to gather in one's arms the hyacinthine color of the distance.
>
> The past is only the present become invisible and mute; and because it is invisible and mute, its memoried glances and its murmers are infinitely precious. We are tomorrow's past. Even now we slip away like those pictures painted on the moving dials of antique clocks—a ship, a cottage, sun and moon, a nosegay. The dial turns, the ship rides up and sinks again, the yellow painted sun has set, and we, that were the new thing, gather magic as we go.
> **Mary Webb** from foreword to "Precious Bane."
> Jonathon Cape, London.

THE FRONTISPIECE portrait (inside cover) shows Fanny Cerrito between the years 1855 and 1860 and, it is easily possible, from new light shed on her career by Mr. George Chaffee in "The Romantic Ballet In London" (Dance Index—Vol. II, Nos. 9, 10, 11, 12), before her dancing days were over. This photograph falls exactly halfway between the Kriehuber lithograph above (1842) and the cartes-de-visites of Cerrito in retirement (1875) in the Harvard Theatre Collection.

. . . we should mention Francesca Cerito, whose début had taken place at the Scala, in Milan, and who owes her success to the famous pas de quatre, which she danced in London in company with Taglioni, Carlotta Grisi, and Lucille Grahn. No one carried farther than Cerito the love of her art. In order to preserve the graceful outline of her knees, she always slept in a certain position, with her feet strapped to the bed-post.

Magazine article by Rosita Mauri (1895)

Jerome Bonaparte

Louis Napoleon was taken sick at Compiegne, and for some hours the household were much alarmed. The chances of the possibility of establishing Jerome were earnestly canvassed, but the application of leeches saved us from that miserable realization. I will not undertake to say how many times the Emperor was shot at during his sojourn in the North; everyday brought forth some new revolver or infernal machine. The papers are never allowed to mention any illness or indisposition of the Emperor's, in the present tense. They are never permitted to say the Emperor *is* sick. When he has recovered, the intelligence is made public. So that those who are not in the way of hearing verbal news, learn of his convalescence before they heard of his being unwell. The *Moniteur* is less scrupulous when Jerome's maladies are concerned, and announced the other day, with a painful bluntness, that that gentleman was in bed with the grippe, and could not receive on Wednesday evening. He may have been too sick to see company, but he was not too sick to see Cerito, and was present at the *rentreé* of that delightful danseuse, in the new ballet of Orfa.

January 6th, 1853.

Typographical Note

Cerito, Cerrito, Ceritto, Cerritto, Cherito,—same person.

Mlle. Cerito in the Lithuanian??? (Pre-stroboscopic Vision)

Another illustration occurs in the history of Jedediah Buxton, the plowman, of wonderful arithmetical capacities. You might have given him the size of the circumference of a wheel, and he would have told you on the spot how many circumvolutions it would make in going round the globe. This was his only forte. In almost all other points he was deficient. As usual in England, they lionized the plowman. Among other places, they took him to the Opera. Upon inquiring what he thought of the celebrated dancer, he replied, "Wonderful! she danced . . . steps in so many minutes!" That was all that he had attended to; that was all that he remembered. The gracefulness, the attitudes, the science were all thrown away on him, and would be soon forgotten. Only in his own particular department of numbers, where his attention was stimulated by habit, did he see or remember anything.

Prefatory Observations to Mons. Zaba's Lecture on Polish Mnemonics by Frederick W. Robertson, M.A.

122

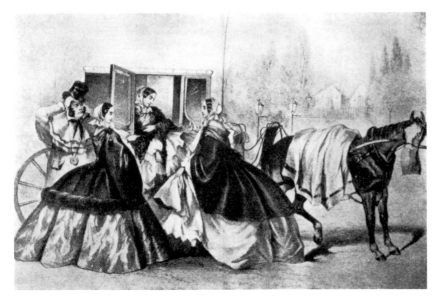

Carriages and Crinolines (Fanny Cerrito Album)

The thin faded pamphlet biography of Leopold de Meyer ("imperial and royal court pianist, by diploma, to their majesties the Emperors of Austria and Russia") states that in 1845 (the year of the Pas de Quatre) " 'new epithets were invented by the Paris *feuillitonnistes* to describe M. de Meyer's powers and peculiarities, and burlesque casts in plaster and lithographic caricatures were seen in every shop, more truly testifying his popularity and greatness than all the praises expended by the entire press.' It is in such waggish mode the wits of the French capital are wont to display their talents on those—and those only—of highest note. Witness their casts of Rossini, Paganini, and Berlioz."

But "keyboard lions" like Leopold de Meyer that flourished so abundantly in the Romantic era (Thalberg, Jaell, et. al.) left little with which to attach themselves to posterity. It is generally in old bound volumes of sheet music such as once graced the racks of Victorian pianos (the proud owners' names stamped elegantly in gold on marbleized board covers) that we stumble across their "creations" — transcriptions, arrangements, operatic pot-pourris, etc. Such is the case of the Pas de Quatre, passed off as de Meyer's own but which more correctly should have been designated as "transcrit et varié pour le pianoforte," as another of his arrangements was so marked. We are grateful that de Meyer left this curious souvenir of the apotheosis of the Romantic Ballet, for outside of the original Pugni manuscript in the British Museum it is possible that it is the only other record extant.

Inscribed in a Victorian hand at the beginning of the music,—"outrageously hard but perfectly lovely."

Note on de Meyer's keyboard style: "But in all this savage energy, there were moments, for what would it have been worth but for these —in which he tickled the piano into the sweetest and most dulcet harmonies, and tickled the souls of his hearers as they listened to him, out of their five senses—moments, in which wearied himself for the time by his previous labor, and prepairing himself for a new toil, he wove the most delicate melodies in with his music, and compelled you to hear and love him in spite of his fat, fleshy and sensual face, and unmeaning blue eyes. Scarcely, however, would you have begun to do so, than whack - slash - thump and bang came his hand down upon the keys, and all your gentler emotions were knocked upon the head, and indefinitely thrust out of your heart by that savage thunder.
"You Have Heard of Them" by Q.

Drawn from life by ANDRIEU, after the Lion gave his eighth Concert with extraordinary success at the St. Charles Theatre, New Orleans, April 1846

Maria

Published by Joseph Cornell, ca. 1954

THE magic splendour of a Southern evening sky in the month of May hung over * * * * and its charming neighbourhood. The landscape smiled, lighted alternately by the kisses of the most luxuriant spring and those of the mildest evening. . . .

★

Near this romantic city stood a country-seat, encircled by a blooming garden; a Spanish family had taken it for a few weeks. "A garden in Italy!" This thought fills our Northern fancy with pleasing emotion: pine-trees rustle, cypress-trees cast their shadowy veil over laughing flowers, in order to soften their burning colours; lemon and orange trees playfully drop their delicious blossoms upon the ground; the stately laurel gazes seriously upon their sport, whilst the lovely myrtle extends her delicate arms towards him with silent longing, and it seems as though tiny silver stars glittered amidst her sombre foliage. The voices of countless birds animate the odorous Paradise, and glittering butterflies, free and unfettered as thoughts of love, flutter in blissful intoxication from flower to flower.

In such a garden, lighted by the moonlight—which in this blessed land is a silver sunshine—lay a child, playing; she possessed the delicate and dreamy loveliness of an elf; her pure brow had been kissed by but six summers, but she was unusually thoughtful, and a strangely elevated light shone forth from her dark-brown eyes.

The solitary little one would smilingly heap up blossoms, bury her curly head in the soft perfumed pillow, rest a while and seem to dream, then, unwearied, commence anew her sport. The inquisitive butterflies flew near, wishing to taste caressingly the young lips that glowed as brightly as the proudest rose; the little birds seemed to know the fair little maid, for they hopped near and pulled her long brown locks with their tiny bills. The child looked on, half breathless with joy; she did not even seek to drive away the thirsty gnats, that sank their stings with an enchanted humming into the child's round, white arm.

It is true that the birds and flowers, the beetles and butterflies, the gay flies and the audacious gnats, were the child's playmates; she had no little sister, then, and her father and mother were but serious companions for the dreamy little elf; so the ever-beautiful world of blossoms and free, luxurious nature became the wise and beloved preceptors of the susceptible child.

When the last sigh of ardent Day had died away, Night approached with her light step; she gently breathed upon the flowers, and allowed the pearly tears of her eyes to trickle upon the pining leaves. Then resounded from the rich foliage of a lemon-tree a wondrously beautiful song. It was that of a nightingale, decked in her plain, gray, feathery dress.

How fortunate are we, also, in knowing this lovely little creature! She is like a sunbeam full of song, thrown from the glowing South into our Northern spring by the loving hand of God! Who, on hearing the name of "nightingale," does not imagine himself seated by the side of a hidden, gently murmuring brook that is densely shaded by drooping willows, the delicate tips of whose green fingers are refreshingly dipped into its cool waters? The moonlight trembles through the branches, as the wondrous song of the bird is wafted through the air. Then the closed heart opens, and inhales thirstily the magical silver tones; they fall like balm upon every wound, they heighten every joy; they bring sweet nameless sorrows and rapturous longing to the happy, and dreams of heaven to those whose every joy has vanished and whose every hope is dead.

The child trembled with delight at the tones, which she heard for the first time. The bird sang on, and the little girl's whole soul hung upon the voice, and soared and floated with it far away into the infinite.

All around was deep silence; birds and flowers blissfully sipped the precious drops of sound.

Do you know *whence* the nightingale, of all other birds, obtained this enchanting voice? "The nightingale once"—so related to me the little bird's beloved, a slight, charming rose-elf—"touched with her wings and breast the mighty, golden, gigantic harp of the great Creator of the world in the glorious Paradise. The chords rustled, the eternal harmonies sounded, welled, and streamed over the delicate creature; thence she received the heavenly, beautiful voice. She was not permitted to enjoy her precious gift, for God punished the curious one, and death accompanied the voice. She must sing and sing ever. It was impossible for the frail body to sustain the fulness, the mightiness, of these tones, and the poor bird faded, in the midst of life's bloom, in the midst of her loveliest melodies. The brilliant treasure descended through ages from nightingale to nightingale; but all sang, and died, like this first punished singer of Paradise.

"The All-merciful One, in his boundless compassion, has given a consolation to the nightingale race: they can *bestow* the dangerous stolen treasure upon a pure imploring child of man. Then they can live on in peace, they can enjoy their life; for, as the voice leaves them, death, the inseparable companion of the magic gift, departs.

"Such donations occur but seldom," playfully added the rose-elf, in conclusion, "for *we* love only the *singing* nightingales; the sly ones know this well, and prefer a short but intoxicating life of love to a long, soundless, unadorned existence." With these words the pleasing narrator, some-what fatigued, slipped into the calyx of a half-closed moss-rose, and reposed.

The listening child did not know of this legend; but the secret, magical power of the nightingale's song cast a spell upon this young heart: it beat wildly with happiness, presentiments, dreams, and hopes which the half-awakened soul of the child could not as yet comprehend. Her little hands were unconsciously folded in prayer, and tears flowed from the glittering eyes. "Oh," softly sighed the child, "would that I were such a singing bird!"

Ever more lengthened grew the heart-moving sounds, ever more seductive the wondrous song! The siren of the air drew her indestructible fetters ever more and more closely about those who lent an ear to the enchanting melodies. Suddenly the singer became silent; a melodious sigh, a restless fluttering, and the little bird fell dying at the feet of the terrified child. Weeping and astonished, she bent over the expiring one, and laid the little quivering body of the bird upon a bed of perfumed rose-leaves. Then a grateful glance flashed from the nightingale's half-closed eyes; the pitying child laid her blooming cheek upon the numbed body, and gently pressed her round rosy mouth upon the little bird's head. A breath touched her; it was a wondrously balmy breath, and she was forced to draw it deep, deep into her breast! How strange! As she sank upon the grass, it appeared to her that the nightingale, cured and merry, had flown away with a singular chirping. Then came charming forms; they covered the resting one with flowers, and cast golden wreaths of laurel upon her. It seemed to her that she had wings, and that she soared and sang as did the gray wondrous bird that she had kissed. Then the veil of unconsciousness spread itself over the feverishly excited being; and thus the seeking parents found their missing child.

Many years had passed since that May night. The icy hand of winter lay upon the warm heart of the earth, and a brilliant assemblage filled the Italian Opera-House in Paris. The rays of the dazzling chandelier fell flatteringly upon many a charming countenance, upon many a snowy neck; they were mirrored in beautiful eyes, and

glittered boldly in the countless dewdrops of diamonds, rubies, and emeralds which a fairy-hand seemed to have lavishly scattered over these fair mortal flowers. A joyous impatience was manifested; when the overture to Rossini's "Othello" commenced, low murmurs were heard, and glances of excited expectation were directed towards the curtain. The opera began: forms appeared, tones arose and vanished;—the assembled multitude still watched and waited. At last Desdemona appeared. Then a unanimous cry of delight resounded through the glittering walls of the temple of art; then countless flowers and wreaths were cast upon the stage; a ray of joy flashed from every eye, a smile of rapture played upon every lip.

To whom belonged this delicate ethereal form, this pale countenance, this glance so full of soul, this irresistible voice? Who was that fair woman, whose song reanimated withered hearts and brought to them dreams of their vanished childhood, mingled with the still brighter ones of their long-buried love?

It was the playing child in the garden, the blest heiress of the nightingale, the queen of song:

Maria Malibran-Garcia

She has vanished, the praised one; but let us not complain, for she died, as all know, as a nightingale must die; the star of her existence was extinguished in the midst of the most exuberant life. She has left for us her memory and a wondrous singing flower that bloomed beneath her eyes—her sister Paulina.

FROM THE GERMAN OF ELISE POLKO

Peony blossoming time 1954

Illustrated by W. G. & K. J. for Salamander Editions

The Bel Canto Pet

Published by Joseph Cornell, 1955

the

BEL
CANTO
PET

"the light of other days"

143

I was at one of those private concerts given at an enormous expense during the opera season, at which "assisted" Julia Grisi, Rubini, Lablache, Tamburini, and Ivanhoff. Grisi came in the carriage of a foreign lady of rank, who had dined with her, and she walked into the room looking like an empress. She was dressed in the plainest white, with her glossy hair put smooth from her brow, and a single white japonica dropped over one of her temples. The lady who brought her chaperoned her during the evening, as if she had been her daughter, and under the excitement of her own table and the kindness of her friends, she sung with a rapture and a freshet of glory (if one may borrow a word from the Mississippi) which set all hearts on fire. She surpassed her most applauded hour on the stage—for it was worth her while. The audience was composed, almost exclusively, of those who are not only cultivated judges, but who sometimes repay delight with a present of diamonds.

Lablache shook the house to its foundations in his turn; Rubini ran through his miraculous compass with the ease, truth, and melody, for which his singing is unsurpassed; Tamburini poured his rich and even

fullness on the ear, and Russian Ivanhoff, the one southern singing-bird who has come out of the north, wire-drew his fine and spiritual notes, till they who had been flushed, and tearful, and silent, when the others had sang, drowned his voice in the poorer applause of exclamation and surprise.

The concert was over by twelve, the gold and silver paper bills of the performance were turned into fans, and every one was waiting till supper should be announced—the prima donna still sitting by her friend, but surrounded by foreign attachés, *and in the highest elation at her own success. The doors of an inner suite of rooms were thrown open at last, and Grisi's cordon of admirers prepared to follow her in and wait on her at supper. At this moment, one of the powdered menials of the house stepped up and informed her very respectfully* that supper was prepared in a separate room for the singers!

Medea, in her most tragic hour, never stood so absolutely the picture of hate as did Grisi for a single instant, in the centre of that aristocratic crowd. Her chest swelled and rose, her lips closed over her snowy teeth, and compressed till the blood left them, and, for myself, I looked unconsciously to see where she

would strike. I knew, then, that there was more than fancy—there was nature and capability of the real—in the imaginary passions she plays so powerfully. A laugh of extreme amusement at the scene from the high-born woman who had accompanied her, suddenly turned her humor, and she stopped in the midst of a muttering of Italian, in which I could distinguish only the terminations, and, with a sort of theatrical quickness of transition, joined heartily in her mirth. It was immediately proposed by this lady, however, that herself and their particular circle should join the insulted prima donna at the lower table, and they succeeded by this manoeuvre in retaining Rubini and the others, who were leaving the house in a most unequivocal Italian fury.

I had been fortunate enough to be included in the invitation, and with one or two foreign diplomatic men, I followed Grisi and her amused friend to a small room on a lower floor, that seemed to be the housekeeper's parlor. Here supper was set for six (including the man who had played the piano), and on the side-table stood every variety of wine and fruit, and there was nothing in the supper, at least, to make us regret the table we had left. With a most impera-

tive gesture and rather an amusing attempt at English, Grisi ordered the servants out of the room, and locked the door, and from that moment the conversation commenced and continued in their own musical, passionate, and energetic Italian. My long residence in that country had made me at home in it; every one present spoke it fluently; and I had an opportunity I might never have again, of seeing with what abandonment these children of the sun throw aside rank and distinction (yet without forgetting it), and join with those who are their superiors in every circumstance of life, in the gayeties of a chance hour.

Out of their own country these singers would probably acknowledge no higher rank than that of the kind and gifted lady who was their guest; yet, with the briefest apology at finding the room too cold after the heat of the concert, they put on their cloaks and hats as a safeguard to their lungs (more valuable to them than to others); and as most of the cloaks were the worse for travel, and the hats opera-hats with two corners, the grotesque contrast with the diamonds of one lady, and the radiant beauty of the other, may easily be imagined.

Singing should be hungry work, by the knife and fork they played; and between the excavations of truffle pies, and the bumpers of champagne and burgundy, the words were few. Lablache appeared to be an established droll, and every syllable he found time to utter was received with the most unbounded laughter. Rubini could not recover from the slight he conceived put upon him and his profession by the separate table; and he continually reminded Grisi, who by this time had quite recovered her good humor, that, the night before, supping at Devonshire house, the duke of Wellington had held her gloves on one side, while his grace, their host attended to her on the other.

"E vero!" said Ivanhoff, with a look of modest admiration at the prima donna.

"E vero, e bravo!" cried Tamburini, with his sepulchral-talking tone, much deeper than his singing.

"Si, si, si, bravo!" echoed all the company; and the haughty and happy actress nodded all round with a radiant smile, and repeated, in her silver tones, "Grazie! cari amici! grazie!"

As the servants had been turned out, the removal of the first course was managed in pic-nic fashion; and when the fruit and fresh bottles of wine were set upon the table by the attachés, and younger gentlemen, the health of the princess who honored them by her presence was proposed in that language, which, it seems to me, is more capable than all others of expressing affectionate and respectful devotion. All uncovered and stood up, and Grisi, with tears in her eyes, kissed the hand of her benefactress and friend, and drank her health in silence.

It is a polite and common accomplishment in Italy to improvise in verse, and the lady I speak of is well known among her immediate friends for a singular facility in this beautiful art. She reflected a moment or two with the moisture in her eyes, and then commenced, low and soft, a poem, of which it would be difficult, nay impossible, to convey, in English, an idea of its music and beauty. It took us back to Italy, to its heavenly climate, its glorious arts, its beauty and its ruins, and concluded with a line of which I remember the sentiment to have been, "out of Italy every land is exile!"

The glasses were raised as she ceased, and every one repeated after her, "Fuori d'Italia tutto e esilio!"

"Ma!" cried out the fat Lablache, holding up his glass of champagne, and looking through it with one eye, "siamo ben esiliati qua!" and, with a word of drollery, the party recovered its gayer tone, and the humor and wit flowed on brilliantly as before.

The house had long been still, and the last carriage belonging to the company above stairs had rolled from the door, when Grisi suddenly remembered a bird that she had lately bought, of which she proceeded to give us a description, that probably penetrated to every corner of the silent mansion. It was a mocking-bird, that had been kept two years in the opera-house, and between rehearsals and performances had learned parts of everything it had overheard. It was the property of the woman who took care of the wardrobes. Grisi had accidentally seen it, and immediately purchased it for two guineas. How much of embellishment there was in her imitations of her treasure I do not know; but certainly the whole power of her wondrous voice, passion, and knowledge of music, seemed drunk up at once in the wild, various, difficult, and rapid mixture of the capricious melody she undertook. First came, without the passage which it usually terminates, the long, throat-down, gurgling, water-toned

trill, in which Rubini (but for the bird and its mistress, it seemed to me) would have been inimitable: then, right upon it, as if it were the beginning of a bar, and in the most unbreathing continuity, followed a brilliant passage from the Barber of Seville, run into the passionate prayer of Anna Bolena in her madness, and followed by the air of "Suoni la tromba intrepida," the tremendous duet in the Puritani, between Tamburini and Lablache. Up to the sky, and down to the earth again—away with a note of the wildest gladness, and back upon a note of the most touching melancholy—if the bird but half equals the imitation of his mistress, he were worth the jewel in a sultan's turban.

"Giulia!" "Giulietta!" "Giuliettina!" cried out one and another, as she ceased, expressing in their Italian diminutives, the love and delight she had inspired by her incomparable execution.

The stillness of the house in the occasional pauses of conversation reminded the gay party, at last, that it was wearing late. The door was unlocked, and the half-dozen sleepy footmen hanging about the hall were despatched for the cloaks and carriages; the drowsy porter was roused from his deep leathern dormeuse, and opened the door—and broad upon the street lay the cold gray light of a summer's morning.

147

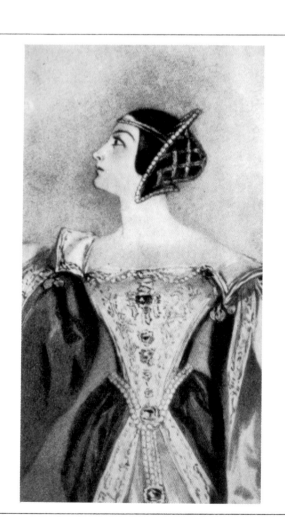

☆

Original title given to an excerpt from the writings of
Nathaniel Parker Willis

First Day of Locust Song
Mid-Summer 1955

"ENCHANTED WANDERER"

★ Excerpt from a Journey Album for Hedy Lamarr ★

By
JOSEPH CORNELL

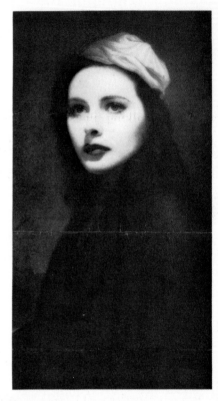

Among the barren wastes of the talking films there occasionally occur passages to remind one again of the profound and suggestive power of the silent film to evoke an ideal world of beauty, to release unsuspected floods of music from the gaze of a human countenance in its prison of silver light. But aside from evanescent fragments unexpectedly encountered, how often is there created a superb and magnificent imagery such as brought to life the portraits of Falconetti in "Joan of Arc," Lillian Gish in "Broken Blossoms," Sibirskaya in "Menilmontant," and Carola Nehrer in "Dreigroschenoper?"

And so we are grateful to Hedy Lamarr, the enchanted wanderer, who again speaks the poetic and evocative language of the silent film, if only in whispers at times, beside the empty roar of the sound track. Amongst screw-ball comedy and the most superficial brand of clap-trap drama she yet manages to retain a depth and dignity that enables her to enter this world of expressive silence.

Who has not observed in her magnified visage qualities of a gracious humility and spirituality that with circumstance of costume, scene, or plot conspire to identify her with realms of wonder, more absorbing than the artificial ones, and where we have already been invited by the gaze that she knew as a child.

Her least successful roles will reveal something unique and intriguing — a disarming candor, a naivete, an innocence, a desire to please, touching in its sincerity. In implicit trust she would follow in whatsoever direction the least humble of her audience would desire.

"She will walk only when not bid to, arising from her bed of nothing, her hair of time falling to the shoulder of space. If she speak, and she will only speak if not spoken to, she will have learned her words yesterday and she will forget them to-morrow, if to-morrow come, for it may not."

(Or the contrasted and virile mood of "Comrade X" where she moves through the scenes

* Parker Tyler

like the wind with a storm-swept beauty fearful to behold).

* * * * * * *

At the end of "Come Live With Me" the picture suddenly becomes luminously beautiful and imaginative with its nocturnal atmosphere and incandescence of fireflies, flashlights, and an aura of tone as rich as the silver screen can yield. Her arms and shoulders always covered, our gaze is held to her features, where her eyes glow dark against the pale skin and

her earrings gleam white against the black hair. Her tenderness finds a counterpart in the summer night. In a world of shadow and subdued light she moves, clothed in a white silk robe trimmed with dark fur, against dim white walls. Through the window fireflies are seen in the distance twinkling in woods and pasture. There is a long shot (as from the ceiling) of her enfolded in white covers, her eyes glisten in the semi-darkness like the fireflies. The reclining form of Snow White was not protected more

lovingly by her crystal case than the gentle fabric of light that surrounds her. A closer shot shows her against the whiteness of the pillows, while a still closer one shows an expression of ineffable tenderness as, for purposes of plot, she presses and intermittently lights a flashlight against her cheek, as though her features were revealed by slow-motion lightning.

In these scenes it is as though the camera had been presided over by so many apprentices of Caravaggio and Georges de la Tour to create for her this benevolent chiaroscuro . . . the studio props fade out and there remains a drama of light of the *tenebroso* painters . . . the thick night of Caravaggio dissolves into a tenderer, more star-lit night of the Nativity . . . she will become enveloped in the warmer shadows of Rembrandt . . . a youth of Giorgione will move through a drama evolved from the musical images of "Also Sprach Zarathustra" of Strauss, from the opening sunburst of sound through the subterranean passages into the lyrical soaring of the theme (apotheosis of compassion) and into the mystical night . . . the thunderous procession of the festival clouds of Debussy passes . . . the crusader of "Comrade X" becomes the "Man in Armor" of Carpaccio . . . in the half lights of a prison dungeon she lies broken in spirit upon her improvised bed of straw, a hand guarding her tear-stained features . . . the bitter heartbreak gives place to a radiance of expression that lights up her gloomy surroundings . . . she has carried a masculine name in one picture, worn masculine garb in another, and with her hair worn shoulder length and gentle features like those portraits of Renaissance youths she has slipped effortlessly into the role of a painter herself . . . le chasseur d'images . . . out of the fullness of the heart the eyes speak . . . are alert as the eye of the camera to ensnare the subtleties and legendary loveliness of her world. . . .

[The title of this piece is borrowed from a biography of Carl Maria von Weber who wrote in the horn quartet of the overture to "Der Freischutz" a musical signature of the Enchanted Wanderer.]

"Enchanted Wanderer"

Among the barren wastes of the talking films there occasionally occur passages to remind one again of the profound and suggestive power of the silent film to evoke an ideal world of beauty, to release unsuspected floods of music from the gaze of a human countenance in its prison of silver light. But aside from evanescent fragments unexpectedly encountered, how often is there created a superb and magnificent imagery such as brought to life the portraits of Falconetti in "Joan of Arc," Lillian Gish in "Broken Blossoms," Sibirskaya in "Menilmontant," and Carola Nehrer in "Dreigroschenoper?"

And so we are grateful to Hedy Lamarr, the enchanted wanderer, who again speaks the poetic and evocative language of the silent film, if only in whispers at times, beside the empty roar of the sound track. Amongst screwball comedy and the most superficial brand of claptrap drama she yet manages to retain a depth and dignity that enables her to enter this world of expressive silence.

Who has not observed in her magnified visage qualities of a gracious humility and spirituality that with circumstance of costume, scene, or plot conspire to identify her with realms of wonder, more absorbing than the artificial ones, and where we have already been invited by the gaze that she knew as a child.

From *View* magazine, December 1941–January 1942.

Her least successful roles will reveal something unique and intriguing—a disarming candor, a naïveté, an innocence, a desire to please touching in its sincerity. In implicit trust she would follow in whatsoever direction the least humble of her audience would desire.

"She will walk only when not bid to, arising from her bed of nothing, her hair of time falling to the shoulder of space. If she speak, and she will only speak if not spoken to, she will have learned her words yesterday and she will forget them to-morrow, if to-morrow come, for it may not."

—PARKER TYLER

(Or the contrasted and virile mood of "Comrade X" where she moves through the scenes like the wind with a storm-swept beauty fearful to behold).

. . .

At the end of "Come Live With Me" the picture suddenly becomes luminously beautiful and imaginative with its nocturnal atmosphere and incandescence of fireflies, flashlights, and an aura of tone as rich as the silver screen can yield. Her arms and shoulders always covered, our gaze is held to her features, where her eyes glow dark against the pale skin and her earrings gleam white against the black hair. Her tenderness finds a counterpart in the summer night. In a world of shadow and subdued light she moves, clothed in a white silk robe trimmed with dark fur, against dim white walls. Through the window fireflies are seen in the distance twinkling in woods and pasture. There is a long shot (as from the ceiling) of her enfolded in white covers; her eyes glisten in the semidarkness like the fireflies. The reclining form of Snow White was not protected more lovingly by her crystal case than the gentle fabric of light that surrounds her. A closer shot shows her against the whiteness of the pillows, while a still closer one shows an expression of ineffable tenderness as, for purposes of plot, she presses and intermittently lights a flashlight against her cheek, as though her features were revealed by slowmotion lightning.

152

In these scenes it is as though the camera had been presided over by so many apprentices of Caravaggio and Georges de la Tour to create for her this benevolent chiaroscuro . . . the studio props fade out and there remains a drama of light of the *tenebroso* painters . . . the thick night of Caravaggio dissolves into a tenderer, more starlit night of the Nativity . . . she will become enveloped in the warmer shadows of Rembrandt . . . a youth of Giorgione will move through a drama evolved from the musical images of "Also Sprach Zarathustra" of Strauss, from the opening sunburst of sound through the subterranean passages into the lyrical soaring of the theme (apotheosis of compassion) and into the mystical night . . . the thunderous procession of the festival clouds of Debussy passes . . . the crusader of "Comrade X" becomes the "Man in Armor" of Carpaccio . . . in the half lights of a prison dungeon she lies broken in spirit upon her improvised bed of straw, a hand guarding her tear-stained features . . . the bitter heartbreak gives place to a radiance of expression that lights up her gloomy surroundings . . . she has carried a masculine name in one picture, worn masculine garb in another, and with her hair worn shoulder length and gentle features like those portraits of Renaissance youths she has slipped effortlessly into the role of a painter herself . . . *le chasseur d'images* . . . out of the fullness of the heart the eyes speak . . . are alert as the eye of the camera to ensnare the subtleties and legendary loveliness of her world. . . .

[The title of this piece is borrowed from a biography of Carl Maria von Weber, who wrote in the horn quartet of the overture to "Der Freischutz" a musical signature of the Enchanted Wanderer.]

153

TWO

MEMOIRS OF CORNELL

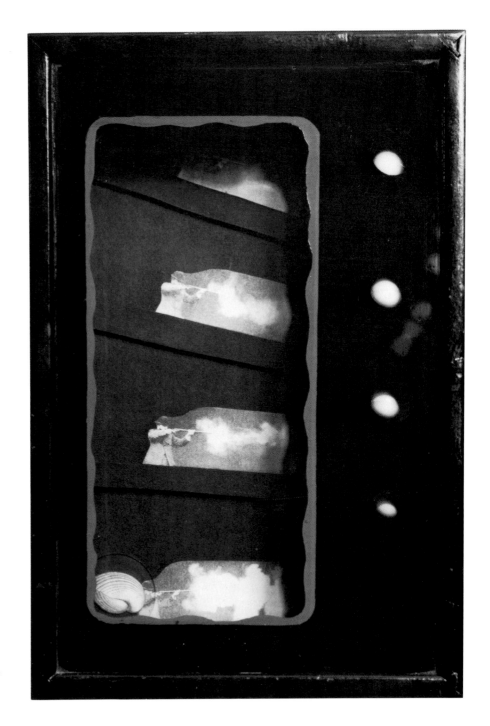

Black Hunter, 1939
—reflecting Cornell's deep in-
terest in Magritte's imagery

156

Cornell:
The Enchanted
Wanderer

Is this a good title for an homage to the recently deceased Joseph Cornell? It was used by Cornell for a piece written for *View Magazine* in 1941 with the subtitle, "Excerpt from a Journey Album for Hedy Lamarr." A footnote explains that the title is borrowed from a biography of Carl Maria von Weber who wrote in the horn quartet of the overture to "Der Freischutz" a musical signature, "The Enchanted Wanderer." In the middle of this one-page article is a reproduction of a Giorgione portrait with the face of Hedy Lamarr replacing the original face, but so artfully substituted that one cannot quite perceive this is a collage. Cornell quotes a poem by Parker Tyler: "She will walk only when not bid to, arising from her bed of nothing, her hair of time falling to the shoulder of space." The last sentence of the "excerpt" finishes: "out of the fullness of the heart the eyes speak; are alert as the eye of the camera to ensnare the subtleties and legendary loveliness of the world."

In the April 1942 issue of *View* one comes across another collage entitled "Story Without Name for Max Ernst." In sixteen interrelated images Cornell sounds a warning to the world which is *outside* childhood, which menaces it. The images are fire, natural eruptions, disaster. It is a nightmarish presentiment of what children may expect once they enter the so-called reality of the adults.

From "Cornell: The Enchanted Wanderer," *Art in America*, vol. 61, no. 5, September–October 1973.

Cornell's final contribution to *View* (January 1943) has a cover design which tells us the story of Blondin, the famous tightrope walker who crossed the gorge of Niagara Falls on a cable. Vast crowds congregated to see this amazing feat, and when he had done it, skeptics said it was done with mirrors. Blondin repeated his stunt, this time wheeling out on the cable a stove upon which he flipped pancakes in midair. Again the press declared the whole thing a fake, an illusion. In desperation, Blondin advertised for a stunt man to sit on his shoulders while he walked his rope across the great gorge. The partner was found; Blondin began for a third time his "perilous journey." When the two men were nearly two-thirds across, a strong wind began to blow. Blondin had to rest; the man sitting on his shoulders had to remain utterly still. Blondin sat down, got up, and continued. Security lines at one end of the cable began to give way. The crowds could hear the snap of these auxiliary ropes as they gave way under the impact of the wind. Just before the last rope snapped Blondin arrived safely at the other end of the cable; he had achieved the impossible. He had convinced the world that he had done what he set out to do. Soon after that Blondin disappeared in obscurity. We are in what Cornell called *The Crystal Cage*. On page fifteen of this same issue of *View* we see Blondin in a nineteenth-century landscape. It is a put-together of a little boy practicing on a rope, high above a benign nineteenth-century expanse of river, fields and woods. . . .

He |Cornell| looked through windows and knew he was fated to be a voyeur searching for *le pays bleu*. "It may have been the biting wind that Saturday morning that made glow any routine trifle with the slightest glint of warmth; it may have been the desperate mood, which still would not explain the first sign of activity in the brick tenement. A tenement observed almost daily for years from the vantage point of the head of the first subway car with the skyscrapers starting to loom up across the river."

Through the windows he saw snatches of life, the often sad, grim life in the tenements along Third Avenue. Above them the glories of Western architecture; below and on a level of the

elevated train, the poor. When he came home back to the endless rows of look-alike houses in Flushing, was there a reprieve? . . . Joseph rarely came home later than eight-thirty in the evening. In fact, he avoided almost all social life. There were many responsibilities to be met.

"Last Thursday I was invited to drive out to a secluded part of the North Shore of Long Island after a sultry day spent in the city. Finishing dinner I wandered alone toward the water in the hope of finding an interesting piece of flotsam before the light faded. Intent upon my mission, I almost collided with a child of about six years bent over the sands for the same purpose. In three or four minutes we were life-long friends, and there was just enough time before the darkness completely enveloped us for me to become impressed by the deep earnestness and sweetness expressed by her features. I was soon the recipient of the startling information that she was in the habit of getting up at dawn and picking up real stars on the beach before anyone was awake to discover her secret and that Indians from across the water had fashioned a shining white birch bark canoe solely for her use, which was carefully kept hidden in the woods. I might see it if I came back sometime. Other revelations were forthcoming when a voice from the direction of her cottage shattered the twilight calm ordering her to bed. . . ."

A new Hans Christian Andersen was walking the avenues of Gotham. Let us recall the intensely sensitive Andersen in Copenhagen complaining how only that morning someone had brushed against his arm and how he felt it had been broken. The pathos of the matchseller, the staunch tin soldier, the little mermaid are invoked, distilled in an imagination racked with the same pain as the dying Emperor who "thought it was time for the real nightingale to do some singing . . . but wherever was she?"

The life of a voyeur sometimes becomes the life of a mystic. Did Blake really see an angel sitting in a tree? How shall we understand the "trances," the "hallucinations" of Cornell? What did he see as he stared fixedly (at what?) in his workroom for minutes on end? What voices did he hear as he paced his front

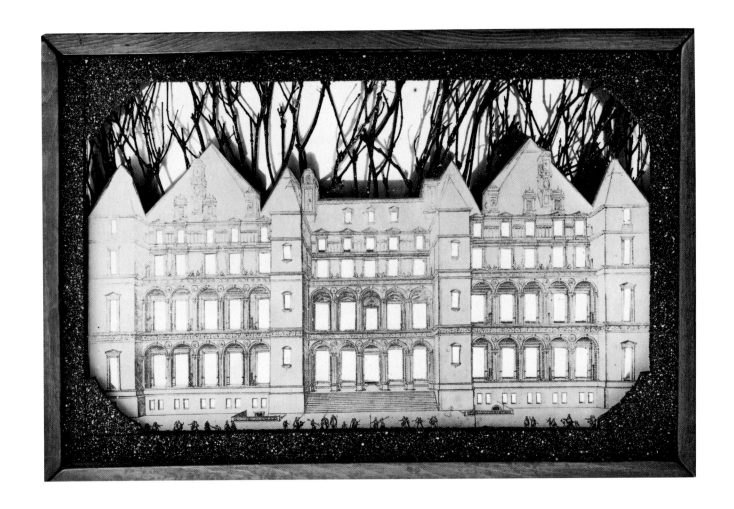

porch listening to something "out there"? How does one explain his consistent and accurate presentiments of disaster? Extra-sensory perception? Like Andersen, he lived in the presence of pain the better part of his life, but succeeded in transmuting this suffering into a series of works of art unlike anything that had ever existed before in the whole of art's history.

Pink Palace, 1946

JONAS MEKAS

The
Invisible Cathedrals
of Joseph Cornell

How to write about the movies of Joseph Cornell? Where can I find such lightness and grace and unpretentiousness and directness? My typewriter is here, in front of me, very real. The paper, the keys. I'm searching for words, letter by letter. To pay a tribute to a unique artist.

One amazing part of Joseph Cornell's film work—and he is the first one to stress this and remind us of it—is that a number of other people have been involved in the making of his films, either in photographing them or editing them. But when you see them (nine were shown at the Anthology Film Archives in December 1970), the same unmistakable Cornellian qualities mark them all. I spoke with Stan Brakhage, who did camera work on a few Cornell movies, and he said, yes, I held the camera, but I was only a medium who followed every indication, every movement, every suggestion that Cornell made: Cornell didn't touch the camera, but he made my every movement, he took every shot. Rudy Burckhardt, who photographed a good number of other Cornells, relates the same experience.

Yes, this invisible spirit of a great artist hovers over everything he does; a certain movement, a certain quality that he imposes upon everything he touches. When in contact with people, this quality rises again from the work, like a sweet mist, and it touches us, through our eyes, through our mind. Cornell's

Originally published in *Village Voice*, Dec. 31, 1970; collected in Mekas's book *Movie Journal* (New York: Macmillan, 1972).

mist (art is the opiate of the people . . .), Cornell's fragrance, is at once unique and at the same time very simple and unimposing. It's so unimposing that it's no wonder his movies have escaped, have slipped by unnoticed through the grosser sensibilities of the viewer, the sensibilities of men who need strong and loud bombardment of their senses to perceive anything. What Cornell's movies are is an essence of the home movie. They deal with things very close to us, every day and everywhere. Small things, not the big things. Not wars, not stormy emotions, dramatic clashes or situations. His images are much simpler. Old people in the parks. A tree full of birds. A girl in a blue dress, looking around, in the street, with plenty of time on her hands. Water dripping into the fountain ring. An angel in the cemeteries, sweetest face, under a tree. A cloud passes over the wing of the angel. What an image. "A cloud passes, touching lightly the wing of an angel." The final image of *Angel* is to me one of the most beautiful metaphors cinema has produced.

Cornell's images are all very real. Even when they are taken from other movies, as in *Rose Hobart*, they seem to gain the quality of reality. The Hollywood unreality is transported into Cornellian unreality, which is very, very real. Here is an evidence of the power of the artist to transform reality by choosing, by picking out only those details which correspond to some subtle inner movement or vision, or dream. No matter what he takes, be it a totally "artificial" reality, or bits of "actual" reality, he transforms them, bit by bit, into new unities, new things, boxes, collages, movies, with no other thing on earth resembling them. I have seen some of these movies in process of assembling themselves in Cornell's studio during the years, as they were put together, or maybe as they were putting themselves together from earth's dream matter, from things that people usually either throw away or don't pay attention to or pass by without looking, taking them for granted—be it a flock of birds, or an angel's wing, or a melancholy looking doll in a store window—people are always interested in important matters. . . .

Ah, but do not get misled, either by my writing, the way I'm

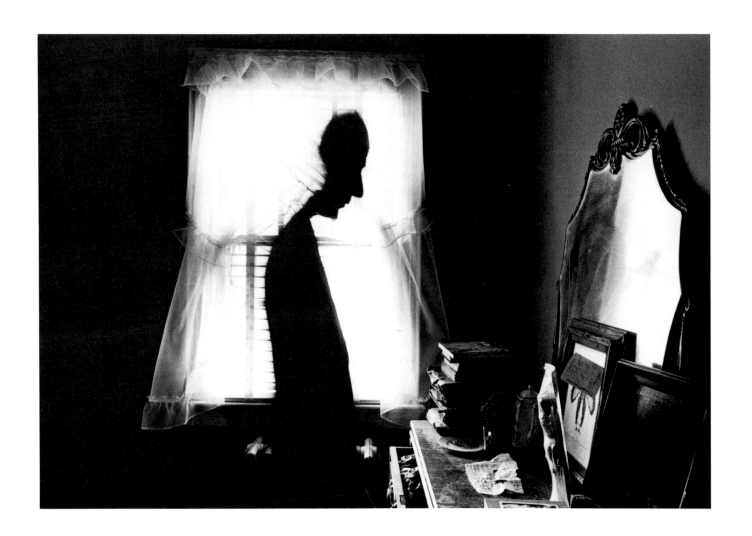

Photograph of Cornell 165

writing about Cornell's little movies, nor by the seeming simplicity of the movies themselves: Don't assume for a moment that they are a work of a "home" artist, a dabbler in cinema. No, Cornell's movies, like his boxes and his collages, are products of many years of work, of collecting, of polishing, of caring. They grow, like some things of nature grow, little by little, until the time arrives to let them out. It's like all things that Cornell does. Like his studio, like his basement. I stood in his basement and I looked in amazement at all kinds of little things in incredible number, frames, boxes, reels, little piles of mysterious objects and parts of objects, on walls, on tables, on boxes, and on the floor, in paper bags, and benches and chairs—wherever I looked I saw mysterious things growing, little by little. Some of them were just at the stage of birth, a detail or two, a fragment of a photograph, a toy's arm; other things in further stages of growth, and still others almost completed, almost breathing (on the table there was a pile of objects a little girl who was visiting the studio months ago spilled out, and he didn't touch them, he thought the creation was perfect)—the entire place looked like some magic hothouse of buds and flowers of art. And there was Joseph Cornell himself, walking kindly among them, touching one, touching another, adding some detail, or just looking at them, or dusting them off—the Gardener—so they grow into their fragile, sensitive, sublime, and all-encompassing perfections.

Once I was foolish enough to ask Cornell about the exact dates of the completion of his movies. When was *Cotillion* made? When was *Centuries of June* made? No, said Cornell, don't ask for the dates. Dates tie things down to certain points. Yes, when was it made? . . . Somewhere there . . . many years . . . So there I was, a fool, asking a foolish question. The dates! Cornell's art is timeless, both in its processes of coming (or becoming) and in what it is. His works have the quality—be they boxes, collages, or movies—of being located in some suspended area of time, like maybe they are extensions of our "realness" into some other dimension where our reality can be fixed. Our dimensions come and go, Cornell's dimensions remain and can always be touched

again by sensibilities of those who come and look at his work. Yes, spaces, dimensions. No great surprise to find in Cornell's work so much geometry and astronomy. It has something to do with retracing our feelings, our thoughts, our dreams, our states of being on some other, very fine dimension from where they can reflect back to us in the language of the music of the spheres.

Or like the girls, the timeless girls of Cornell's art, they are either angels or children—in any case they are at the age when the time is suspended, doesn't exist. Nymphs are ageless and so are the angels. A girl of ten, in a blue dress, in a park, with nothing to do, with plenty of time on her hands, looking around, in a timeless dream.

So where was I? I was talking about the movies of Joseph Cornell. Or at least I thought I was talking about them. I will be talking about them for a long time. There aren't many such sublime things left around us to talk about. Yes, we are talking about cathedrals, civilization. What's his name? Professor Clark? The cathedrals of today, wherever they are, are very unimposing, very unnoticeable. The boxes, the collages, the home movies of Joseph Cornell are the invisible cathedrals of our age. That is, they are almost invisible, as are all the best things that man can still find today: They are almost invisible, unless you look for them.

CORNELL'S

RECOMMENDED READINGS

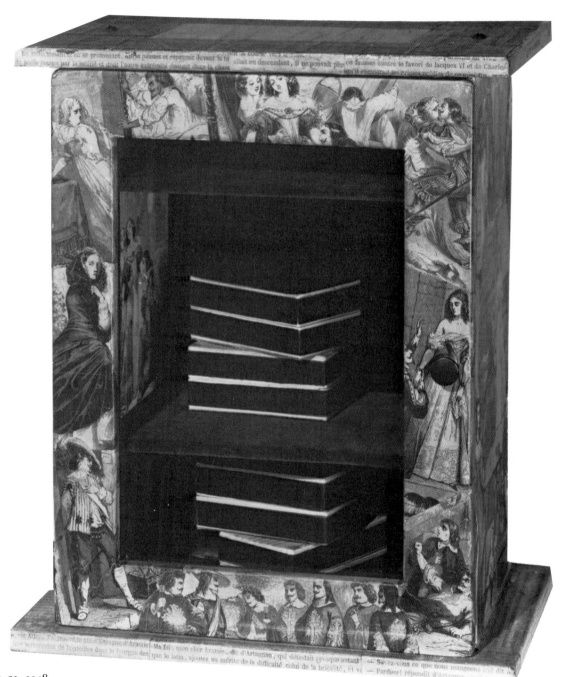

170 *Les Trois Mousquetaires*, ca. 1948

From the
Memoirs
of Hector Berlioz

I was twelve years old before the magic of music was revealed to me; but earlier than that I had experienced the pangs of that great passion which Virgil depicts with so much power. It came about in this wise. My maternal grandfather, who bore the same name as Walter Scott's hero, Marmion, had a country house at Meylan, three miles from Grenoble, near the frontier of Savoy. The village and the neighbouring hamlets, with the Isère valley winding below them, and the mountains of Dauphiné rising beyond, form one of the loveliest views I have ever beheld. My mother and sisters and I used to pay my grandfather a three weeks' visit at the end of the summer, and were sometimes joined there by my uncle, Felix Marmion. He was then deep in the brilliant vortex of the great Emperor, and came among us perfumed with gunpowder, and bearing on his person tangible traces of the battlefield. One time it was a bullet-wound in his foot, another time a splendid sabre-cut across his cheek, and then again a mere lance-thrust which needed healing. Our young cavalry adjutant never doubted that the Emperor's throne was as immovable as Mont Blanc; he was intoxicated with glory, and would

Hector Berlioz, *Memoirs*, trans. Rachel and Eleanor Holmes, ed. Ernest Newman (New York: Alfred A. Knopf, 1932).

gladly have laid down his life for his hero; he was a joyous, gallant, accomplished young fellow, who played the violin admirably, and sang opéra-comique music to perfection.

Above Meylan, and close under the steep wall of the mountain, lies a little white villa buried in gardens and vineyards, with a far-reaching outlook over the valley of the Isère; it is surrounded by rocky hills and woods; behind it rises the bold mass of the great St. Eynard rock; close by is a ruined tower, and it looks as if it were made to be the scene of a romance. This villa belonged to a Madame Gautier, who used to spend the summer there with two nieces, the younger of whom was called Estelle.[1] The name of itself would have attracted me because of its association with Florian's idyl (*Estelle et Némorin*), which I had discovered in my father's library and devoured in secret. The real Estelle was a tall, slight girl of eighteen, with splendid shining eyes, a mass of hair which might have waved on the casque of Achilles, and the feet—I will not say of a Spaniard, but of a thoroughbred Parisian—clad in a pair of pink shoes! You laugh? Well, I had never seen a pair of pink shoes before! I have forgotten the colour of her hair (I think it was black); but whenever I think of her I see a vision of large brilliant eyes and equally brilliant pink shoes.

The moment I set eyes on her I felt an electric shock; in fact, I fell in love with her, desperately, hopelessly. I had no wishes, no hopes, I had no idea what was the matter with me, but I suffered acutely and spent my nights in sleepless anguish. In the daytime I crept away like a wounded bird and hid myself in the maize-fields and the orchards. I was haunted by Love's ghostly companion, Jealousy, and suffered tortures when any man

[1] Her surname was Dubœuf. In later years she was Madame Fornier.

approached my idol; and it makes me shudder even now when I recall the ring of my uncle's spurs as he danced with her.

The spectacle of so young a child overwhelmed with a feeling so far beyond his years, seemed to afford all our neighbours the keenest amusement. Estelle was the first to discern my feelings, and she was, I am sure, more amused than anyone. One evening there was a large party at my aunt's; prisoner's base was proposed, and the guests were divided into two parties, the men choosing their companions. I was purposely called up first, but I dared not choose, and stood motionless with downcast eyes and beating heart, while they all laughed at me. At last Estelle took me by the hand and said, "Well then, I will choose. I take Mr. Hector!" Alas! the cruel girl, too, was laughing at me, as she stood looking down on me in her beauty. . . .

No, time itself is powerless . . . no after-loves can blot out the first. . . . I was but thirteen when I ceased to see her . . . I was thirty when, on my return from Italy, I caught sight of St. Eynard in the distance, the little white villa and the old tower, through a mist of tears. . . . I still loved her. . . . I heard that she was . . . married . . . and all the rest of it . . . and even that did not cure me. . . .

 . . .

The one was a memory of childhood. It comes to me radiant with smiles, adorned with all the charms of a perfect landscape, the mere sight of which was sufficient to move me. Estelle was then the hamadryad of my valley of Tempe; and at the age of twelve I experienced for the first time, and together, love and the love of nature.

The other love came to me in my manhood, with Shakespeare, in the burning bush of Sinai, amid the thunders and lightnings of poetry entirely new to me.

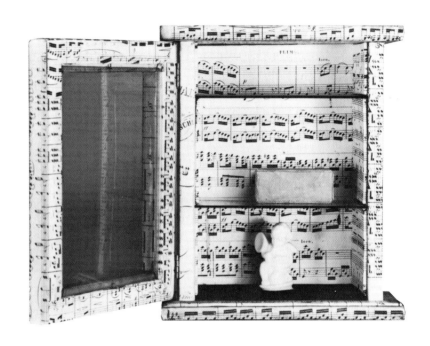

La Favorite, 1948

It prostrated me, and my heart and whole being were invaded by a cruel, maddening passion, in which the love of a great artist and the love of a great art were mingled together, each intensifying the other.

The power of such an antithesis may be imagined, if indeed there be any antithesis. Between Henrietta and myself, my Meylan idyll was no secret. She knew how vividly it remained in my mind. Who has not had his first idyll? Notwithstanding her jealous temper, she had too much sense to be hurt. Indeed, she used sometimes to rally me gently on the subject.

Those who cannot understand this will still less enter into another peculiarity of my nature. I have a vague feeling of poetic love whenever I smell a rose, and for a long time past I have felt the same at sight of a beautiful harp. When I see that instrument, I can hardly restrain myself from falling on my knees and embracing it. Estelle was the rose, "left blooming alone"; Henrietta was the harp, that took part in all my concerts, in all my joys and sorrows; and of which, alas! I broke many strings.

And now, if not at the end of my career, I am at any rate on the last steep decline—exhausted, consumed, but ever ardent, and full of an energy that sometimes revolts with an almost overwhelming force. I begin to know French, to be able to write a page of music, of verse, or of prose fairly well; I can direct and inspire an orchestra; I adore and venerate art under all forms. . . . But I belong to a nation which has ceased to be interested in the nobler manifestations of intelligence, and whose only deity is the golden calf. The Parisians have become a barbarous people. In ten rich houses you will scarcely find a single library. I am not speaking of musical libraries. No; books are no longer bought. Miserable novels are hired from the circulating library at a penny per volume;

such is the literary food of all classes of society. In the same way, people subscribe to the music-shop, for a few francs a month, in order to select, from the infinite commonplace rubbish of our day, some masterpiece of the sort which Rabelais has characterised by a contemptuous epithet.

The industrialism of art, followed by all the base instincts it flatters and caresses, marches at the head of an absurd procession, full of stupid disdain for its vanquished enemies.

In Paris, therefore, I can do nothing, for there I am considered only too fortunate to be able to fulfil the task of writing feuilletons—the only one, some would say, for which I was sent into the world. I know well what I could accomplish in the way of dramatic music, but it would be both useless and dangerous to attempt it. In the first place, most of our lyrical theatres are houses of ill fame, musically speaking; the Opéra especially is disgraceful. In the next place, I could not give full scope to my thoughts in this style of composition unless I felt myself to be as absolutely master in a great theatre as I am of my orchestra when conducting one of my symphonies.

I should have to be assured of the goodwill and obedience of all, from the first soprano and the first tenor, chorus, orchestra, dancers, and supernumeraries, down to the scene-painters, machinists, and stage-manager. A lyrical theatre as I take it, is first and foremost a vast musical instrument. I can play on it, but in order to play it well it must be entrusted to me without reserve. That is just what will never take place. The intrigues, conspiracies, and cabals of my enemies would have only too full scope. They dare not come and hiss me in a concert-room, but in a huge theatre like the Opéra they would not fail to do so.

From
The Journal of
Eugène Delacroix

January 27 [1847]

Worked at the *Arab Horsemen* and at the *Valentin*. In the evening went to Labbé, and then Leblond. Garcia[1] was there. Spoke of the opinion of Diderot on the actor. He affirms that the actor, even while controlling himself, should be passionate. In reply, I maintain that everything takes place in the imagination. Diderot, when he refuses all sensibility to the actor, does not sufficiently state that imagination replaces it. What I have heard Talma[2] say explains well enough the two combined effects: those of the inspiration necessary to the actor, and of the mastery of himself which he must at the same time preserve. He said that when on the stage, he was perfectly able to direct his inspiration and to judge himself, even though having the full appearance of giving himself up to his part; but he added, that if, at that moment, someone had come to tell him that his house was on fire, he could not have torn himself from the scene: it is the condition of any man engaged on work which occupies all his faculties, but whose soul is not, on that account, overcome by an emotion.

The Journal of Eugène Delacroix, trans. Walter Pach (New York: Covici, Friede, 1937; Compass ed., The Viking Press, 1972).
[1] Manuel Garcia (1805–1906), musician, son of the celebrated singer, and brother of the two singers, Marie (la Malibran, who died in 1836) and Pauline (Mme Viardot).
[2] Talma, the celebrated tragedian.

Garcia, in defending the role of sensibility and of true passion, thinks of his sister, Mme Malibran. He tells us as proof of her talent as a great actress that she never knew how she would play. Thus, in *Romeo* when she reaches the tomb of Juliet, she would sometimes stop at a pillar, on entering, in a burst of grief; at other times she would throw herself down sobbing before the stone, etc.; she thus achieved moments full of energy and seemingly full of truth, but it also happened that she would seem exaggerated and faulty in her timing, and as a consequence unbearable. I do not recall ever having seen her *noble*. When she came the nearest to the sublime, it was only to such a conception of it as a bourgeoise might possess; in a word, she was completely lacking in the sense of the ideal. She was like the young people who have talent, but whose turbulent time of life and whose inexperience always makes them think that they cannot do enough with it. It seems that she was endlessly seeking new effects in a situation. If one takes that course, one is never finished: that is never the way of consummate talent; when such a person has done his study and found his personal note, he breaks away from it no more. That was the distinguishing feature of the talent of Mme Pasta.[3] It characterizes the art of Rubens, Raphael, and all the great composers. Outside of the fact that with the other method the mind finds itself in perpetual uncertainty, one's whole life would be spent in trying over the same thing. When la Malibran had finished her evening, she was exhausted: mental fatigue was added to physical fatigue, and her brother agrees that she could not have lived for long in that way.

I tell him that Garcia, his father, was a great actor, constantly the same in all his roles, despite his apparent

[3] The Italian singer.

inspiration. He had seen him, for Othello,[4] study a grimace before the mirror; sensibility would not proceed in such fashion.

Garcia related to us that la Malibran, when she was puzzled as to the effect that she should seek for the moment when the unforeseen arrival of her father interrupts the transports of joy that she feels on learning that Othello is alive after his combat with Roderigo, she asked advice on this point from Mme Naldi, the wife of that Naldi who was killed by the explosion of a shell, and the mother of Mme de Sparre. That woman had been an excellent actress. She told her that, having to play the role of Galatea in *Pygmalion*, and having remained motionless in astounding fashion for all the time necessary, she had produced the greatest effect, at the moment when she makes the first movement which tells of the spark of life.

Mme Malibran, in *Mary Stuart*, is brought before her rival, Elizabeth, by Leicester, who implores her to humiliate herself before her rival. She finally consents to do so, and, falling on her knees, gives herself to the deepest supplication; but, outraged by the inflexible hardness of Elizabeth, she would rise up impetuously and throw herself into a fury which, he said, produced the greatest effect. She tore her handkerchief and even her gloves to tatters. There again is one of those effects to which a great artist will never descend: they are the kind which delight people in the boxes and afford a passing reputation to those who are willing to indulge themselves that way.

There is this unfortunate thing about the talent of the actor: after his death it is impossible to establish any comparison between him and his rivals, those who competed

[4] Opera by Rossini (1814).

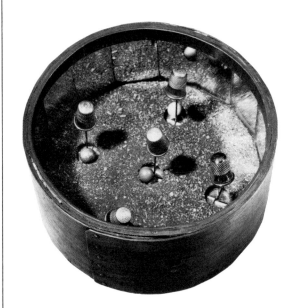

Thimble Forest, 1948

179

with him for applause during his lifetime. Posterity knows nothing of an actor save the reputation which his contemporaries made for him; and for our descendants, la Malibran will be placed on the same line as la Pasta; perhaps she will even be preferred, if one takes into account the exaggerated praise of her contemporaries. Garcia, in speaking of la Pasta, classed her among the cold and controlled talents, *plastic*, as he said. As to that word "plastic," what he should have said was ideal. At Milan, she had created *Norma* with extraordinary brilliancy; people no longer talked of la *Pasta*, but la *Norma*. Mme Malibran arrives, she demands that role for her début, and she succeeds, with that piece of childishness. The public, divided in the beginning, carries her to the clouds, and la *Pasta* was forgotten; it was la Malibran who had become la *Norma*, and I have no difficulty in believing it. The people whose minds do not rise very high, and who are not at all difficult in matters of taste—which is to say, unfortunately, the majority, will always prefer talents of the type possessed by la Malibran.

If the painter left nothing of himself, and if we were obliged to judge him, on the testimony of the people of his time, how different reputations would be from those that posterity has established! How many names, obscure today, must have been shining lights in their time, thanks to the caprice of fashion and to the bad taste of contemporaries! By good fortune, however fragile it is, painting or, replacing it, engraving preserves the documents of the case, places them under the eyes of posterity which can thus give back his place to the man of real eminence who has been underesteemed by the foolish public that comes and goes and is always fascinated by tinsel, and by the husks of truth.

From
The Life of Rossini

The temptation to sketch a musical portrait of Madame Pasta is too strong to be resisted. It may be averred that there was never a more difficult undertaking; the language of musical description is ungrateful and outlandish; I shall find myself constantly baulked by inadequacies of vocabulary; and even on those occasions when I *am* lucky enough to light upon the exact word required to convey my thought, the chances are that it will awaken none but the vaguest associations in the reader's mind. Furthermore, there can scarcely be one single music-lover in all Paris who has not already invented his own epithets in praise of Madame Pasta; none, therefore, will escape the disappointment of failing to find his own thought reflected here; and even the most favourably disposed of readers, in the heat of devotion which this great singer so deservedly inspires among her admirers, is bound to find any portrait of her from another hand flat, insipid, and a thousand times less wondrous than he had a right to expect.

Madame Pasta's voice has a considerable range. She can achieve perfect resonance on a note as low as bottom *A*,

Life of Rossini, trans. Richard N. Coe (New York: Grossman, 1970).

and can rise as high as $C\sharp$, or even to a slightly sharpened *D*; and she possesses the rare ability to be able to sing contralto as easily as she can sing soprano.[1] I would suggest, in spite of my atrocious lack of technical knowledge, that the true designation of her voice is *mezzo-soprano*, and any composer who writes for her should use the *mezzo-soprano* range for the thematic material of his music, while still exploiting, as it were incidentally and from time to time, notes which lie within the more peripheral areas of this remarkably rich voice. Many notes of this last category are not only extremely fine in themselves, but have the ability to produce a kind of resonant and magnetic vibration, which, through some still unexplained combination of physical phenomena, exercises an instantaneous and hypnotic effect upon the soul of the spectator.

This leads me to the consideration of one of the most uncommon features of Madame Pasta's voice: it is *not all moulded from the same metallo*, as they would say in Italy (*i.e.*, it possesses more than one *timbre*); and this fundamental variety of tone produced by a single voice affords one of the richest veins of musical expression which the artistry of a great *cantatrice* is able to exploit.

. . .

Without such a palette of breath-taking colour deep within her own being, and without such an extraordinary and compelling natural gift, Madame Pasta could never have achieved the over-mastering force of natural expression which we have learnt to associate with her—a miracle of emotional revelation, which is always true to nature, and, although tempered by the intrinsic laws of

[1] An ability of which she gave ample proof by singing, not only the part of Tancred, but also those of Curazio (in Cimarosa's *Gli Orazii e Curiazii*), Romeo and Medea.

ideal Beauty,[2] always alive with that unmistakable, burning energy, that extraordinary dynamism which can electrify an entire theatre. But think how much pure artistry, and how much discipline and training has been necessary before this enthralling singer learned to harness the restive secrets of weaving such divine enchantments out of two different and utterly contrasting voices.

Her art appears to be infinitely perfectible; its miracles grow daily more astonishing, and nothing can henceforth stop its power over the audience from growing progressively more binding. Madame Pasta long ago overcame the last of the physical obstacles which stood in the way of the realization of pure musical enjoyment; and her voice to-day is as fascinating to the listener's ear as it is electrifying to his soul. Each new opera in which she appears fires her audience with feelings of ever-deepening intensity, or surprises them with new and strange aspects of a familiar delight. She possesses the great secret of imprinting a fresh pattern of colour upon old music, not through the medium of the words, or thanks to her genius as a great tragic actress, but purely and simply *as a singer*; and thus she is able to transmute a rôle (such as that of Elcia in *Mosè*), which might seem comparatively insignificant, into a thing of new and splendid beauty.[3]

. . .

Where should I find words adequate to describe the visions of celestial beauty which spread before us in dazzling glory when Madame Pasta sings, or the strange

[2] This unusual *pacatezza* [sedateness] of voice and gesture serves to distinguish Madame Pasta from every other great *prima donna* whom I have ever seen.

[3] Madame Pasta's singing-master, Signor Scappa, of Milan, is at present in London, where his method is achieving uncommon popularity.

glimpses into the secrets of sublime and fantastic passions which her art affords us? Ineffable mysteries, dreams which lie beyond the powers of poetry, vistas unknown, unfathomable, deep-hidden in the recesses of the human heart, which no mere Canova with his sculptor's chisel, no mere Correggio with his painter's brush, could hope to reveal to our enquiring souls! Who could recall without a shudder that terrible instant when Medea draws her children towards her, while her hand feels for the dagger . . . and then pushes them away, as though shaken by some invisible tempest of remorse? The suggestion is so subtle, so delicate, that it would cause even the greatest of writers, I feel, to despair of the crudity of his own medium!

. . .

Any of the regular *habitués* of the *Théâtre Louvois* will recall the evening when Madame Pasta first ventured to use these extraordinarily original variants in her interpretation, and the kind of electric shock, infinitely more flattering than any mere applause,[4] which ran instantaneously round the auditorium; and yet, at any one of the twenty or thirty performances of the same opera which had been given earlier, the audience might have sworn that this admirable *prima donna* had already carried her part to a height of unsurpassable perfection.

Later, during the course of the same evening, Madame Pasta enthralled us still further by displaying the prodigious contrast of her two voices; and it was on this occasion that a friend of mine, a charming young Neapolitan with a wide reputation as a connoisseur of music and a wider one still as an enchanting lover, spoke to me in a tone of such burning enthusiasm that I would give

[4] Any fool can applaud with the rest; but to be *spell-bound*, one must possess a soul. This is rare.

184

everything that I possess in the world to be able to re-
produce it here in cold print:

*This wondrous voice, with its swift succession of tones
which shift like shadow chasing sunlight, seems to distil
a rare quintessence of delight and memory, conjuring
up the half-forgotten softness of the night in our un-
happy land—of those pure, crystalline nights, when the
pattern of stars lay like a silver web across the deepest
blue of the sky, when the moonlight fell in shafts of
silence, haunting the quiet of that enchanted landscape
which lay in stillness spread across the banks of the
Mergellina . . . the Mergellina, which I shall never see
again! Lost in the infinity of distance lies Capri, alone
and islanded in its silver sea, whose waves move softly
at the cool beckoning of the night-wind. And then, im-
perceptibly, gently, a diaphanous mist begins to steal
across the Huntress of the Night; an instant, and her
light falls more tenderly, more caressingly; nature, half-
darkened, stirs the spirit more deeply, and wakes a strange
awareness in the souls of men. But wait . . . behold! Purer,
brighter than ever in her naked loneliness, Diana stands
forth again in the Heavens, and the shores of Italy lie
bathed once more in the living innocence of her silver-
silent light. Thus with Madame Pasta: her voice, changing
from register to register, inspires in me the same sensation
as this memory of moonlight, veiled an instant, darker,
softer, more entrancing . . . then shining forth anew, a
silver shower a thousandfold increased.*[5]

*Or again, think how, at sunset, as the day-star sinks to
rest behind Posilippo, our hearts seem to yield insensibly
to sadness, and to be borne away upon a gentle tide of
melancholy; a strange, inexpressible seriousness steals over
our minds, and the harmony of our souls longs to be at*

[5] There is only one *rational* standard by which *ideal beauty* may
be assessed in any art: the *intensity of emotion* in the beholder.

peace with the still sadness of the evening. Likewise, just now, when Madame Pasta sang the phrase:

Ultimo pianto . . .[6]

I experienced the same emotion, with this difference only, that the transition was perhaps a little more rapid. It is the same feeling as that which clutches at my heart, but more persistently in the reality of life, when the first chill days of September steal across the traces of summer, and a light mist hovering about the tree-tops heralds the approach of winter and the death of nature's loveliness.

. . .

People have frequently sounded Madame Pasta's friends as to who taught her her craft as an *actress*. The answer is—*no one!* The only instruction which she has ever received has come straight from her own heart, from her own acutely sensitive reactions to the most delicate *nuances* of human passions, and from her admiration, so boundless as to verge upon the limits of absurdity, for *ideal beauty*. Once, in Trieste, while she was walking beside the harbour with a company of friends, a little three-year-old beggar-boy came up to her and asked for alms on behalf of his blind mother; she burst into tears and gave him all she had. Her friends, who had witnessed this incident, immediately began to speak of her virtue, her charitableness and the compassion of her heart. But she merely wiped away her tears and turned on them angrily: "I refuse to accept your commendation!" she exclaimed. "And I am *not* virtuous! But when that child came begging to me, he begged like a great artist. In a flash, I could see in his gesture all the despair of his mother, all the poverty of their home, the clothes which

[6] Final lamentation.

they need and the biting cold which is their relentless enemy. If, when the scene called for it, *I* could discover a gesture so faithfully portraying every suggestion of indescribable misery, I should be a very great actress indeed."

I suspect that Madame Pasta's genius as a tragic actress is made up of a thousand-and-one little casual *observations* of the kind which I have just recorded, modelled upon a series of tiny incidents which she has been gathering since the age of six, remembering them with vivid distinctness, and using them on the stage when the occasion demands.

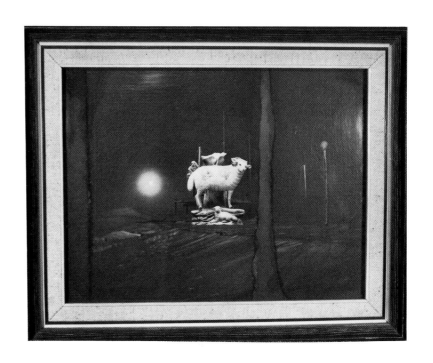

The Journeying Sun
(for Samuel Taylor Coleridge),
Autumn 1963, front and back

. . . if you can heare a good Organ at Church, and have the musique of a domestique peace at home, peace in thy walls, peace in thy bosome, never hearken after the musique of sphears, never hunt after the knowledge of higher secrets, than appertaine to thee.

From
the Sermons of
John Donne

GÉRARD DE NERVAL

From *Aurélia*

Another dream of mine confirmed me in this belief. I suddenly found myself in a room which formed part of my grandfather's house, only it seemed to have grown larger. The old furniture glowed with a miraculous polish, the carpets and curtains were as if new again, daylight three times more brilliant than natural day came in through the windows and the door, and in the air there was a freshness and perfume like the first warm morning of spring. Three women were working in the room and, without exactly resembling them, they stood for relatives and friends of my youth. Each seemed to have the features of several of them. Their facial contours changed like the flames of a lamp, and all the time something of one was passing to the other. Their smiles, the color of their eyes and hair, their figures and familiar gestures, all these were exchanged as if they had lived the same life, and each was made up of all three, like those figures painters take from a number of models in order to achieve a perfect beauty.

The eldest spoke to me in a vibrant, melodious voice which I recognized as having heard in my childhood, and whatever it was she said struck me as being profoundly

Selected Writings of Gérard de Nerval, trans. Geoffrey Wagner (New York: Grove Press, 1957).

true. But she drew my attention to myself and I saw I was wearing a little old-fashioned brown suit, entirely made of needlework threads as fine as a spider's web. It was elegant, graceful, and gently perfumed. I felt quite rejuvenated and most spruce in this garment which their fairy fingers had made, and I blushingly thanked them as if I had been a small boy in the presence of beautiful grown-up ladies. At that moment one of them got up and went towards the garden.

It is a well-known fact that no one ever sees the sun in a dream, although one is often aware of some far brighter light. Material objects and human bodies are illumined through their own agencies. Now I was in a little park through which ran long vine arbors, loaded with heavy clusters of black and white grapes; and as the lady, guiding me, passed beneath these arbors, the shadows of the intertwined trellis-work changed her figure and her clothes. At last we came out from these bowers of grapes to an open space. Traces of the old paths which had once divided it cross-wise were just visible. For some years the plants had been neglected and the sparse patches of clematis, hops and honeysuckle, of jasmine, ivy, and creepers, had stretched their long clinging tendrils between the sturdy growths of the trees. Branches of fruit were bowed to the ground and a few garden flowers, in a state of wildness now, bloomed among the weeds.

At distant intervals were clumps of poplars, acacias and pine-trees, and in the midst of these were glimpses of statues blackened by time. I saw before me a heap of rocks covered with ivy, from which gushed a spring of fresh water whose splashes echoed melodiously over a pool of still water, half-hidden by huge water-lilies.

The lady I was following stretched her slender figure in a movement that made the folds of her dress of shot

taffeta shimmer, and gracefully she slid her bare arm about the long stem of a hollyhock. Then, in a clear shaft of light, she began to grow in such a way that gradually the whole garden blended with her own form, and the flowerbeds and trees became the patterns and flounces of her clothes, while her face and arms imprinted their contours on the rosy clouds in the sky. I lost her thus as she became transfigured, for she seemed to vanish in her own immensity.

"Don't leave me!" I cried. "For with you Nature itself dies."

With these words I struggled painfully through the brambles trying to grasp the vast shadow that eluded me. I threw myself on a fragment of ruined wall, at the foot of which lay the marble bust of a woman. I lifted it up and felt convinced it was of *her* . . . I recognized the beloved features and as I stared around me I saw that the garden had become a graveyard, and I heard voices crying: "The universe is in darkness."

. . .

This dream, which began so happily, perplexed me deeply, for I did not discover what it meant until much later. Aurélia was dead.

At first I only heard that she was ill. Owing to my state of mind I only felt a vague unhappiness mixed with hope. I believed that I myself had only a short while longer to live, and I was now assured of the existence of a world in which hearts in love meet again. Besides, she belonged to me much more in her death than in her life . . . A selfish enough thought for which my reason later paid with bitter remorse.

I did not like abusing a presentiment, however. Chance does strange things. But at that time I was obsessed by a memory of our too rapid union. I had given her a ring of antique workmanship whose stone was a heart-shaped

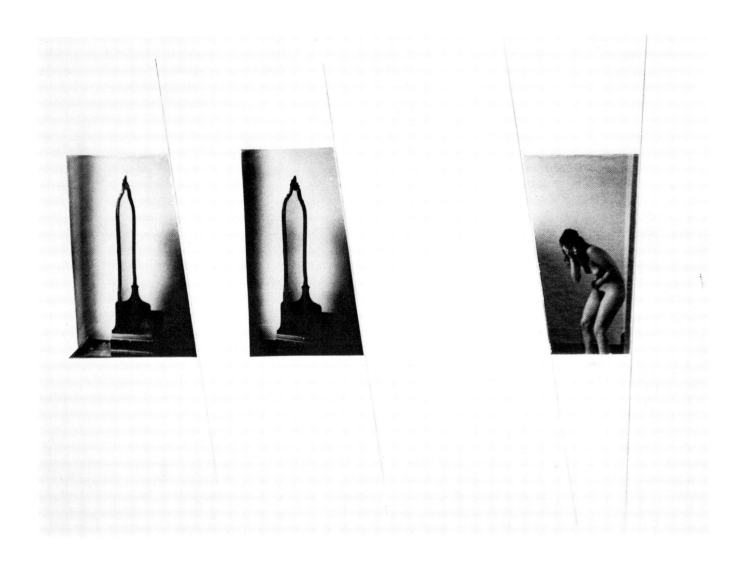

Montage by Cornell based on three photographs
by Duane Michals, ca. 1970

opal. As this ring was too big for her finger, I had conceived the fatal idea of having it cut down; I only realized my mistake when I heard the noise of the saw. I seemed to see blood flowing . . .[1]

Medical treatment had restored me to health without having yet brought my mind back to the regular functioning of human reason. The house I was in was on a hill and had a large garden full of valuable trees. The pure air of the slopes on which it stood, the first breath of spring, the pleasure of a sympathetic society, all brought me long days of calm.

I was enchanted by the vivid colors of the early sycamore leaves, like the crests of cock pheasants. From morning to evening one could gaze over the plain to charming horizons, the graduated hues of which delighted my imagination. I peopled the hills and clouds with heavenly figures whose shapes I seemed to see distinctly. I wanted to fix my favorite thoughts more clearly, and with some charcoal and a few bits of brick that I collected I had soon covered the walls with a set of frescoes recording my impressions. One face dominated the rest—that of Aurélia, painted in the shape of a divinity, as she had appeared to me in my dream. Beneath her feet a wheel was turning and the gods processed behind her. I succeeded in coloring this group by crushing out the juice from plants and flowers. How many times have I dreamed in front of that dear idol! I did more, I tried to shape the body of my beloved in clay. Every morning I had to begin again, for the lunatics, jealous of my happiness, took pleasure in destroying its image.

[1] An incident probably borrowed from Hoffmann, whose cabalist Dapfühl files down a ring belonging to his daughter Annette, thereby producing thick black blood. Jenny's death, to which Nerval refers in the lines before this, was on June 5th, 1842.

EMILY DICKINSON

I cannot dance upon my toes,
No man instructed me,
But often times among my mind
A glee possesseth me
That had I ballet knowledge
Would put itself abroad
In pirouette to blanch a troupe,
Or lay a Prima mad!
And though I had no gown of gauze,
No ringlet to my hair,
Nor hopped for audiences like birds,
One claw upon the air,—
Nor tossed my shape in
Eider balls,
Nor rolled on wheels of snow
Till I was out of sight in sound,
The house encored me so—
Nor any knew I know the art
I mention easy here—
Nor any placard boast me,
It's full as opera!

Poem # 326 in *The Complete Poems of Emily Dickinson*, ed.
Thomas H. Johnson (Boston: Little, Brown, 1960).

Poem

JOSEPH CORNELL

Postcard sent by Cornell to Dore Ashton, 1970 195

THOMAS DE QUINCEY

From
Ann of Oxford Street

O youthful benefactress! How often in succeeding years, standing in solitary places, and thinking of thee with grief of heart and perfect love—how often I have wished that, as in ancient times the curse of a father was believed to have a supernatural power, and to pursue its object with a fatal necessity of self-fulfilment, even so the benediction of a heart oppressed with gratitude might have a like prerogative; might have power given it from above to chase, to haunt, to waylay, to pursue thee into the central darkness of a London brothel, or (if it were possible) even into the darkness of the grave, there to awaken thee with an authentic message of peace and forgiveness, and of final reconciliation!

· · ·

If she lived, doubtless we must have been sometimes in search of each other, at the very same moment, through the mighty labyrinths of London; perhaps even within a few feet of each other—a barrier no wider, in a London street, often amounting in the end to a separation for eternity! During some years I hoped that she *did* live, and I suppose that, in the literal and unrhetorical use of

From De Quincey's *Collected Writings* (Edinburgh: A. & C. Black, 1889–90).

the word *myriad*, I must, on my different visits to London, have looked into many female faces, in the hope of meeting Ann. I should know her again amongst a thousand, and if seen but for a moment. Handsome she was not; but she had a sweet expression of countenance, and a peculiarly graceful carriage of the head. I sought her, I have said, in hope. So it was for years; but now I should fear to see her; and her cough, which grieved me when I parted with her, is now my consolation. Now I wish to see her no longer, but think of her, more gladly, as one long since laid in the grave—in the grave, I would hope, of a Magdalen; taken away before injuries and cruelty had blotted out and transfigured her ingenuous nature, or the brutalities of ruffians had completed the ruin they had begun.

· · ·

I thought that it was a Sunday morning in May; that it was Easter Sunday, and as yet very early in the morning. I was standing, as it seemed to me, at the door of my own cottage. Right before me lay the very scene which could really be commanded from that situation, but exalted, as was usual, and solemnised by the power of dreams. There were the same mountains, and the same lovely valley at their feet; but the mountains were raised to more than Alpine height, and there was interspace far larger between them of savannahs and forest lawns; the hedges were rich with white roses; and no living creature was to be seen, excepting that in the green churchyard there were cattle tranquilly reposing upon the verdant graves, and particularly round about the grave of a child whom I had once tenderly loved, just as I had really beheld them, a little before sunrise, in that same summer when that child died. I gazed upon the well-known scene, and I said to myself, "It yet wants

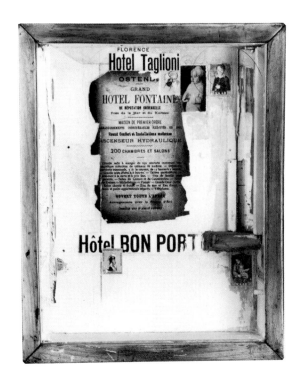

Hôtel Bon Port (for Ann in Memory), 1954

197

much of sunrise; and it is Easter Sunday; and that is the day on which they celebrate the first-fruits of Resurrection. I will walk abroad; old griefs shall be forgotten today: for the air is cool and still, and the hills are high, and stretch away to heaven; and the churchyard is as verdant as the forest lawns, and the forest lawns are as quiet as the churchyard; and with the dew I can wash the fever from my forehead; and then I shall be unhappy no longer." I turned, as if to open my garden gate, and immediately I saw upon the left a scene far different; but which yet the power of dreams had reconciled into harmony. The scene was an oriental one; and there also it was Easter Sunday, and very early in the morning. And at a vast distance were visible, as a stain upon the horizon, the domes and cupolas of a great city—an image or faint abstraction, caught perhaps in childhood from some picture of Jerusalem. And not a bow-shot from me, upon a stone, shaded by Judean palms, there sat a woman; and I looked, and it was—Ann! She fixed her eyes upon me earnestly; and I said to her at length, "So, then, I have found you at last." I waited; but she answered me not a word. Her face was the same as when I saw it last; the same and yet again, how different! Seventeen years ago when the lamp-light of mighty London fell upon her face, as for the last time I kissed her lips (lips, Ann, that to me were not polluted!), her eyes were streaming with tears. The tears were now no longer seen. Sometimes she seemed altered; yet again sometimes *not* altered; and hardly older. Her looks were tranquil, but with unusual solemnity of expression, and I now gazed upon her and, turning to the mountains, I perceived vapours rolling between us; in a moment all had vanished; thick darkness came on; and in the twinkling of an eye I was far away from mountains, and by lamp-light in London, walking again with Ann—just as we had walked when both

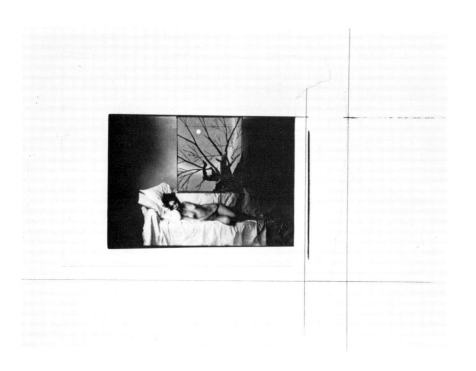

Two collages composed by Cornell with prints from Duane Michals's series, "A Young Girl's Dream," ca. 1970

children, eighteen years before, along the endless terraces of Oxford Street. Then suddenly would come a dream of far different character—a tumultuous dream—commencing with a music such as now I often heard in sleep—music of preparation and of awakening suspense. The undulations of fast-gathering tumults were like the opening of the Coronation Anthem; and, like *that*, gave the feeling of a multitudinous movement, of infinite cavalcades filing off, and the tread of innumerable armies. The morning was come of a mighty day—a day of crises and of ultimate hope for human nature, then suffering mysterious eclipse, and labouring in some dread extremity. Somewhere, but I knew not where—somehow, but I knew not how—by some beings, but I know not whom—a battle, a strife, an agony was travelling through all its stages—was evolving itself, like the catastrophe of some mighty drama, with which my sympathy was the more insupportable from deepening confusion as to its local scene, its cause, its nature, and its undecipherable issue. I (as is usual in dreams where, of necessity, we make ourselves central to every movement) had the power, and yet had not the power, to decide it. I had the power, if I could raise myself to will it; and yet again had not the power, for the weight of twenty Atlantics was upon me, or the oppression of inexpiable guilt. "Deeper than ever plummet sounded," I lay inactive. Then, like a chorus, the passion deepened. Some greater interest was at stake, some mightier cause, than ever yet the sword had pleaded, or trumpet had proclaimed. Then came sudden alarms; hurryings to and fro; trepidations of innumerable fugitives, I knew not whether from the good cause or the bad; darkness and lights; tempest and human faces; and at last, with the senses that all was lost, female forms, and the features that were worth all the world to me; and but a moment allowed—and clasped hands, with heart-break-

Joseph Cornell, ca. 1970

ing partings, and then—everlasting farewells! and, with a sigh such as the caves of hell sighed when the incestuous mother uttered the abhorred name of Death, the sound was reverberated—everlasting farewells!—and again, and yet again reverberated—everlasting farewells!

From
William Wetmore Story and His Friends

Another notice of the Opera yields a deeply disconcerting allusion to a ballet, called prettily "Die Blumen-Fee," the Flower-Fairy, "in which Marie Taglioni, a woman whose ankles were as great as her name, flung herself about clumsily enough." But for this untoward stroke we might have invited Marie Taglioni to flit across our stage, on the points of those toes that we expected never to see compromised, as one of our supernumerary ghosts; in the light, that is, of our own belated remembrance, a remembrance deferred to the years in which, as a very ugly and crooked little old woman, of the type of the superannuated "companion," or of the retired and pensioned German governess, she sometimes dined out, in humane houses, in London, and there indeed, it must be confessed, ministered not a little to wonderment as to what could have been the secret of her renown, the mystery of her grace, the truth, in fine, of her case. Her case was in fact really interesting, for the sensitive spectator, as a contribution to the eternal haunting question of the validity, the veracity from one generation to another, of social and other legends, and it could easily, in the good lady's presence, start a train of speculations—almost one indeed of direct inquiry. The possibilities were

Henry James, *William Wetmore Story and His Friends* (London: Blackwood, 1903).

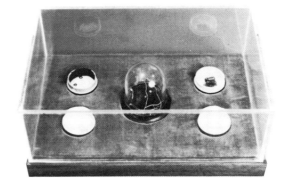

Three Objects, 1933

Photograph by Terry Schutté taken at the request
of the artist

numerous—how were they to be sifted? Were our fathers benighted, were ravage and deformity only triumphant, or, most possibly of all, was history in general simply a fraud? For the Sylphide had been, it appeared, if not the idol of the nations, like certain great singers, at least the delight of many publics, and had represented physical grace to the world of her time. She had beguiled Austrian magnates even to the matrimonial altar, and had acquired, as a climax of prosperity, an old palace, pointed out to the impressed stranger, in Venice. The light of testimony in the London winter fogs was, at the best, indirect, and still left the legend, at the worst, *one* of the celebrated legs, so often in the past precisely serving as a solitary support, to stand on. But to read, after all, that she flung herself about, with thick ankles, "clumsily enough," is to rub one's eyes and sigh—"Oh history, oh mystery!"—and give it up.

· · ·

Hans Andersen, whose private interest in children and whose ability to charm them were not less marked than his public, knew his way well to the house, as later to Palazzo Barberini (to the neighbourhood of the *The Improvvisatore* was able even to add a charm); where the small people with whom he played enjoyed, under his spell, the luxury of believing that he kept and treasured—in every case and as a rule—the old tin soldiers and broken toys received by him, in acknowledgment of favours from impulsive infant hands. Beautiful the queer image of the great benefactor moving about Europe with his accumulations of these relics. Wonderful too our echo of a certain occasion—that of a children's party later on—when, after he read out to his young friend *The Ugly Duckling*, Browning struck up with *The Pied Piper*; which led to the formation of a grand march through the spacious Barberini apartment, with Story doing his best on a flute in default of bagpipes.

MARY BAKER EDDY

From
Science and Health

If we were to derive all our conceptions of man from what is seen between the cradle and the grave, happiness and goodness would have no abiding-place in man, and the worms would rob him of the flesh; but Paul writes: "The law of the Spirit of life in Christ Jesus hath made me free from the law of sin and death."

Man undergoing birth, maturity, and decay is like the beasts and vegetables,—subject to laws of decay. If man MAN NEVER were dust in his earliest stage of exist- LESS THAN MAN ence, we might admit the hypothesis that he returns eventually to his primitive condition; but man was never more nor less than man.

If man flickers out in death or springs from matter into being, there must be an instant when God is without His entire manifestation,—when there is no full reflection of the infinite Mind.

Man in Science is neither young nor old. He has neither birth nor death. He is not a beast, a vegetable, MAN NOT nor a migratory mind. He does not pass EVOLVED from matter to Mind, from the mortal to the immortal, from evil to good, or from good to evil. Such admissions cast us headlong into darkness and dogma.

Mary Baker Eddy, *Science and Health with Key to the Scriptures* (Boston: The First Church of Christ, Scientist, 1875, 1906).

Both sides of
*The Missing Girl (Piero
della Francesca)*, 1963

Mathematics in Nature

The curve of probability,

Nature has made some beautiful models of the curves and polygons and solids that are studied in mathematics. We find them in the sky, on the earth, and in the sea.

CASSIOPEIA

The pseudo-sphere is a curved surface whose geometry is non-Euclidean. On this surface, the sum of the angles of a triangle is less than 180°

PRO PATRIA 1958
20 HELVETIA

B

A C

A + B + C < 180°

Even Shakespeare's poetry pictures age as infancy, as helplessness and decadence, instead of assigning to man the everlasting grandeur and immortality of development, power, and prestige.

The error of thinking that we are growing old, and the benefits of destroying that illusion, are illustrated in a sketch from the history of an English woman, published in the London medical magazine called *The Lancet*.

Disappointed in love in her early years, she became insane and lost all account of time. Believing that she PERPETUAL was still living in the same hour which YOUTH parted her from her lover, taking no note of years, she stood daily before the window watching for her lover's coming. In this mental state she remained young. Having no consciousness of time, she literally grew no older. Some American travellers saw her when she was seventy-four, and supposed her to be a young woman. She had no care-lined face, no wrinkles nor gray hair, but youth sat gently on cheek and brow. Asked to guess her age, those unacquainted with her history conjectured that she must be under twenty.

This instance of youth preserved furnishes a useful hint, upon which a Franklin might work with more certainty than when he coaxed the enamoured lightning from the clouds. Years had not made her old, because she had taken no cognizance of passing time nor thought of herself as growing old. The bodily results of her belief that she was young manifested the influence of such a belief. She could not age while believing herself young, for the mental state governed the physical.

Impossibilities never occur. One instance like the foregoing proves it possible to be young at seventy-four; and the primary of that illustration makes it plain that decrepitude is not according to law, nor is it a necessity of nature, but an illusion.

The infinite never began nor will it ever end. Mind and its formations can never be annihilated. Man is not a pendulum, swinging between evil and good, joy and MAN REFLECTS GOD sorrow, sickness and health, life and death. Life and its faculties are not measured by calendars. The perfect and immortal are the eternal likeness of their Maker. Man is by no means a material germ rising from the imperfect and endeavoring to reach Spirit above his origin. The stream rises no higher than its source.

The measurement of life by solar years robs youth and gives ugliness to age. The radiant sun of virtue and truth coexists with being. Manhood is its eternal noon, undimmed by a declining sun. As the physical and material, the transient sense of beauty fades, the radiance of Spirit should dawn upon the enraptured sense with bright and imperishable glories.

Never record ages. Chronological data are no part of the vast forever. Time-tables of birth and death are so UNDESIRABLE RECORDS many conspiracies against manhood and womanhood. Except for the error of measuring and limiting all that is good and beautiful, man would enjoy more than threescore years and ten and still maintain his vigor, freshness, and promise. Man, governed by immortal Mind, is always beautiful and grand. Each succeeding year unfolds wisdom, beauty, and holiness.

Life is eternal. We should find this out, and begin the demonstration thereof. Life and goodness are immortal. TRUE LIFE ETERNAL Let us then shape our views of existence into loveliness, freshness, and continuity, rather than into age and blight.

Acute and chronic beliefs reproduce their own types. The acute belief of physical life comes on at a remote period, and is not so disastrous as the chronic belief.

I have seen age regain two of the elements it had lost,

sight and teeth. A woman of eighty-five, whom I knew, had a return of sight. Another woman at ninety had new teeth, incisors, cuspids, bicuspids, and one molar. One man at sixty had retained his full set of upper and lower teeth without a decaying cavity.

EYES AND TEETH RENEWED

Beauty, as well as truth, is eternal; but the beauty of material things passes away, fading and fleeting as mortal belief. Custom, education, and fashion form the transient standards of mortals. Immortality, exempt from age or decay, has a glory of its own,—the radiance of Soul. Immortal men and women are models of spiritual sense, drawn by perfect Mind and reflecting those higher conceptions of loveliness which transcend all material sense.

ETERNAL BEAUTY

Comeliness and grace are independent of matter. Being possesses its qualities before they are perceived humanly. Beauty is a thing of life, which dwells forever in the eternal Mind and reflects the charms of His goodness in expression, form, outline, and color. It is Love which paints the petal with myriad hues, glances in the warm sunbeam, arches the cloud with the bow of beauty, blazons the night with starry gems, and covers earth with loveliness.

THE DIVINE LOVELINESS

The embellishments of the person are poor substitutes for the charms of being, shining resplendent and eternal over age and decay.

From
Where is Science Going?

I am inclined to believe, with many famous philosophers, that the solution of the problem lies in quite another sphere. On close examination, the above-stated alternative —Is the human will free or is it determined by a law of strict causality?—is based on an inadmissible logical disjunction. The two cases opposed here are not exclusive of one another. What then does it mean if we say that the human will is causally determined? It can only have one meaning, which is that every single act of the will, with all its motives, can be foreseen and predicted, naturally only by somebody who knows the human being in question, with all his spiritual and physical characteristics, and who sees directly and clearly through his conscious and subconscious life. But this would mean that such a person would be endowed with absolutely clear-seeing spiritual power of vision; in other words he would be endowed with divine vision.

Now, in the sight of God, all men are equal. Even the most highly gifted geniuses, such as a Goethe or a Mozart, are but as primitive beings the thread of whose innermost thought and most finely spun feelings is like a chain of pearls unrolling in regular succession before His eye. This does not belittle the greatness of great men. But it

Max Planck, *Where Is Science Going?* (New York: Norton, 1932).

would be a piece of stupid sacrilege on our part if we were to arrogate to ourselves the power of being able, on the basis of our own studies, to see as clearly as the eye of God sees and to understand as clearly as the Divine Spirit understands.

The profound depths of thought cannot be penetrated by the ordinary intellect. And when we say that spiritual happenings are determined, the statement eludes the possibility of proof. It is of a metaphysical character, just as the statement that there exists an outer world of reality. But the statement that spiritual happenings are determined is logically unassailable, and it plays a very important role in our pursuit of knowledge, because it forms the basis of every attempt to understand the connections between spiritual events. No biographer will attempt to solve the question of the motives that govern the acts of his hero by attributing these to mere chance. He will rather attribute his inability to the lack of source materials or he will admit that his own powers of spiritual penetration are not capable of reaching down into the depths of these motives. And in practical everyday life our attitude to our fellow beings is based on the assumption that their words and actions are determined by distinct causes, which lie in the individual nature itself or in the environment, even though we admit that the source of these causes cannot be discovered by ourselves.

What do we then mean when we say that the human will is free? That we are always given the chance of choosing between alternatives when it comes to a question of taking a decision. And this statement is not in contradiction with what I have already said. It would be in contradiction only if a man could see through himself; for then, on the basis of the law of causality, he would foresee every action of his own will and thus his will would no longer be free. But that case is logically ex-

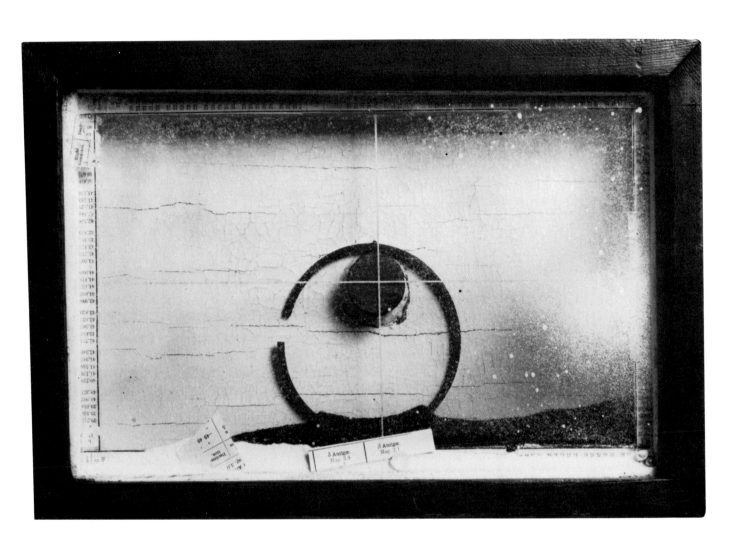

Symphony in C (for Paul Dukas), undated 2 1 3

cluded; for the most penetrative eye cannot see itself, no more than a working instrument can work upon itself. The object and subject of an act of knowing can never be identical; for we can speak of the act of knowing only when the object to be known is not influenced by the action of the subject who initiates and performs the act of knowing. Therefore the question as to whether the law of causality applies in this case or in that is in itself senseless if you apply it to the action of your own will, just as if somebody were to ask whether he could lift himself above himself or race beyond his shadow.

In principle every man can apply the law of causality to the happenings of the world around him, in the spiritual as well as in the physical order, according to the measure of his own intellectual powers; but he can do this only when he is sure that the act of applying the law of causality does not influence the happening itself. And therefore he cannot apply the law of causality to his own future thoughts or to the acts of his own will. These are the only objects which for the individual himself do not come within the force of the law of causality in such a way that he can understand its play upon them. And these objects are his dearest and most intimate treasures. On the wise management of them depend the peace and happiness of his life. The law of causality cannot lay down any line of action for him and it cannot relieve him from the rule of moral responsibility for his own doings; for the sanction of moral responsibility comes to him from another law, which has nothing to do with the law of causality. His own conscience is the tribunal of that law of moral responsibility and there he will always hear its prompting and its sanctions when he is willing to listen.

It is a dangerous act of self-delusion if one attempts to get rid of an unpleasant moral obligation by claiming

that human action is the inevitable result of an inexorable law of nature. The human being who looks upon his own future as already determined by fate, or the nation that believes in a prophecy which states that its decline is inexorably decreed by a law of nature, only acknowledges a lack of will power to struggle and win through.

And so we arrive at a point where science acknowledges the boundary beyond which it may not pass, while it points to those farther regions which lie outside the sphere of its activities. The fact that science thus declares its own limits gives us all the more confidence in its message when it speaks of those results that belong properly to its own field. But on the other hand it must not be forgotten that the different spheres of activity of the human spirit can never be wholly isolated from one another; because there is a profound and intimate connection between them all.

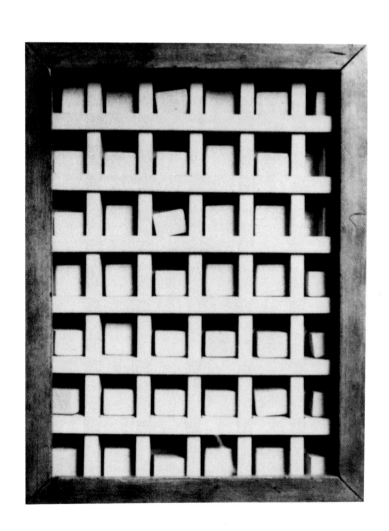

216 *Multiple Cubes, 1946–48*

STÉPHANE MALLARMÉ

Sonnet

Ses purs ongles très haut dédiant leur onyx,
L'Angoisse,-ce minuit, soutient, lampadophore,
Maint rêve vespéral brûlé par le Phénix
Que ne recueille pas de cinéraire amphore

Sur les crédences, au salon vide: nul ptyx,
Aboli bibelot d'inanité sonore,
(Car le Maître est allé puiser des pleurs au Styx
Avec ce seul objet dont le Néant s'honore).

Mais proche la croisée au nord vacante, un or
Agonise selon peut-être le décor
Des licornes ruant du feu contre une nixe,

Elle, défunte nue en le miroir, encor
Que, dans l'oubli fermé par le cadre, se fixe
De scintillations sitôt le septuor.

Sonnet IV from "Plusieurs Sonnets" in *Mallarmé*, ed. Anthony Hartley (Baltimore: Penguin Books, 1965).

CORNELL'S

HOMAGE TO CHILDREN

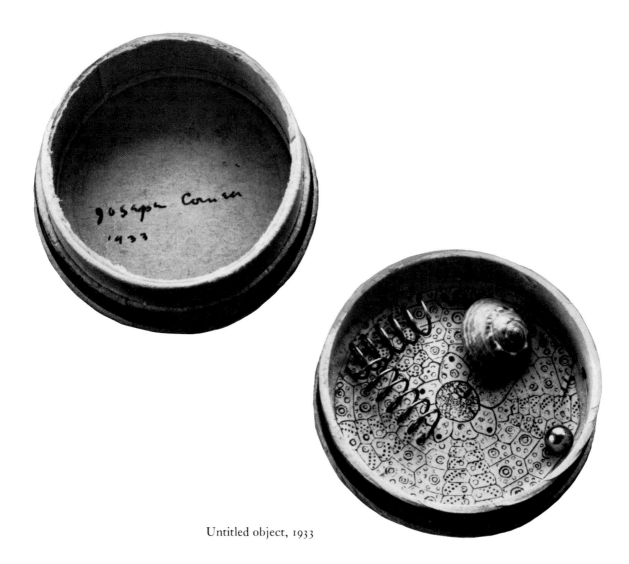

Untitled object, 1933

Memoir

There is in Joseph Cornell's art a fragile sense of grace and nostalgia, an air of wit, that has always affected me. Cornell spoke to Dore Ashton's art history class at Cooper Union at the time of an installation there of a children's exhibition of his work; I was delighted to experience the same qualities in the artist himself. Perhaps something of a list of what he did and said will convey a sense of his visits with us.

After apologizing for coming to class unprepared, because he couldn't have an assistant bring anything large to class, he spilled out of a leather bag a pile of paper boxes, which he said he had just made and were mostly uncompleted. A few of the boxes were painted, and some were covered with what looked like wallpaper or old maps. While he told us of his long love for bel canto singing, he arranged the piece *Seven Tears for Anna Moffo*, seven blue glass teardrops from a chandelier falling from a dark velvet-lined box.

When we began questioning him about the process of making his sculptures, he told us how he had collected his "incunabula," art reproductions, penny prints, railway maps, menu cards, in the old Fourth Avenue bookshops, mentioning his youth in the New York of 1915. He explained his personal but not autobiographical use of nostalgic images; never having left this country, he would use a French timetable or menu for its more general associations.

He read us his personal reading list. I remember only that he

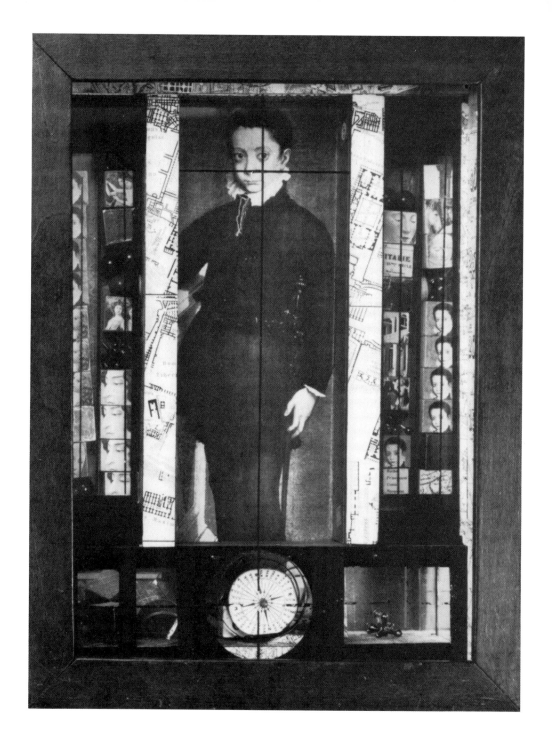

222 *Medici Slot Machine*, 1942

was hesitant to mention Mary Baker Eddy; later he referred to Theosophy and the artists of his generation. He had brought a record of excerpts from French opera; he was sorry that young people seemed uninterested in classical music. (He also deftly mentioned a recent visit from John Lennon.) He seemed eager to refute the old charge that he was a recluse.

While he talked, he opened the boxes he brought, fitting pieces together, and explaining some of their contents. I remember one as being a reproduction cut into tiny strips, which he bound with blue and red thread. He also showed us a drawing of a sun face his brother had made on his deathbed, of which he had made several copies. A similar face in painted tin, a child's toy, possibly the model for the drawing, appeared in one of the exhibition pieces.

Preferring not to lecture to us, he approached our class with informality and great charm. He welcomed the opportunity, he said, to speak to students. I wish our questions could have been better informed, less callow, but he seemed to enjoy our real curiosity about his work and our delight in him.

DENISE HARE

Photo Essay

Joseph Cornell often said children were his most receptive and enthusiastic audience. They were filled with the innocence needed to *see*.

In the winter of 1972, with this in mind, the Cooper Union School of Art and Architecture organized an exhibition of his work directed to the children of Lower Manhattan. It was, and probably still is, the only art exhibition to be held for "Children Only."

On the opening day, only Cornell and the very few other grown-ups present were seen bending down to view the work, which was hung about three feet off the floor. Showing none of his noted vagueness or illusiveness, he enthusiastically answered the children's questions: "That's Andromeda, a lady up in the stars"; "That's a head of a real Dutch pipe I got at the World's Fair in 1939"; etc.

Brownies, a favorite of his, were the refreshments of the day, along with cherry Coke, which he said brought back memories "of Sheree North—a starlet they were going to build up to Marilyn Monroe roles, but it didn't happen. I sent her a small box once, but never heard from her."

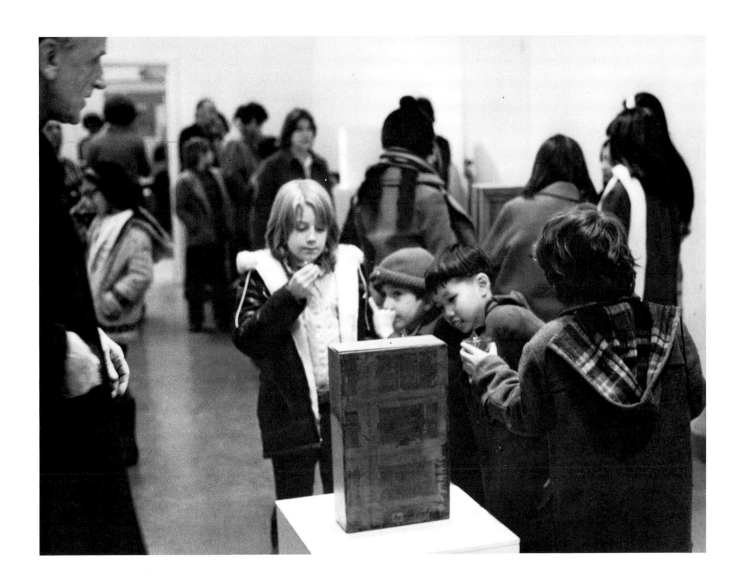

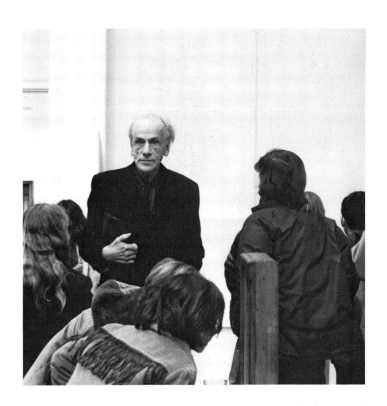

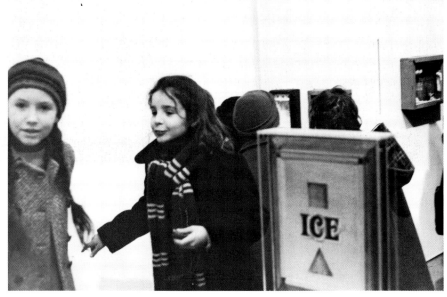

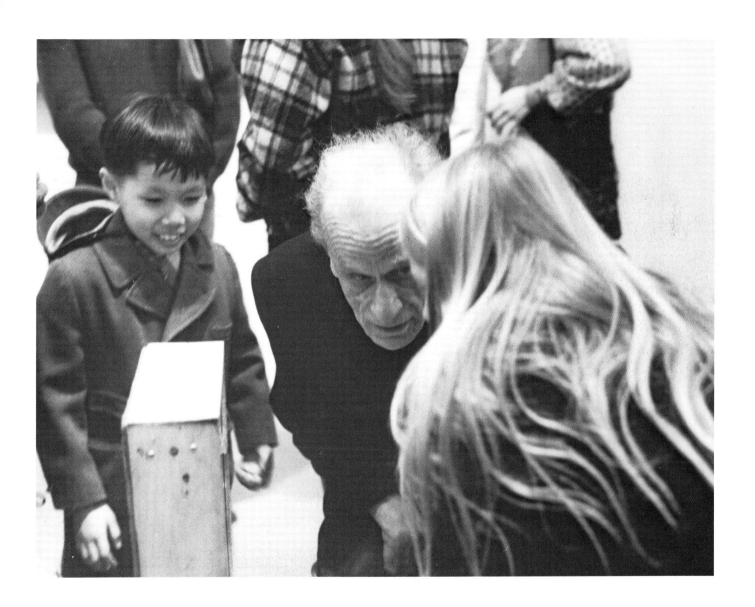

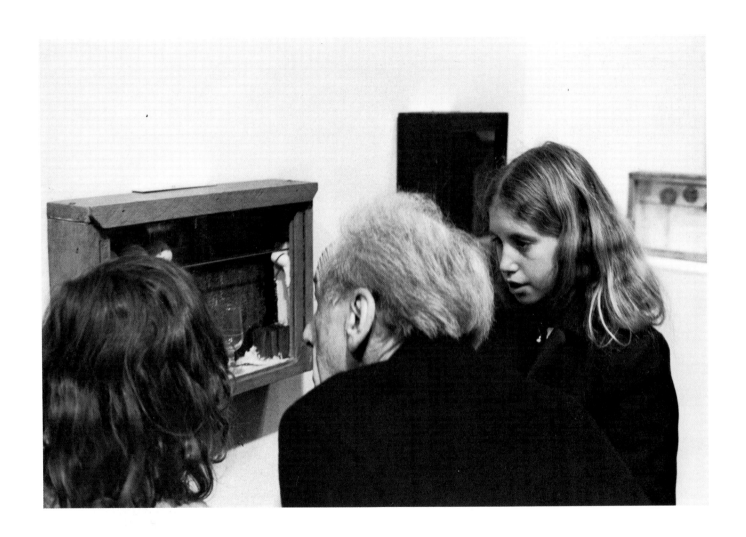

229

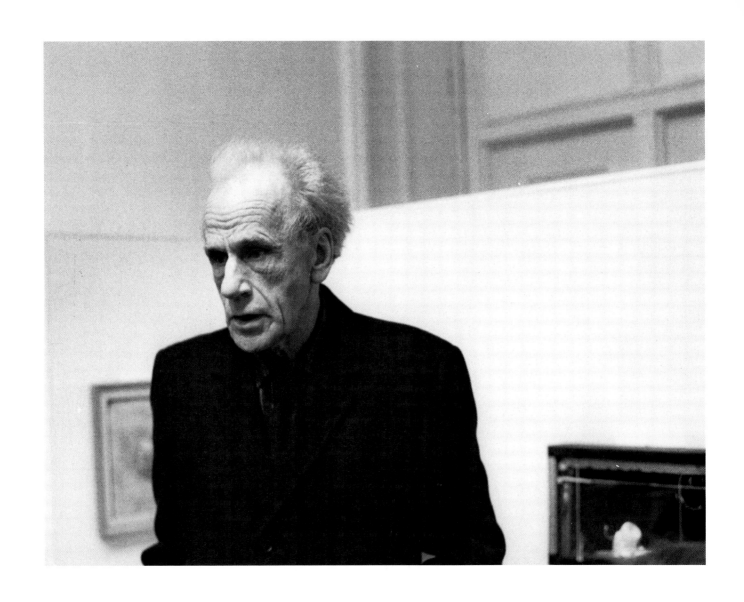

This was the last exhibition
Cornell attended before his death.

am saving your card part of a beautiful mail—
mail for but the day went awry —
tomorrow now, — in the cold — my assistant
morning is carrying a line to you —
again to come out again if you should
also care to — I am not able to get
cheated into town unfortunately — I have
something in the nature of a "once in
a lifetime" to show you — hope you
can make it soon.

à bientôt —

Joseph C.

Best to all —

List of Illustrations

238

ACKNOWLEDGMENT IS MADE TO THE FOLLOWING FOR PERMISSION TO USE MATERIAL:

George Allen & Unwin Ltd., for material from *Where Is Science Going?* by Max Planck.

John Ashbery, for "Pantoum." Copyright © 1956 by John Ashbery.

The quotation from *Science and Health with Key to the Scriptures* by Mary Baker Eddy is used with the permission of The Christian Science Board of Directors.

Stanley Kunitz, for "The Crystal Cage," Copyright © 1974 by Stanley Kunitz.

Crown Publishers, for material from *The Journal of Eugène Delacroix*, translated from the French by Walter Pach. Copyright 1948 by Covici, Friede, Inc., Copyright © 1973 by Crown Publishers. Used by permission of Crown Publishers.

Grossman Publishers and Calder and Boyars Ltd., for material from *The Life of Rossini* by Stendhal, translated by Richard Coe. Copyright © 1970 by Calder & Boyars Ltd.

Harcourt Brace Jovanovich, Inc., and Cyrilly Abels, for excerpts from *The Life and Times of Hans Christian Andersen*, Copyright © 1965 by Monica Stirling. Reprinted by permission.

Harvard University Press, for material from *The Poems of Emily Dickinson*, edited by Thomas H. Johnson, Cambridge, Mass.: The Belknap Press of Harvard University Press, Copyright, 1951, 1955, by the President and Fellows of Harvard College. Reprinted by permission of the publishers and the Trustees of Amherst College.

The Johns Hopkins University Press, for excerpts from *Mallarmé*, translated by Bradford Cook. Copyright © 1956 by The Johns Hopkins University Press.

Alfred A. Knopf, Inc., for material from *Memoirs of Hector Berlioz: 1803 to 1865*, translated by Rachel and Eleanor Holmes, edited by Ernest Newman. Copyright 1932 by Alfred A. Knopf, Inc., and renewed 1960 by Vera Newman. Reprinted by permission of Alfred A. Knopf, Inc.

Little, Brown & Co., for material from *The Complete Poems of Emily Dickinson*, edited by Thomas Johnson. Copyright 1929, © 1957 by Mary L. Hampson. Reprinted by permission.

The New Yorker, for "Objects & Apparitions" by Octavio Paz, translated by Elizabeth Bishop. Copyright © 1974 by The New Yorker Magazine, Inc. Reprinted by permission.

The Philip A. & A. S. W. Rosenbach Foundation and Clive E. Driver, for Marianne Moore's letter to Joseph Cornell.

Frederick Ungar Publishing Co., Inc., for material from *Henry Von Ofterdingen* by Novalis. Translated by Palmer Hilty. Copyright © 1964 by Frederick Ungar Publishing Co., Inc.

The University of Chicago Press, for material from "Petit Air II," from *Mallarmé*, translated by Wallace Fowlie. Copyright 1953 by Wallace Fowlie.

The Village Voice, for material from "The Invisible Cathedrals of Joseph Cornell" from *Movie Journal* by Jonas Mekas. Copyrighted by The Village Voice, Inc., 1970.

Geoffrey Wagner, for material from *Selected Writings of Gerard D. Nerval*, translated by Geoffrey Wagner.